Aleene's®

Angels
Made
Easy

Oxmoor
House®

Aleene's Angels Made Easy
from the Best of *Aleene's Creative Living* series
©1997 by Oxmoor House, Inc.
Book Division of Southern Progress Corporation
P.O. Box 2463, Birmingham, Alabama 35201

Published by Oxmoor House, Inc., and Leisure Arts, Inc.

Library of Congress Catalog Number: 96-72277
Hardcover ISBN: 0-8487-1609-4
Softcover ISBN: 0-8487-1610-8
Manufactured in the United States of America
First Printing 1997

Aleene's™ is a registered trademark of Artis, Inc.
Trademark Registration #1504878
Aleene's™ is used by permission of Artis, Inc.
Designs by Heidi Borchers

We're Here for You!
We at Oxmoor House are dedicated to
serving you with reliable information that
expands your imagination and enriches your
life. We welcome your comments and
suggestions. Please write us at:
 Oxmoor House, Inc.
 Editor, *Aleene's Angels Made Easy*
 2100 Lakeshore Drive
 Birmingham, AL 35209
To order additional publications, call
1-205-877-6560.

Editor-in-Chief: Nancy Fitzpatrick Wyatt
Senior Crafts Editor: Susan Ramey Cleveland
Senior Editor, Editorial Services: Olivia Kindig Wells
Art Director: James Boone

Aleene's Angels Made Easy

Editor: Catherine Corbett Fowler
Editorial Assistant: Barzella Estle
Copy Editor: L. Amanda Owens
Senior Photographer: John O'Hagan
Photo Stylist: Connie Formby
Assistant Art Director: Cynthia R. Cooper
Designer: Carol Damsky
Illustrator: Kelly Davis
Senior Production Designer: Larry Hunter
Publishing Systems Administrator: Rick Tucker
Production and Distribution Director: Phillip Lee
Associate Production Manager: Theresa L. Beste
Production Assistant: Faye Porter Bonner

*Cover portrait of Aleene Jackson and Heidi Borchers
by Christine Photography*

Greetings

I have always loved angels. When I was a child, my mom, Aleene, would decorate our home at Christmastime with lots of angel designs. The angel ornaments were always my favorite decorations. Throughout the years angels have taken on even more significance for me.

About five years ago I attended a seminar given by Terry Lynn Taylor, author of *Messengers of Light.* I was fascinated by her explanation of angels' influence in everyday life. She explained how some coincidences should be looked at more closely as possible angelic interventions. I have read many books about angels since her seminar, and I truly believe there is a creative angel energy in my life.

Regardless of whether I'm developing book ideas or working in Simply Angels, the shop my daughter Starr Hall and I run, when I ask my angels for assistance, they are always there for me. I know they certainly were with me when I was designing the projects for this book!

I hope that the angels on the following pages will find a very special place in both your heart and home!

Sincerely,

Heidi

Contents

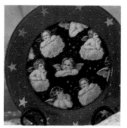

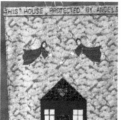
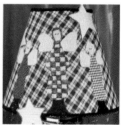
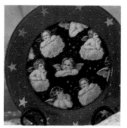

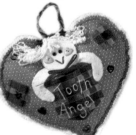
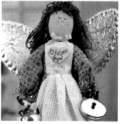

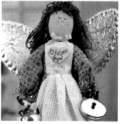

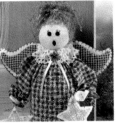
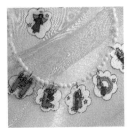

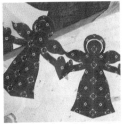

Beanbag Babies

These angels don't fly—they flop! Plop one on
your shoulder, on a computer monitor, or on
a little girl's nightstand.

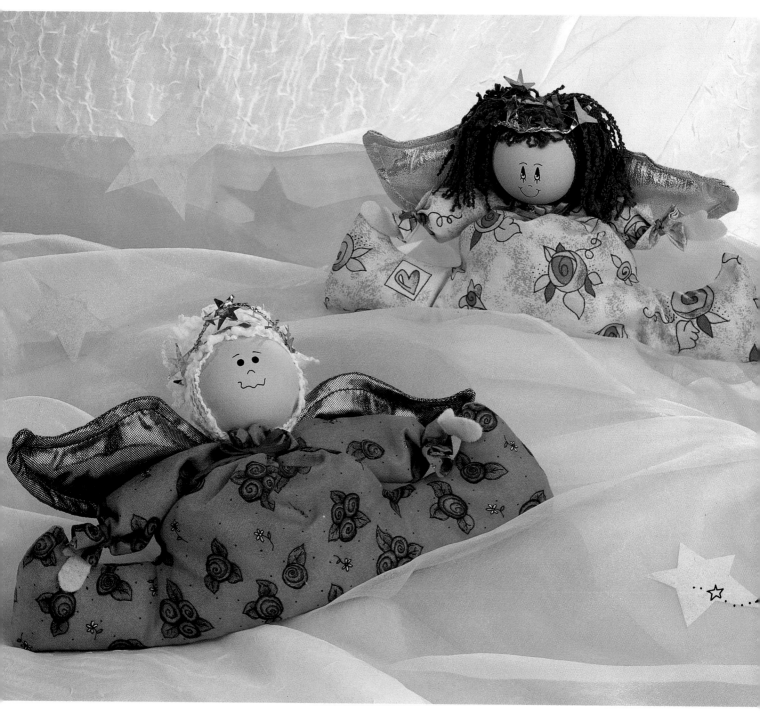

Materials (for 1 angel)

Fabric: 1 (12" x 15") piece, 1 (4" x 9") piece

8" x 12" piece gold or silver lamé

2" square flesh-colored felt

Thread

Aleene's Designer Tacky Glue™

2"-diameter wooden bead with hole

Aleene's Premium-Coat™ Acrylic Paint: flesh color

Paintbrush

2½" length ³/₁₆"-diameter wooden dowel

Rub-on doll face *

Cotton string doll hair in desired color *

1 yard ⅛"-wide satin ribbon

Uncooked rice

Stuffing

8" length gold wire star garland

*** See Sources on page 144.**

Directions

1. Transfer pattern on page 8 to 12" x 15" fabric piece and cut 1 body, adding ¼" seam allowance. Transfer pattern to lamé and cut 2 wings pieces, adding ¼" seam allowance to each. Transfer pattern to felt and cut 2 hands.

2. With right sides facing and raw edges aligned, stitch body together, leaving top edge open. Turn. For arms, with right sides facing and raw edges aligned, fold 4" x 9" fabric piece in half lengthwise. Stitch along long edge. Turn. Fold open edges of body piece and arms piece under ¼" and glue. Let dry.

Plastic pellets, available at crafts stores, are also a good stuffing material for your angel.

3. For head, paint wooden bead with flesh color. Let dry. Coat 1 end of dowel with glue. Insert dowel into wooden bead. Let dry. Referring to **Diagram,** rub face onto head. Glue doll hair to top of head. Glue additional hair to head to form 1 or 2 ponytails if desired. Let dry. If desired, cut and tie small piece of satin ribbon in bow and glue in hair. Let dry.

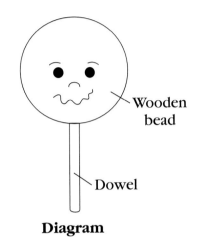

Diagram

4. Fill body with rice to within 1" of top edge. Insert dowel end of head into top of body piece. Cut 3 (8") lengths of satin ribbon. Use 1 length of ribbon to tie top of body piece tightly around dowel. Tie free ends of ribbon in bow. Referring to photo, glue 1 felt hand into 1 open end of arms piece. Repeat with opposite end of arms piece. Let dry. Tightly tie off 1 end of arms piece, using 1 length of satin ribbon. Loosely fill arms piece with rice. Tie off remaining end of arms piece, using remaining length of satin ribbon. Referring to photo, center and glue arms to top back of body piece. Let dry.

5. With right sides facing and raw edges aligned, stitch wings together, leaving area indicated on pattern open. Turn. Lightly stuff. Fold unstitched edges to inside. Staystitch ¼" from edge. Center and glue wings on back of arms piece. Let dry.

6. For halo, shape star garland into 2"-diameter circle. Slip ponytail or ponytails through halo and place halo on head.

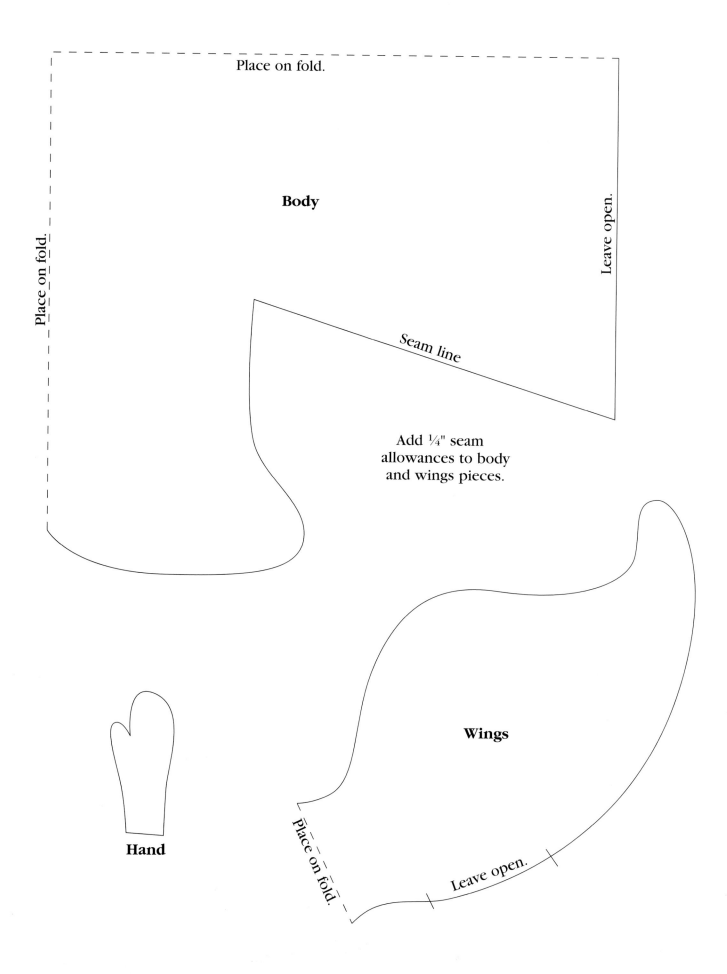

Place on fold.

Body

Place on fold.

Leave open.

Seam line

Add ¼" seam
allowances to body
and wings pieces.

Wings

Hand

Place on fold.

Leave open.

8

Autumn Angels

As leaves fall and shadows lengthen, hang these harvest angels
in a favorite window to herald the change of seasons.

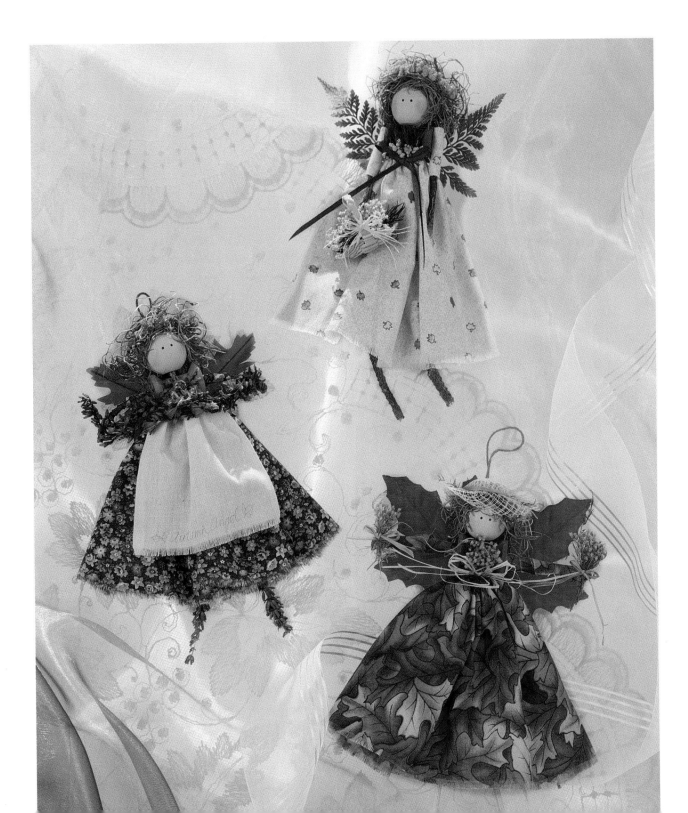

Materials (for 3 angels)

3 (1"-diameter) wooden beads
Aleene's Premium-Coat™ Acrylic
 Paints: flesh color, Black, Medium
 Fuchsia, Deep Peach, Dusty Blush,
 Burnt Umber
Small paintbrushes
4 toothpicks
3 (⅞" x 1⅛") wooden spools
Drill with very small bit
Aleene's Designer Tacky Glue™
Small print fabric: 9 (1" x 8") strips,
 3 (5" x 20") pieces for dresses
4" square of muslin for apron
Fine-tip brown fabric marker (optional)
Thread
Sticks, approximately ¼" in diameter:
 6 (3"-long), 4 (5"-long)
2 (5"-long) sticks dried lavender
Spanish moss
3 (10") lengths embroidery floss for
 hangers
6 leaves or fern fronds for wings (silk
 or real)
Assorted Aleene's Botanical Preserved
 Flowers & Foliage™
Mini straw hat
Raffia
10" length ⅛"-wide brown satin ribbon
Mini straw basket

Directions

1. Paint each wooden ball with flesh color. Let dry. Referring to photo, dip 1 end of 1 toothpick in Black and dot set of eyes on each ball. Let dry. Using very dry paintbrush and Medium Fuchsia, lightly paint cheeks on each ball. Let dry. Paint 1 spool with Deep Peach, 1 spool with Dusty Blush, and 1 spool with Burnt Umber. Let dry.

2. Referring to **Diagram**, drill hole through each wooden ball and through center of each spool. Fill hole in each ball and spool with glue. Slide 1 toothpick through hole in 1 ball and 1 spool **(Diagram)**. Repeat with remaining balls and spools. Let dry. Apply glue to exposed end of each toothpick. Wrap each end with 1 (1" x 8") strip of fabric. Secure final wraps with glue. Let dry.

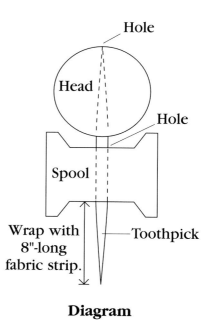

Diagram

3. For each dress, with right sides facing and short ends aligned, stitch 1 (5" x 20") fabric piece together along short edges. Turn. Run gathering stitches along 1 raw edge. Gather tightly and tie off. Slide gathered end onto fabric-covered end of toothpick just below spool. Glue gathered end of dress in place. Pull threads and slightly fray bottom edge of dress.

For apron angel, fold ¼" of 2 opposite edges of muslin under and glue in place. Let dry. Run gathering stitches along 1 remaining raw edge. Gather and tie off. If desired, write "Autumn Angel" along

bottom edge of apron, using fabric marker. Glue gathered edge of apron to top front of 1 dress. Let dry. Pull threads and slightly fray bottom edge of apron.

4. For sleeves, using 1 (1" x 8") strip of fabric, wrap each 3"-long stick, securing short ends of each strip with glue. (Wrap half of stick for short sleeves or wrap entire stick for long sleeves.) Let dry. Fill open ends of spools with glue. Insert 1 fabric-wrapped stick into each hole or glue fabric-wrapped end of 1 stick to each end of spool, covering holes. Let dry. For legs, glue 2 (5"-long) sticks or 2 (5"-long) sticks of lavender to inside of dress, making sure legs extend beyond edge of dress.

5. Glue Spanish moss to top of each ball for hair. Let dry. Fold embroidery floss lengths in half and knot ends. Glue ends of floss to back of angel at arm level for hanger. For wings, glue leaves or fern fronds to back of angel on top of hanger. Let dry.

6. Referring to photo, glue dried botanicals in hair or glue hat on top of head. Let dry. Glue cluster of dried botanicals to front of each spool to make top of dress. Tie satin ribbon or raffia in bow and glue to base of botanicals that forms top of dress. Let dry. If desired, wire botanicals into length of garland and then glue ends of garland to hands of 1 angel. Or glue botanicals in basket and then glue basket in 1 hand of 1 angel. Or glue raffia-tied botanical bouquets in hands of 1 angel. Let dry.

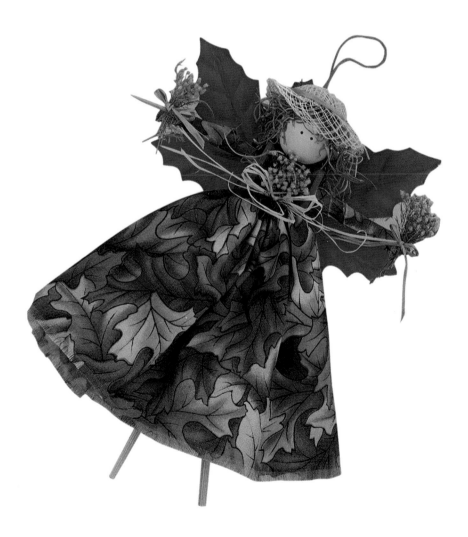

Haloed Stocking Hanger

Weighted with plaster of Paris, this angel will
hold a stocking stuffed full of presents.

Materials

Aleene's Premium-Coat™ Acrylic
 Paints: flesh color, Black, Light
 Fuchsia, True Red, color to match
 dress fabric, accent color for socks
 and sleeves, Yellow Ochre
Paintbrushes
Wooden balls: 1 (2"-diameter),
 1 (1¾"-diameter)
Drill with ⅛" bit
Wooden dowels: 1 (⅛" x 3½"), 4 (¾" x
 2"), 4 (¾" x 1½")
Aleene's Designer Tacky Glue™
4"-diameter clay pot
Plaster of Paris
18-gauge wire: 2 (12") pieces, 1 (5")
 piece, 1 (8") piece
1½"-long wooden egg
Small saw
8 (¾"-diameter) wooden beads with
 holes
1"-wide wooden star
5" x 10" piece cardboard
5" x 10" piece thin batting
Fabric: 12" square for wings, 7¼" x 26"
 piece for dress, 3½" x 32" strip for
 skirt ruffle, 4½" x 6¼" piece for
 apron, 1" x 12" strip for bow
Needle and thread
12" length nylon cording
Doll hair in desired color
12" length ¼"-wide gold metallic
 ribbon
Black embroidery floss

Directions

1. Paint 2" wooden ball with flesh color.
Let dry. Drill hole halfway through 2" ball.
Drill hole all the way through 1¾" wooden
ball. Coat 1 end of ⅛" x 3½" dowel with
glue. Referring to **Body Assembly
Diagram,** insert glued end of dowel into
hole in 2" ball. Let dry. Apply glue around
holes in 1¾" ball. Slide 1¾" ball onto dowel
so that 1 glued end butts up against 2" ball.
Turn clay pot upside down. Insert remain-
der of dowel into hole in bottom of clay
pot so that remaining glued end of 1¾" ball
rests against pot. Let dry.

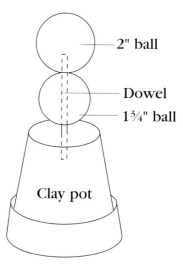

Body Assembly Diagram

*Dress your angel in colors that
complement your decor, and
you can use her as a mantel
decoration year-round.*

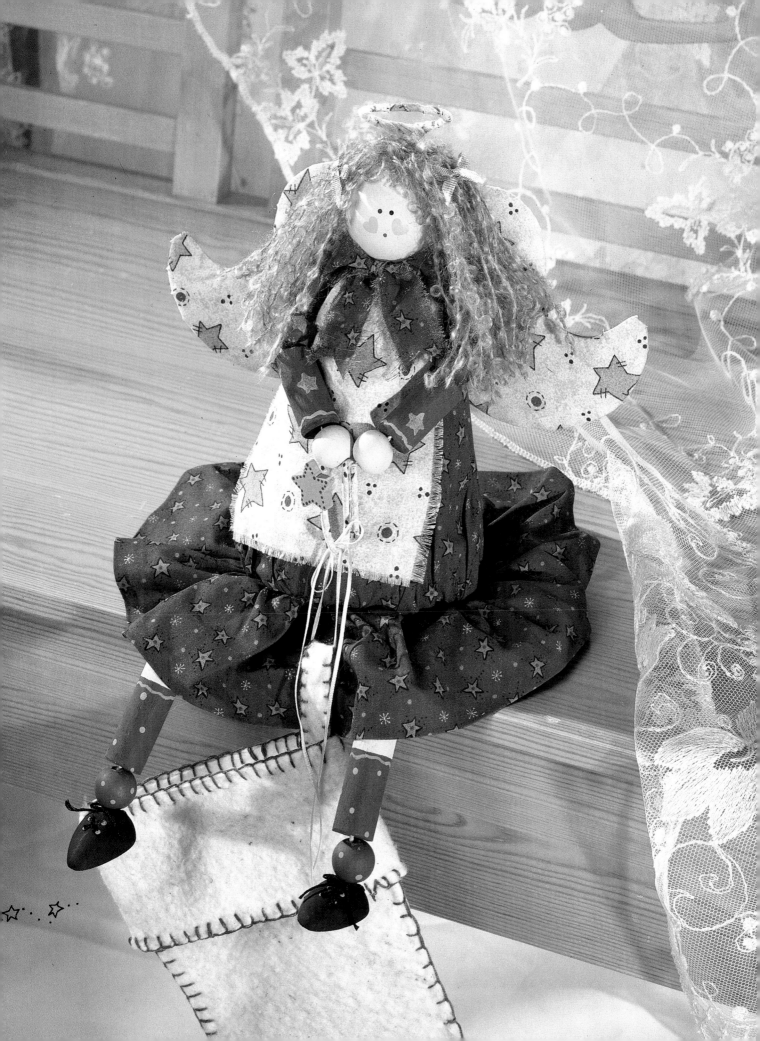

2. Referring to manufacturer's directions, mix plaster of Paris. Turn pot right side up. Prop books on sides of pot so that pot will sit securely. Fill pot with plaster of Paris. Insert 12" pieces of wire into wet plaster of Paris, positioning wires as close to edge of pot as possible, spacing them 1½" apart, and leaving 7½" of each wire extending out of pot. Let pot sit undisturbed until plaster of Paris sets and hardens.

3. Saw wooden egg in half lengthwise. Drill holes all the way through ¾" x 2" dowel pieces and ¾" x 1½" dowel pieces and through widest end of egg halves.

4. Referring to photo, paint face, using Black for eyes, Light Fuchsia for heart-shaped cheeks, and True Red for mouth. Let dry. Paint 2 (¾" x 2") dowel pieces and 4 wooden beads with flesh color. Let dry. Referring to **Leg Painting Diagram,** paint one-third of 2 (¾" x 2") dowel pieces with flesh color. Let dry. For sock area, paint remainder of these 2 dowel pieces and 2 wooden beads with dress fabric color. Let dry. If desired, using accent color, paint accents on sock area (see photo). Let dry. For shoes, paint egg halves with Black. Let

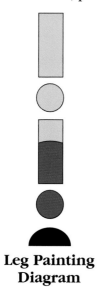

Leg Painting Diagram

dry. Referring to photo and using accent color, paint 4 dots in box shape on top center of each egg half. Let dry. For sleeves, paint ¾" x 1½" dowel pieces and 2 remaining wooden beads with dress fabric color. Let dry. If desired, paint details on sleeve pieces with accent color (see photo). Let dry. Paint wooden star with Yellow Ochre. Let dry. Using dress fabric color, paint dots around edge on 1 side of wooden star. Let dry.

5. Transfer wings pattern to cardboard and batting and cut out. Glue batting to 1 side of cardboard wings. Let dry. Transfer wings pattern twice to fabric. Cut 1 set of wings,

adding ½" seam allowance. Cut remaining set of wings, cutting ¼" inside marked pattern line. Cover batting side of cardboard wings, using large wings fabric piece. Fold excess fabric to back and glue in place, clipping excess as necessary for curves. Let dry. Glue small wings fabric piece to back of cardboard wings, covering ends of folded-over fabric. Let dry.

6. Apply glue along 1 short edge of 7¼" x 26" fabric dress piece. Press remaining short edge of fabric into glue to form circle. Let dry. Run gathering stitches by hand along each cut edge of fabric tube. Place clay pot on work surface so that wooden balls are on top. Slip gathered dress piece over balls and pot. Pull threads to gather top edge of dress tightly between balls. Tie off. Glue top gathered edge in place. Let dry. Pull threads to gather bottom edge of dress. Tie off. Fold gathers slightly to inside rim of clay pot and then glue in place. Let dry.

7. Fold 1 long edge of 3½" x 32" fabric strip under ¼". Glue in place. Let dry. Apply glue along 1 short edge of strip. Press remaining short edge of strip into glue to form circle. Let dry. Run gathering stitches by hand along raw edge of fabric circle. Pull threads to gather circle to circumference of pot rim. Tie off. Glue gathered edge of circle to rim of pot for ruffle. Let dry.

8. Run gathering stitches by hand along 1 short edge of 4½" x 6¼" apron piece. Pull threads to gather slightly. Tie off. Pull fabric threads to slightly fray remaining sides of apron piece. Center and glue gathered edge of apron piece to front of angel at neckline of dress. (Front of angel is side where wires extend out of bottom of pot.)

9. Referring to **Arms Assembly Diagram,** thread ¾" x 1½" dowel pieces, 2 dress-colored wooden beads, and 2 flesh-colored wooden beads onto nylon cording. Tie ends of cording into knot. Glue knot to back of neck of angel. Let dry.

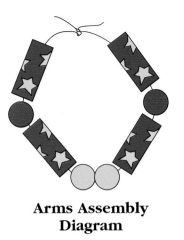

**Arms Assembly
Diagram**

10. Pull fabric threads to slightly fray all edges of 1" x 12" bow strip. Tie strip in bow and glue to front of neck. Let dry. Glue doll hair to top of head. Let dry. Cut gold ribbon in half. Tie each half in bow, trimming as necessary. Glue 1 bow in hair on each side of head. Let dry. For halo, bend 1 end of 5" piece of wire into 1½"-diameter circle. Fold down circle so that it is at 90° angle to stem. Wrap halo with scraps of wing fabric. Glue ends of fabric to secure. Let dry. Glue halo stem to back of head. Let dry. Referring to photo for position, glue wings in place on back of angel. For stocking hanger, wrap remaining wire piece in scraps of wing fabric. Glue ends of fabric to secure. Let dry. Bend wire into S shape. Glue wooden star to 1 end of wire. Let dry. Referring to photo, hook stocking hanger between hands.

11. For each leg, referring to photo, thread 1 flesh-colored ¾" x 2" dowel piece onto 1 wire extending from rim of pot; then thread 1 flesh-colored wooden bead, 1 bicolored ¾" x 2" dowel piece, 1 dress-colored wooden bead, and 1 egg half (rounded side up). Apply thick coat of glue to flat side of egg to hold wooden pieces on wire. Let dry. For each shoelace, tie length of black embroidery floss into small bow. Glue on top of 1 shoe. Cut 2 very short lengths of embroidery floss. Glue lengths in X shape on top of shoe between dots.

Star

Wings
(for Haloed Stocking Hanger and Brown Bag Votive Angel on page 99)

15

Plateful of Angels

Whether hung on a wall, grouped along a plate rail, or placed
on plate stands, these dainty dishes are simply divine.

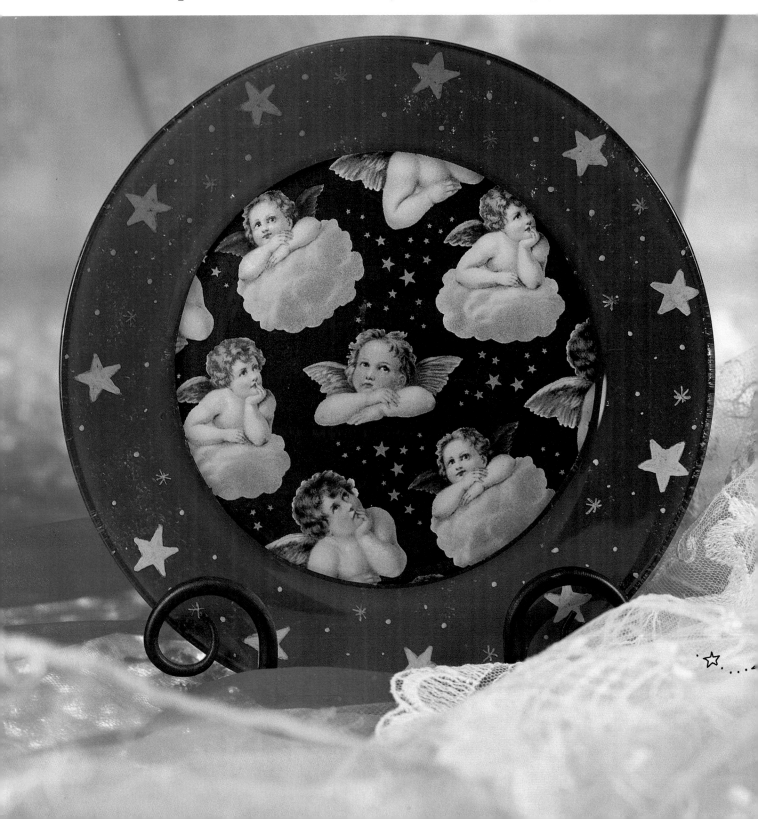

Materials

For each: **Paper angel motif**
Paintbrushes
Aleene's Reverse Collage™ Glue
9"-diameter clear, plain glass plate
Paper towels
Small pop-up craft sponges
**Aleene's Premium-Coat™ Acrylic Paint:
 Deep Lavender**
Aleene's Enhancers™ Matte Varnish
For dark blue plate: **Aleene's
 Premium-Coat™ Acrylic Paint: Gold**
For light blue plate: **Aleene's Premium-
 Coat™ Acrylic Paints: Medium
 Yellow, Light Green, Medium Violet,
 Medium Lavender, True Fuchsia,
 Medium Apricot, White, Medium Blue**
Yellow tissue paper

Directions

Note: See page 141 of Crafting Tips and
Techniques for more information on
sponge painting.

1. For each plate, using paintbrush, apply
glue to right side of angel motif. Place plate
facedown. Place angel motif facedown
where desired on back of plate, using fin-
gers to smooth motif. Wipe off excess glue
with paper towel. Let dry.

2. For dark blue plate, referring to
photo, paint stars and dots randomly on
back of plate, using Gold. Let dry. Sponge-
paint back of plate, using Deep Lavender.

3. For light blue plate, referring to
photo, paint dots and swirls on back of

plate, using Medium Yellow, Light Green,
Medium Violet, and Medium Lavender. Let
dry. Cut stars from yellow tissue paper and
glue randomly to back of plate, referring to
Step 1. Let dry. Cut 1 small heart and 1
small star from sponge. Randomly sponge-
paint hearts and stars on back of plate,
using True Fuchsia and Medium Apricot.
Let dry. Sponge-paint clouds, using White.
Let dry. Sponge-paint light blue back-
ground, using Medium Blue (make sure to
leave some areas unpainted so that next
color will show through). Let dry. Sponge-
paint dark background, using Deep
Lavender. Let dry.

4. Apply coat of varnish to back of plate.
Let dry.

*Good sources for angel motifs are
Christmas cards, paper napkins,
gift wrap, and decoupage papers.*

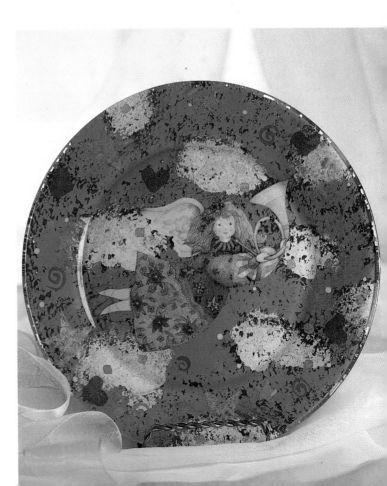

Winged Welcome Mat

What better way to welcome guests crossing your threshold than with an angel quartet. This simple stenciling project also makes a great housewarming gift.

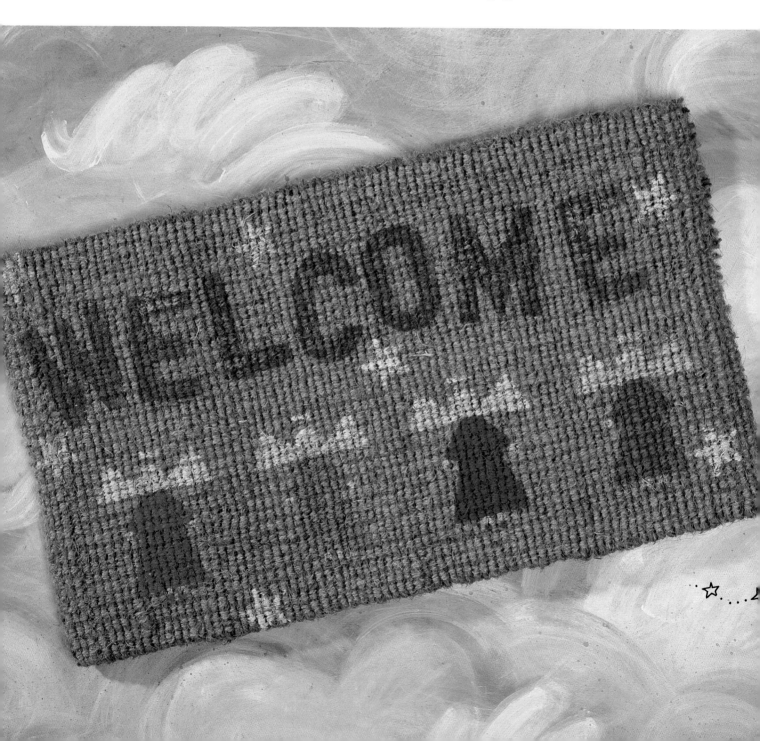

Materials

Aleene's Opake Shrink-It™ Plastic
Craft knife
Aleene's Premium-Coat™ Acrylic
 Paints: Medium Fuchsia, Medium
 Green, True Violet, True Turquoise,
 True Yellow, flesh color, hair color,
 True Blue, Light Blue
Aleene's Enhancers™ Textile Medium
Paper cups
Wooden craft sticks
1" round stencil brush
Natural-fiber outdoor mat
Masking tape
Cotton swabs
4" letter stencils

Directions

1. For design stencils, transfer dress, wings, head, and star patterns to separate pieces of Shrink-It. Using craft knife, cut out patterns, making sure not to cut from outside edge of Shrink-It.

2. Place design stencils on mat to determine desired number and placement of angels, leaving room for stars and letters.

3. In separate plastic cups, use craft sticks to mix equal parts of each paint (except True Blue and Light Blue) and textile medium. Tape dress stencil in place on mat. Paint dress with Medium Fuchsia. Let dry. Remove stencil and reposition for next dress. Paint dress with Medium Green. Let dry. In same manner, paint remaining dresses with True Violet and True Turquoise.

Tape wing stencil in place on 1 angel. Paint wings with True Yellow. Let dry. Repeat to paint wings on remaining angels. Tape head stencil in place on 1 angel. Paint head with flesh color. Let dry. Repeat to paint heads on remaining angels.

4. Referring to photo and using cotton swabs, paint hair with hair color. Let dry. Paint halos with True Yellow. Let dry. Paint hands and feet with flesh color. Let dry. Paint shoes with same color used for dress. Let dry.

5. Mix equal parts True Blue, Light Blue, and textile medium in cup. Tape letter stencils in place. Using blue paint mixture, paint "Welcome." Let dry. Tape star stencil on mat where desired. Using True Yellow mixture, paint star. Repeat as desired. Let dry.

Angel

Star

Textile medium, when added to the acrylic paints, will help the paint soak into the fibers of the mat.

19

Say It with Angels

Use the fanciful alphabet that appears on pages 23-25
to create a variety of handpainted wearables.

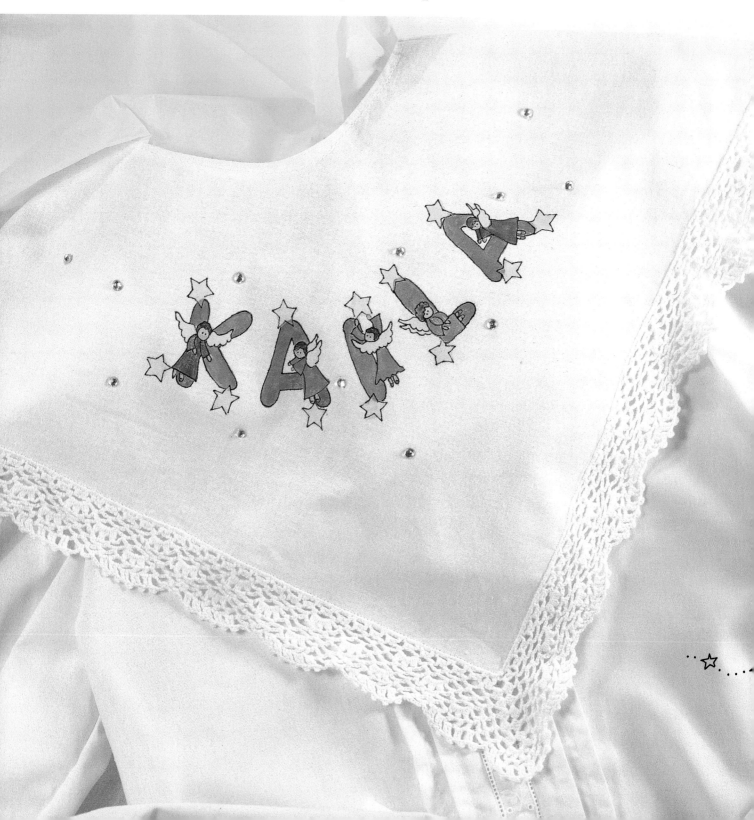

Materials (for collar)
15" x 15½" piece white cotton fabric *
White thread *
2 (½") white buttons *
2 approximately 1" lengths white
 pearl cotton *
1½ yards 1"-wide white crocheted lace *
Cardboard covered with waxed paper
Ultra fine-tip permanent black marker
Aleene's Premium-Coat™ Acrylic
 Paints: Medium Blue, Medium
 Yellow, Medium Fuchsia, Medium
 Turquoise, True Violet, Medium
 Green, flesh color, hair color
Aleene's Enhancers™ Textile Medium
Paper cups
Wooden craft sticks
Small paintbrushes
Small clear round jewels
Aleene's Jewel-It™ Glue
* These materials are for making actual
 collar.

Directions

Note: See page 139 of Crafting Tips and Techniques for more information on transferring patterns.

1. To make collar, referring to **Diagram A,** measure and mark 5½"-diameter circle in center of fabric. Cut out circle, making sure not to cut from outside edge. Measure and mark 9½" from bottom along 15" left edge and 9½" from right edge along 15½" top edge. Draw lines from each mark to center circle. Cut along each marked line **(Diagram B).**

Finish each inside cut edge. Fold ½" of each back closure edge under and machine-stitch in place. Fold ¼" of neck edge under and machine-stitch in place.
Stitch buttons to upper and lower edges of top back closure. Shape each length of pearl cotton into loop. Handstitch ends of each loop to side back closure, making sure that loops correspond to buttons and that buttons can slip through loops.

Using small zigzag stitch, stitch bound edge of crocheted lace to outside edges of fabric.

2. Wash and dry collar; do not use fabric softener in washer or dryer. Press. Position collar so that front point faces you. Place cardboard covered with waxed paper under collar. Using black marker, transfer desired letter patterns from pages 23–25 to front of collar. For each color of acrylic paint, use craft stick to mix equal parts textile medium and paint in paper cup. Referring to photo for inspiration, paint each letter design as desired. Let dry.

3. Glue jewels to front of collar as desired. Let dry. Do not wash collar for at least 1 week. Wash by hand and hang to dry.

For a quick alternative to stitching your own collar, embellish a purchased plain white collar as described in steps 2 and 3.

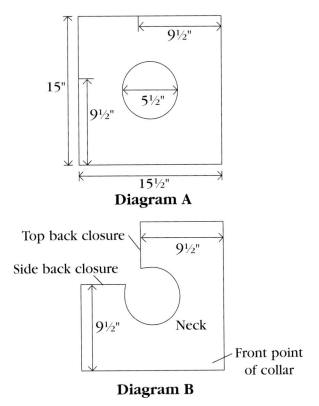

Diagram A

Diagram B

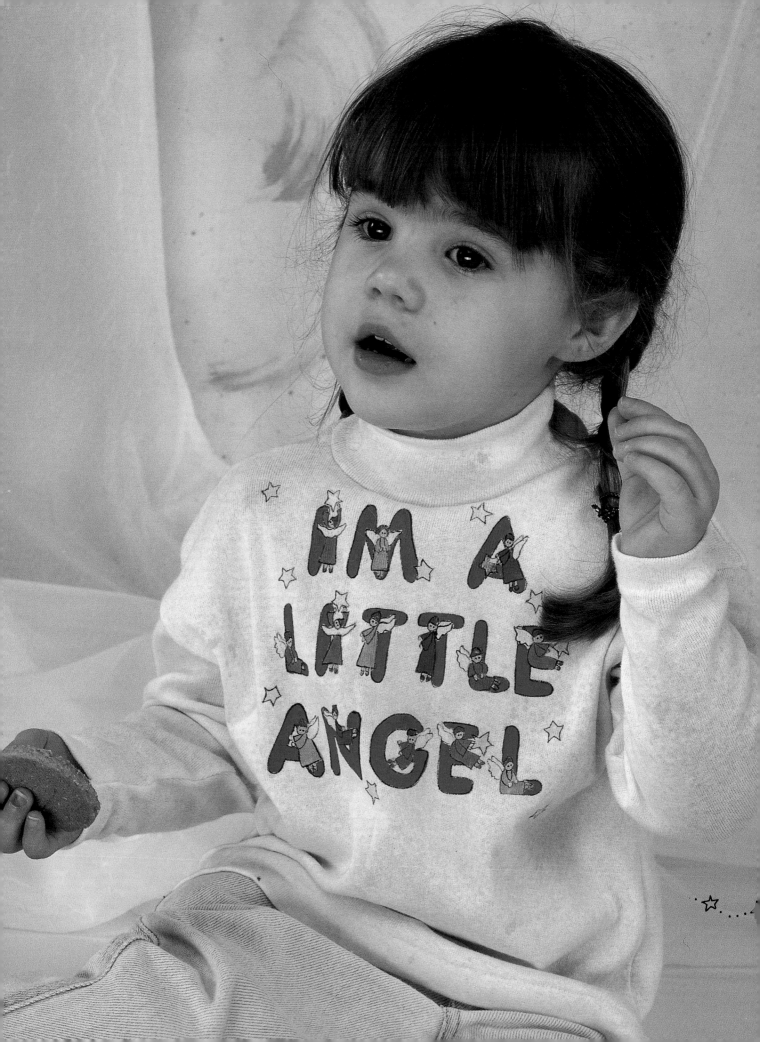

Materials (for toddler shirt)
Purchased white cotton shirt
Spray bottle
Aleene's Premium-Coat™ Acrylic
 Paints: Light Blue, Black, True
 Lavender, Medium Fuchsia, True
 Violet, Medium Green, True
 Turquoise, True Yellow, flesh color,
 hair color
Aleene's Enhancers™ Textile Medium
Cardboard covered with waxed paper
Paper cups
Wooden craft sticks
Paintbrushes: small, fine-line

Directions

Note: See page 139 of Crafting Tips and Techniques for more information on transferring patterns.

1. Wash and dry shirt; do not use fabric softener in washer or dryer. Fill spray bottle with 1 cup water and ½ teaspoon each Light Blue and textile medium. Shake bottle to mix. Spray front and back of shirt with paint mixture. Let dry.

2. Place cardboard covered with waxed paper inside shirt. For each color of acrylic paint, use craft sticks to mix equal parts textile medium and paint.

3. Transfer desired letter patterns to front of shirt. Referring to photo for inspiration and using small paintbrush, paint each letter design as desired. Let dry. Using Black and fine-line paintbrush, paint over outlines of letter designs. Let dry. Do not wash shirt for at least 1 week. Turn shirt wrong side out, wash by hand, and hang to dry.

Adding textile medium to acrylic paints allows painted wearables to retain their softness, while making them washable.

23

24

Blessed Banner

Hang this heavenly banner in your hallway to welcome visitors. No one will ever guess how quickly you made this no-sew project.

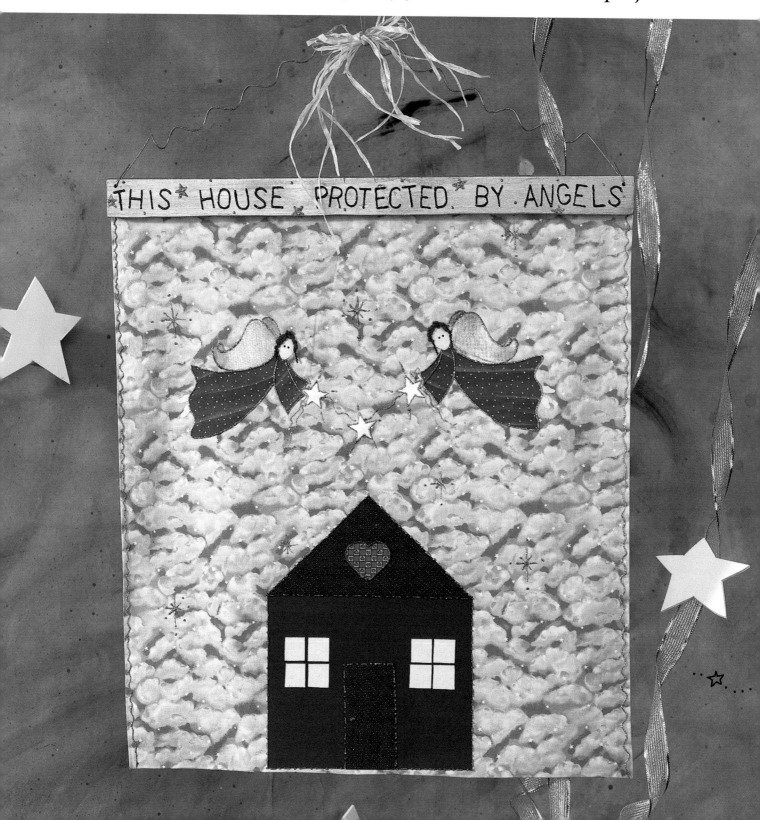

Materials

Fabrics: 22" x 24" piece with stars and clouds, 7" x 8½" piece navy solid, 6" square brown print
Fabric scraps: white, blue-and-peach check, purple with gold pindot, flesh color, gold lamé
Aleene's Fusible Web™
Dimensional paints: gold, silver, black, navy
Aleene's Tacky Glue™
Cotton string doll hair
Drill with ⅛" bit
1½" x 21½" x ¾" block wood
Gold spray paint
18-gauge uncovered florist's wire
Wire cutters
Aleene's Satin Sheen Twisted Ribbon™: ivory

Directions

Note: See page 140 of Crafting Tips and Techniques for more information on working with fusible web.

1. Wash and dry fabrics; do not use fabric softener in washer or dryer. To hem 22" x 24" background fabric piece, fuse ½"-wide strips of web onto wrong side of fabric along 2 long edges and 1 short edge. Remove paper backing. Turn under ½" along these edges and fuse.

2. Fuse web to wrong side of remaining fabrics. Cut 6" brown print square in half diagonally. Set aside 1 resulting triangle for roof. From remaining brown triangle, cut 1 (2" x 4⅛") rectangle. Refer to page 28 to cut the following patterns. From white fabric scraps, transfer pattern and cut 3 stars; cut 8 (⅞") squares from remaining white for windows. Cut 1 heart from blue-and-peach checked scrap. Transfer pattern to purple pindot scrap and cut 1 dress; reverse pattern and cut 1 more dress from purple pindot. Transfer patterns to flesh color and cut 1 head, 2 hands, and 2 feet; reverse patterns and cut 1 more head, 2 hands, and 2 feet from flesh color. Transfer patterns to gold lamé and cut 1 wings; reverse pattern and cut 1 more wings from gold lamé. Remove paper backing from each piece.

3. Referring to photo, arrange pattern pieces on hemmed background piece and fuse in place. (Raw edge is top edge of banner.) Referring to photo and pattern, outline wings, dresses, sleeves, and stars with gold dimensional paint. Let dry. Outline house, roof, door, and heart with silver dimensional paint. Let dry. Paint silver wavy lines down each side edge of banner. Paint silver stars randomly on background fabric. Let dry. Dot eyes on angels, using black dimensional paint. Let dry. Glue doll hair in place on each angel. Let dry.

4. Drill 1 hole in each end of wooden block, ⅜" from each short edge (see photo). Spray-paint entire block gold. Let dry. Using navy dimensional paint, transfer saying to front of wooden block. Let dry. Using silver dimensional paint, embellish wooden block with stars. Let dry.

5. Cut 1 (31") length from wire. Spray-paint wire gold. Let dry. Wrap wire loosely around marker to coil. Insert 1½" of 1 wire end through each hole at top of block, working from back to front. Bend each end up 1". Cut 1 (20") length of Satin Sheen Ribbon. Untwist length. Tear ribbon into narrow lenghtwise strips. Handling several narrow strips as 1, tie in bow at center of wire (see photo).

With right side up, apply glue along top 1¼" of banner. With wooden block right side up, center block along top edge of banner and press firmly into glue. Let dry.

Looking for a way to welcome a new neighbor to your street? What better way to say hello than with this handmade banner.

THIS HOUSE PROTECTED BY ANGELS

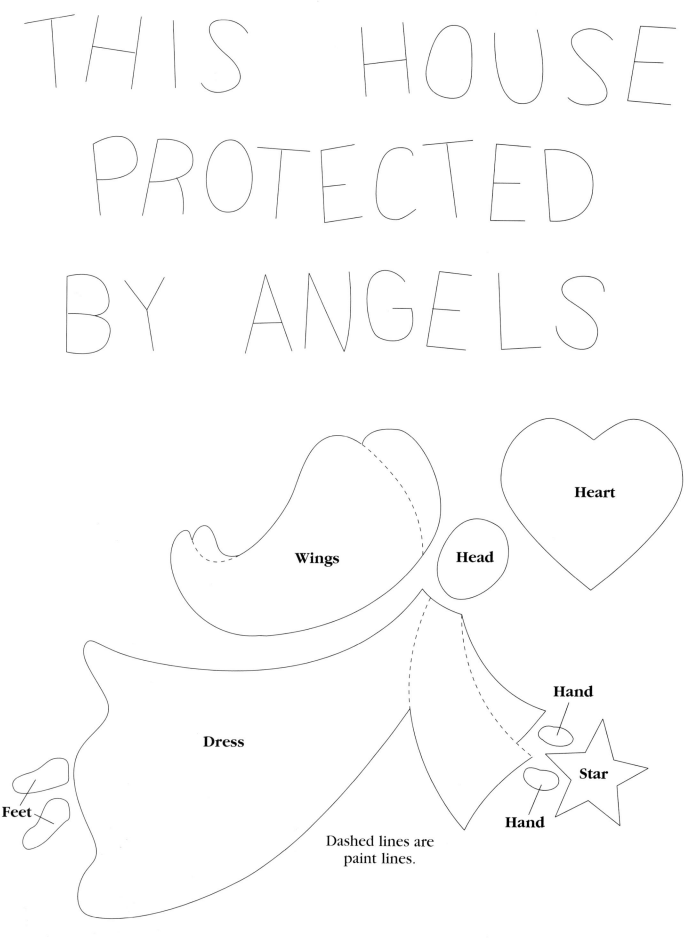

Wings

Head

Heart

Dress

Hand

Star

Hand

Feet

Dashed lines are paint lines.

Heavenly Light

Because you choose the fabrics to cover the lamp,
you can coordinate them to complement your decor.

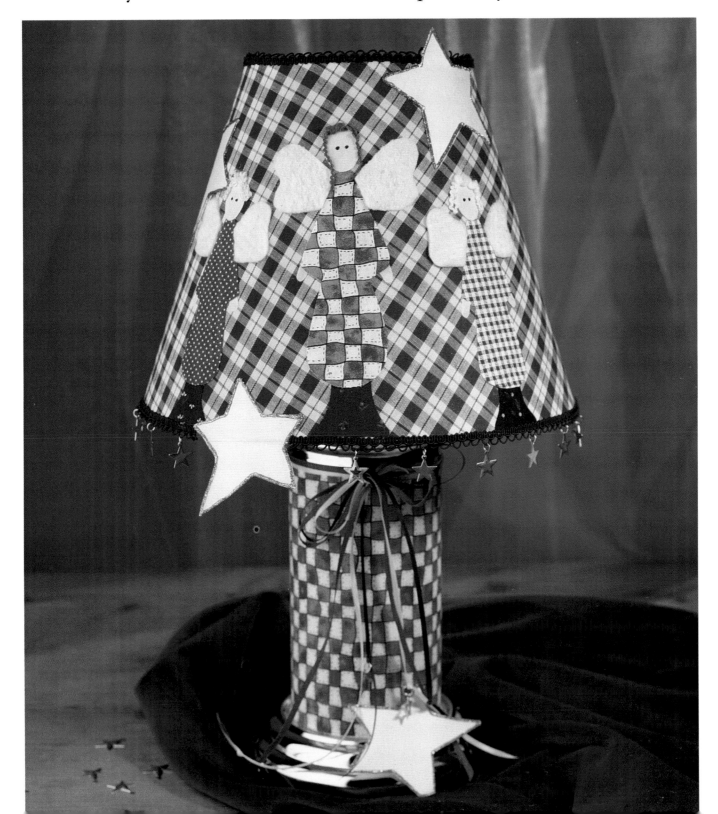

Materials

Self-adhesive decorator lamp kit *
Fabric for the following: base and
 shade (See kit directions for
 amounts.), 3 (4" x 14") pieces yellow
 for stars, 3 (1½" x 6") pieces flesh
 color for faces and hands, 3" x 6"
 piece navy for feet, 3 (3" x 6") pieces
 for angels' dresses
Aleene's Designer Tacky Glue™
Braid
Aleene's Fusible Web™
5" square cotton batting
Cotton string doll hair in desired
 colors *
Dimensional fabric paints: black, gold
 glitter
⅛"-wide satin ribbon in desired colors
Approximately 23 jump rings
Approximately 23 star charms
* See Sources on page 144.

Directions

Note: See page 140 of Crafting Tips and
Techniques for more information on work-
ing with fusible web.

1. Referring to manufacturer's directions,
cover lamp base with desired fabric. Cover
shade with desired fabric, leaving ¼" of
fabric at top and bottom of shade. Turn
excess fabric to inside of shade and glue,
clipping curves as needed. Let dry. Glue
braid to top and bottom rim of shade. Let
dry.

2. Iron fusible web to wrong side of 1
(4" x 14") piece of yellow fabric. Remove
paper. Stack another 4" x 14" piece of yel-
low fabric facedown on fusible web side of
fused fabric piece. Fuse fabric pieces
together. Iron another piece of fusible web
to wrong side of fused 4" x 14" yellow fab-
ric pieces. Remove paper. Stack remaining

4" x 14" yellow fabric piece faceup on
fusible web side of fused fabric pieces.
Fuse fabric pieces together. (All 3 yellow
fabric pieces should be fused into 1 thick-
ness now.) Transfer pattern to yellow fabric
and cut 4 stars.

3. Referring to Step 2, fuse 3 flesh-colored
fabric pieces into 1 thickness. Transfer pat-
terns to flesh-colored fabric and cut 2 small
faces, 1 large face, and 6 hands. Transfer
patterns to navy fabric and cut 2 small feet
pieces and 1 large feet piece. Transfer pat-
terns to desired fabric and cut 2 small
dresses and 1 large dress. Transfer patterns
to batting and cut 4 small wings and 2 large
wings.

4. Referring to photo, glue 1 small feet
piece to bottom rim of lampshade just
above braid. In same manner, attach large
feet piece, positioning it 2½" from small
feet piece; then attach remaining small feet
piece, positioning it 2½" from large feet
piece. Let dry. Glue 1 small dress on top of
each small feet piece and large dress on top
of large feet piece. Let dry. Glue hands in
place. Let dry. Glue 2 small wings on each
small angel and 2 large wings on large angel.
Let dry. Glue 1 small head on top of each
small angel and 1 large head on top of large
angel. Let dry. Glue doll hair on top of each
head. Let dry. Using black dimensional
paint, paint eyes on each angel. Let dry.

5. Outline each star with gold glitter paint.
Let dry. Referring to photo, glue 3 stars in
place on lampshade. Glue 1 star in place on
lamp base. Let dry.

6. Tie lengths of satin ribbon around top of
lamp base. Hook 1 jump ring onto each
star charm. Tie 3 charms to ends of satin
ribbon. Hook remaining charms to braid
around bottom of lampshade, spacing
charms evenly.

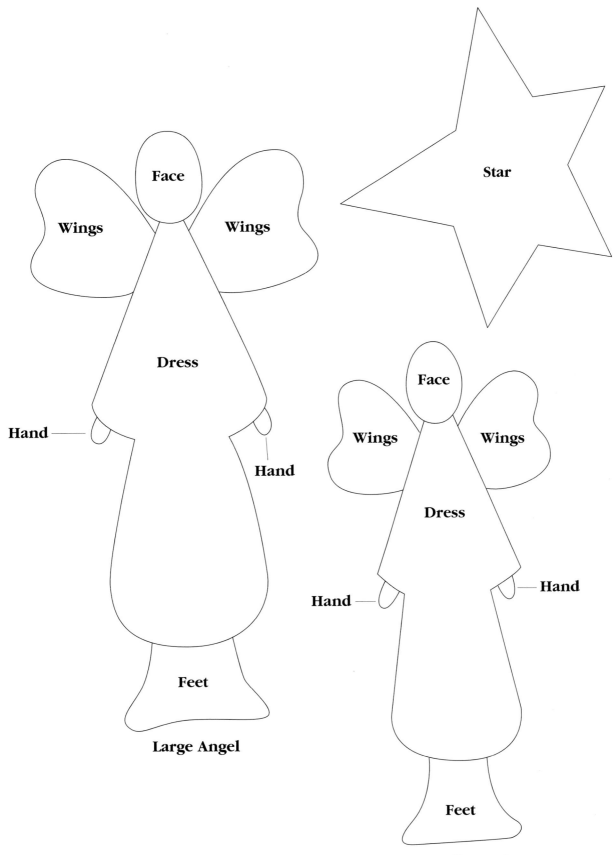

Face

Wings

Wings

Star

Dress

Hand

Hand

Large Angel

Face

Wings

Wings

Dress

Hand

Hand

Feet

Feet

Small Angel

Carefree Carryall

You'll have an angel on your shoulder when you
carry this heavenly tote.

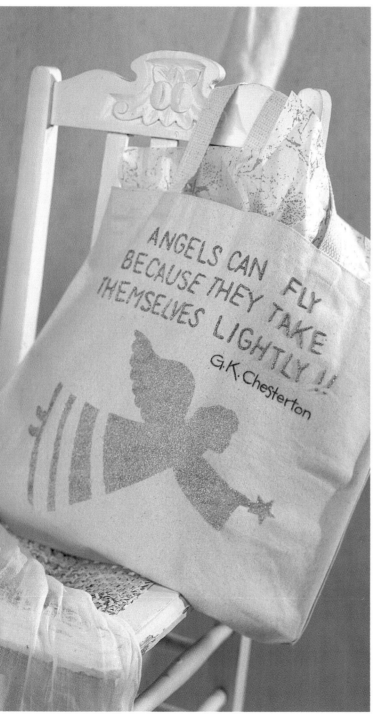

Materials

Peel-and-stick vinyl shelf covering
Craft knife
Plain canvas tote bag
Waxed paper
Aleene's OK to Wash-It™ Glue
Paintbrush
Fine gold glitter
Gold glitter dimensional paint

Directions

1. On vinyl side of shelf covering, transfer angel pattern. Using craft knife, cut out pattern. Remove paper backing from shelf covering. Center shelf-covering stencil on bottom front of canvas tote.

2. Cover work surface with waxed paper. Brush coat of glue on 1 section of stencil at a time. Sprinkle glitter onto glue-coated area. Shake excess glitter off onto waxed paper. Continue in same manner to complete each section of angel stencil. Let dry.

3. Transfer saying on page 34 to top front of canvas tote. Using dimensional paint, trace over transferred letters. If desired, sprinkle additional gold glitter on letters. Shake off excess glitter. Let dry.

A **B** **C** **D**

A

B
C

Match dots to
continue pattern.

D

33

ANGELS CAN FLY BECAUSE THEY TAKE THEMSELVES LIGHTLY!

Cherubim Button Covers

Make these button covers, adorned with Shrink-It cherubs, for a friend who has been an angel to you throughout the years.

Materials (for 1 button cover)

5" length ¾"-wide ivory lace
Needle and thread
Aleene's Jewel-It Glue™
⅝"-diameter hinged button cover
4" x 5" piece Aleene's Opake Shrink-It™ Plastic
Fine-grade sandpaper
Aleene's Baking Board or nonstick cookie sheet, sprinkled with baby powder
Gold spray paint
Ivory ribbon rosette
Small acrylic jewels in desired colors
Silver, gold, and pearl small beads

Directions

Note: See page 143 of Crafting Tips and Techniques for more information on working with Shrink-It.

1. Run gathering stitches by hand along 1 long edge of lace. Pull threads to gather. Curve short edges of lace around until they overlap. Stitch short edges together. Tie off gathers. With gathered edge of lace at center, glue lace to button cover. Let dry.

2. Sand 1 side of Shrink-It so that paint will adhere. Be sure to sand both vertically and horizontally. Transfer cherub pattern on page 44 to Shrink-It and cut 1. Preheat toaster oven or conventional oven to 275° to 300°. Place design on room-temperature baking board and bake in oven. Edges should begin to curl within 25 seconds; if not, increase temperature slightly. If edges begin to curl as soon as design is put in oven, reduce temperature. After about 1 minute, design will lie flat. Remove from oven. Let cool. Spray-paint cherub with gold. Let dry.

3. Referring to photo, glue cherub to center of lace. Let dry. Glue ribbon rosette on top of cherub. Glue jewels and beads around rosette. Let dry.

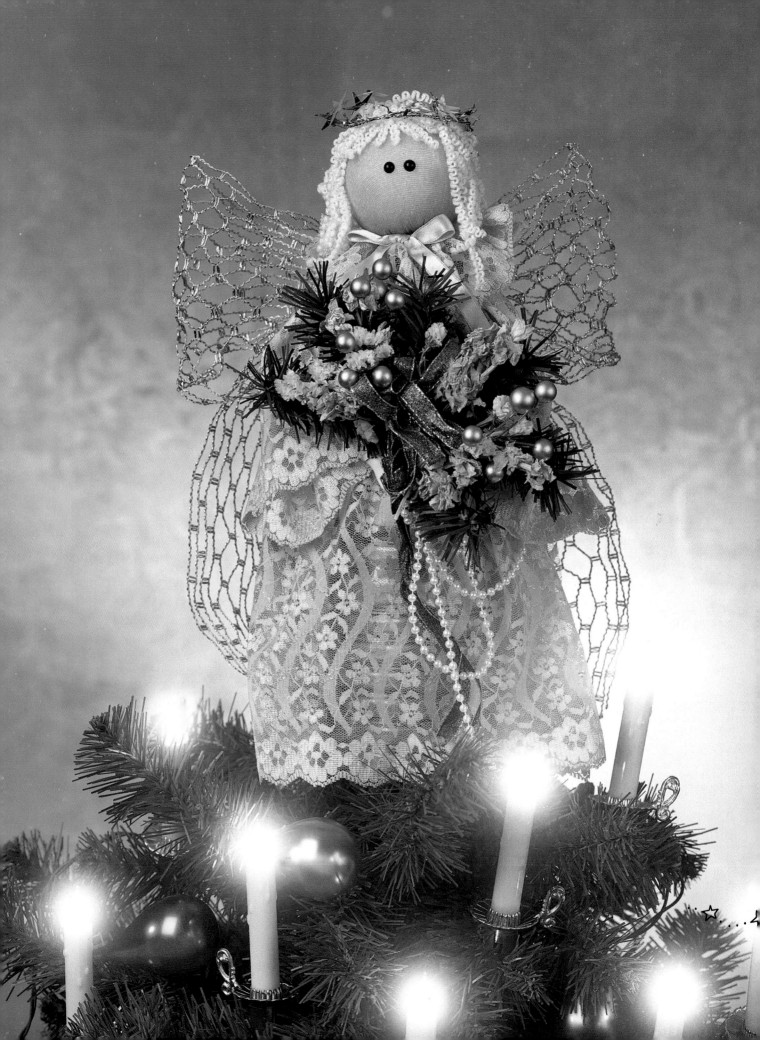

Elegant Angel Tree Topper

Crown your tree with this regal Victorian angel.

Materials

Clean, empty 1-liter plastic water bottle
Craft knife
Gold spray paint
Ecru lace: 1 (12½" x 27½") piece, 2 (6½" x 12") pieces
Aleene's Tacky Glue™
Rubber band
Needle and thread
12" length covered florist's wire
2 doll arms
Panty hose
2½"-diameter Styrofoam ball
Doll hair in desired color
2 black half-round bead eyes
Powder blusher
Ribbons: ⅜"-wide mauve satin, ⅜"-wide gold metallic, 4"-wide gold stretchable
Artificial greenery
Artificial gold berries
Variety of Aleene's Botanical Preserved Flowers & Foliage™
String of pearls
16" length gold wire star garland

Directions

1. Cut off 1¼" of bottom of water bottle so that bottom edge is open and will sit flat. Spray-paint bottle with gold. Let dry.

This angel's wings were made from a stretchable ribbon, however, any ribbon that has a fair amount of body will work well.

2. Fold 12½" x 27½" piece of lace so that short ends overlap. Glue short ends together. Let dry. Slip lace cylinder over bottle so that 1 edge of lace is even with bottom of bottle and remaining edge of lace extends approximately 1¼" beyond top of bottle. Slip rubber band over top of lace-covered bottle. Twist rubber band around neck of bottle to cinch lace. Fold top edge of lace down over rubber band to create collar.

3. For sleeves, fold each 6½" x 12" lace piece so that short ends overlap. Glue short ends together. Let dry. Run gathering stitches by hand along 1 open edge of each sleeve. Pull threads to gather tightly. Tie off. Slip 1 end of florist's wire through gathered end of each sleeve. (Edges of sleeves should be flush with ends of wire.) Glue sleeves in place on lace-covered body, bending wire around back of neck. Glue 1 doll arm to each end of wire.

4. For head, cut 1 (4") length from toe of panty hose. Pull 4" length of hose tightly over Styrofoam ball. Glue raw edges of hose to base of ball. Let dry. Glue base of head to mouth of bottle. Let dry. Glue hair in place. Glue half-round beads in place for eyes. Let dry. Apply blusher for cheeks.

5. Tie satin ribbon in bow. Glue to neck of angel. Referring to photo for inspiration, arrange greenery and berries, dried flowers, gold metallic ribbon, and string of pearls into bouquet. Glue bouquet in hands. Let dry. For wings, tie 4"-wide gold ribbon in bow. Glue bow to top back of angel. For halo, twist star garland into 2½"-diameter circle. Place halo on top of head.

Whisk-Away Angel Ornaments

Any cook would love these ornaments made from kitchen utensils. They'll whip up holiday cheer when hung on the tree or in the breakfast room window.

Materials (for 2 ornaments)

2 (1½"-diameter) wooden beads with hole
Aleene's Premium-Coat™ Acrylic Paints: flesh color, Medium Fuchsia
Paintbrush
Fine-tip permanent black marker
2 small wire whisks
Aleene's Designer Tacky Glue™
20" length 1½"-wide white lace
Needle and thread
Gold ribbon rosette
½"-wide gold star button
Doll hair in desired color
2 costume wedding bands
1 yard 1½"-wide ribbon
20" length gold thread

Directions

1. For each angel, paint bead with flesh color. Let dry. Positioning bead so that hole is at top and bottom, draw eyes and mouth, using black marker (see photo). Paint cheeks with Medium Fuchsia. Let dry. Coat end of handle of 1 whisk with glue. Insert handle into hole in bead. Let dry.

2. Cut lace in half. Run gathering stitches by hand along bound edge of 1 length. Wrap length around handle of whisk just below bead head. Pull thread to gather lace tightly around handle. Tie off. Glue gathered edge in place to secure. Let dry. Referring to photo, glue ribbon rosette or star button on lace just below head. Let dry.

3. Glue doll hair in place on top of head. Let dry. For halo, glue 1 costume wedding band in place on top of head. Let dry. Cut ribbon length in half. For wings, tie 1 length in bow. Glue bow to back of angel just below head. Let dry. Cut gold thread length in half. For hanger, fold 1 length in half. Knot cut ends and loop end of length. Glue knotted loop end to top back of angel head. Let dry.

For a variation of these whisk angels, consider making a set of wooden spoon angels.

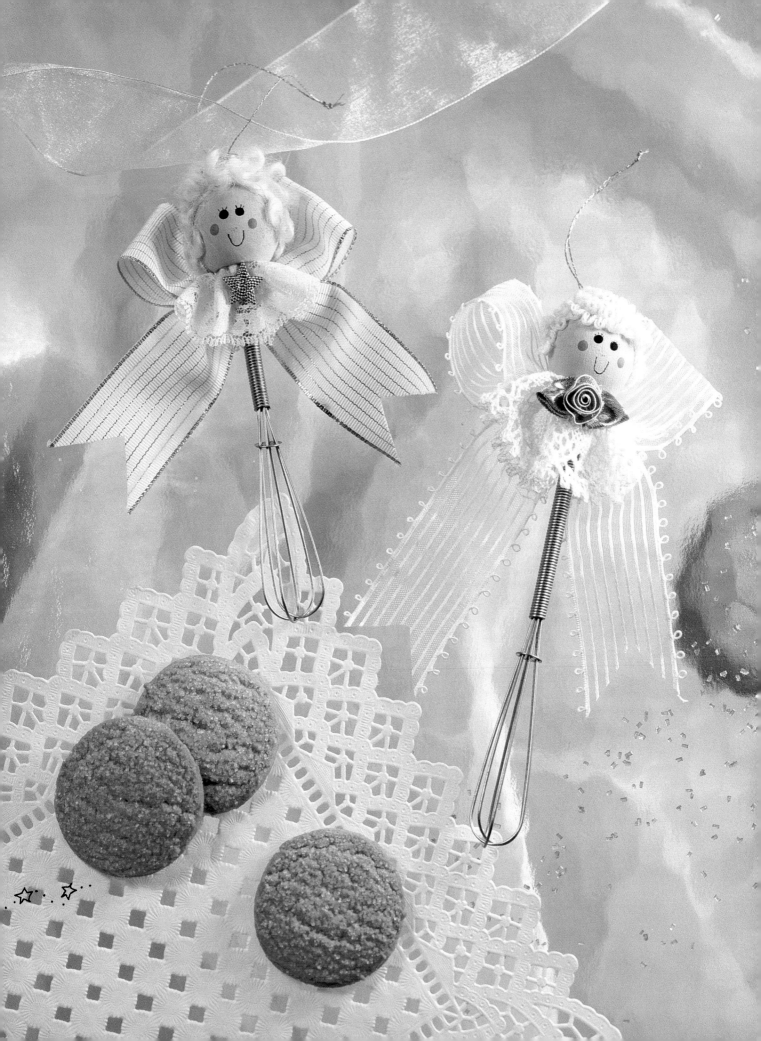

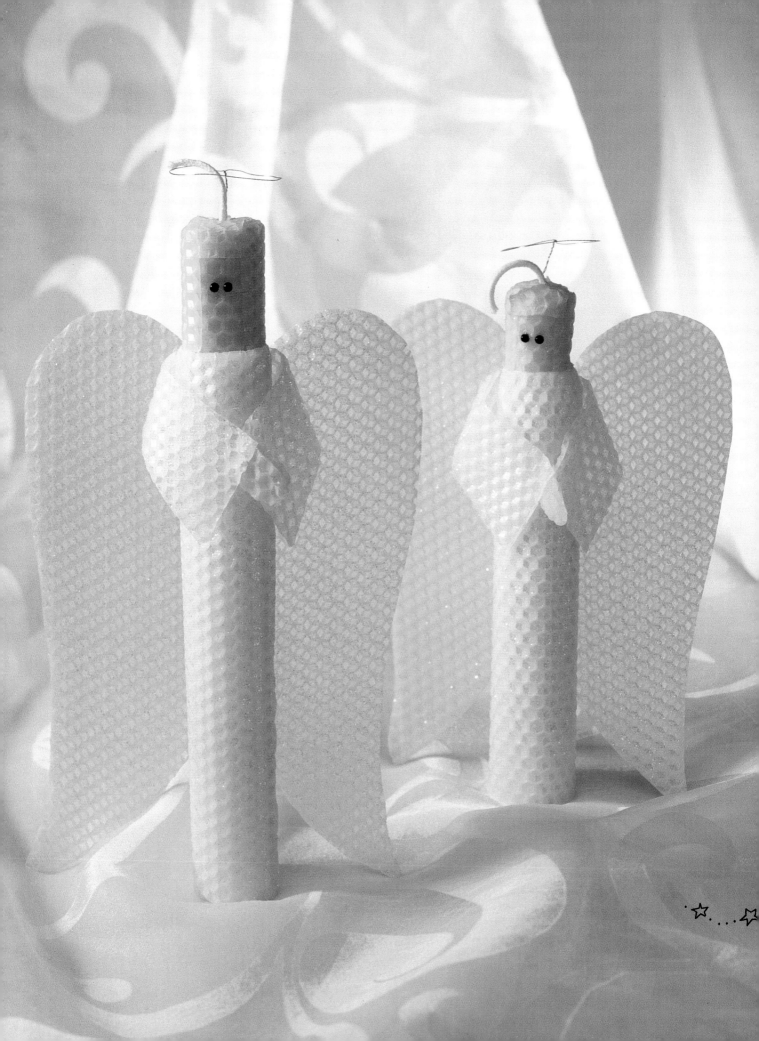

\mathcal{B}eeswax Beauties

Add a divine touch to your holiday mantel decorations with these dazzling candles.

Materials

For each: **Wick**
Craft knife
Aleene's Designer Tacky Glue™
Fine iridescent glitter
2 (⅛"-diameter) black beads
4" length thin copper wire
For large angel: **Beeswax: scraps and 1 (8" x 8½") piece flesh color, scraps and 1 (1½" x 2½") piece hair color, 1 (7" x 8") piece and 1 (8") square white**
For small angel: **Beeswax: scraps and 1 (7" x 8") piece flesh color, scraps and 1 (1½" x 2½") piece hair color, 1 (6" x 8") piece and 1 (8") square white**

Directions

1. For large angel, cut 1 (9¾") length from wick. Place cut wick length on 8" x 8½" piece of flesh-colored beeswax, positioning wick ¼" from 1 long edge and leaving 1 end of wick extending 1¼" beyond end of wax. Roll beeswax edge over wick, keeping wick taut and pressing beeswax against wick to secure. Continue rolling beeswax evenly and tightly toward opposite edge. Press outside edge against rolled wax to secure. Wrap 1½" x 2½" piece of hair-colored beeswax around top of candle for hair. Press in place. Use hair-colored beeswax scraps to make bangs and to cover area around wick.

Although beeswax bends, it breaks easily because it is thin. Do not use excessive pressure when assembling the angels.

2. For angel's dress, with bottom edge of flesh-colored candle even with 1 (8") edge, place candle 1" from short edge of 7" x 8" piece of white beeswax. (Top of candle should extend 1½" beyond end of white beeswax.) Begin rolling evenly and tightly toward opposite edge. Press outside edge against candle to secure.

3. Transfer patterns on page 42 and cut 1 sleeves and 1 wings from 8" square of white beeswax. Transfer pattern and cut 2 large hands from flesh-colored beeswax scraps. Glue 1 hand to inside of each short edge of sleeves. Let dry. Squeeze line of glue along top inside edge of sleeves and hands. With glue side facing dress, wrap sleeves around candle and press hands together (see photo). Let dry. Apply line of glue along center of wings. Press wings to dress. Let dry.

4. Lightly sprinkle glitter on dress, wings, and sleeves. Glue beads in place for eyes. For halo, holding ends together, shape center of wire into 1½"-diameter circle. Twist ends together to secure. Bend ends down at 90° angle from circle. Insert ends of halo into top back of angel's head.

5. For small angel, cut 1 (8") length from wick. Referring to Step 1, roll wick inside 7" x 8" piece of flesh-colored beeswax; then apply 1½" x 2½" piece of hair-colored beeswax. For angel's dress, place flesh-colored candle 1" from short edge of 6" x 8" white beeswax, leaving top of candle extending 1" beyond white beeswax. Continue rolling evenly and tightly toward opposite edge. Press outside edge against candle to secure.

6. Transfer patterns and cut 1 sleeves and 1 wings from 8" square of white beeswax. Transfer pattern and cut 2 small hands from flesh-colored scraps. Repeat steps 3 and 4 to assemble angel.

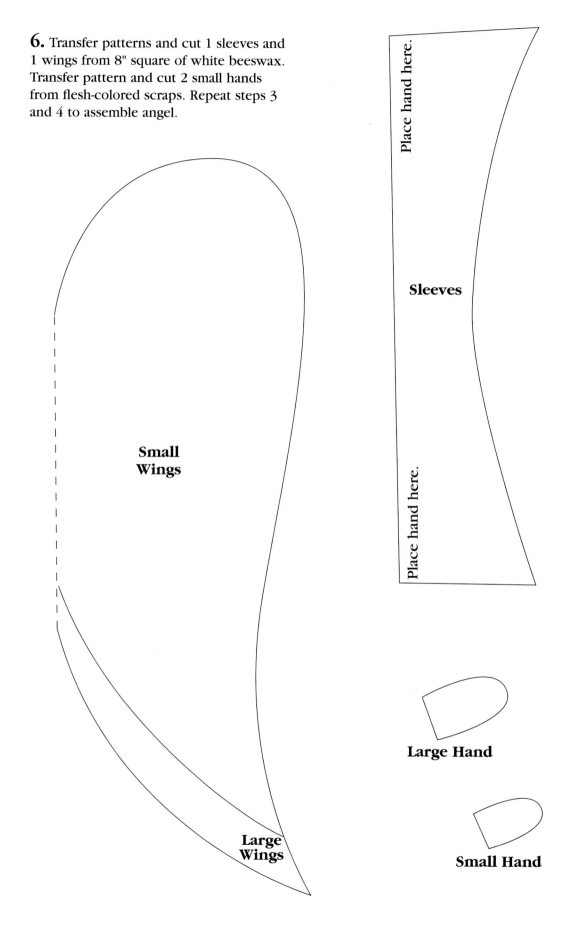

Place hand here.

Sleeves

Place hand here.

Small Wings

Large Wings

Large Hand

Small Hand

Cheery Cherub Stamps

Make two simple foam stamps and then use
them to adorn an array of items.

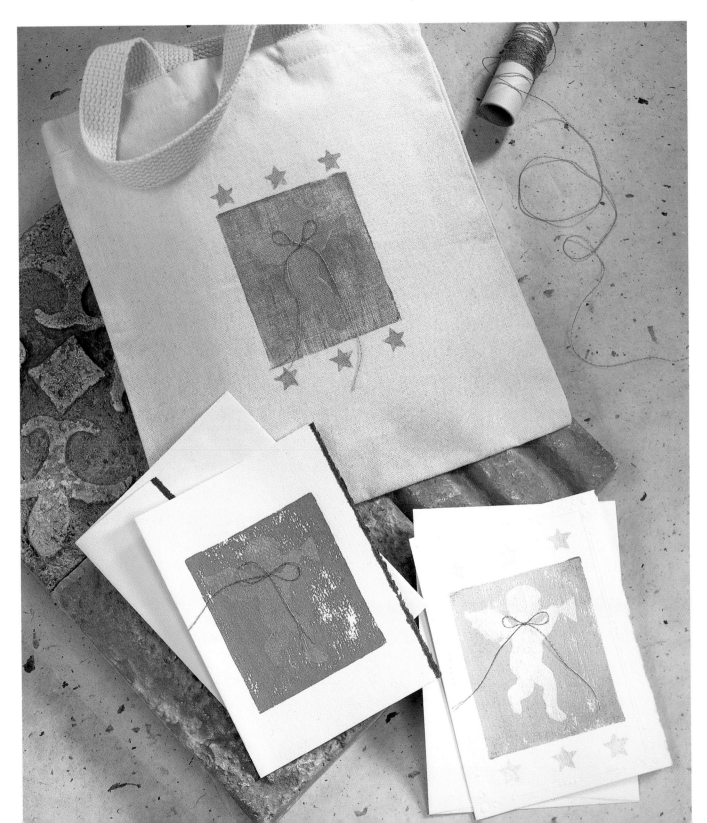

Materials

For each: **2 (3½" x 4") pieces Fun Foam**
2 (3¾" x 4½") pieces foam-core board
Aleene's Tacky Glue™
Craft knife
Paintbrushes
For cards: **2 (5" x 7") blank ivory note**
cards with matching envelopes
Aleene's Premium-Coat™ Acrylic
Paints: Dusty Green, Gold, Silver
2 (12") lengths gold metallic thread
For tote bag: **Aleene's Premium-Coat™**
Acrylic Paints: Gold, Silver
Aleene's Enhancers™ Textile Medium
Paper cups
Wooden craft sticks
Cardboard covered with waxed paper
Plain canvas tote bag
12" length gold metallic thread
Aleene's OK to Wash-It™ Glue
For adult's T-shirt: **Aleene's Premium-**
Coat™ Acrylic Paints: Deep Beige,
Deep Khaki, Ivory
Aleene's Enhancers™ Textile Medium
Paper cups
Wooden craft sticks
Cardboard covered with waxed paper
Purchased beige cotton or cotton-
blend T-shirt
For child's dress: **Aleene's Premium-**
Coat™ Acrylic Paints: True
Turquoise, Silver
Aleene's Enhancers™ Textile Medium
Paper cups
Wooden craft sticks
Cardboard covered with waxed paper
Purchased ivory cotton or cotton-
blend dress
¾ yard ⅛"-wide turquoise satin ribbon
Aleene's OK to Wash-It™ Glue

Directions

1. For stamp, center and glue 1 (3½" x 4")
piece of Fun Foam to 1 (3¾" x 4½") piece
of foam-core board. Let dry. Transfer pattern
to remaining piece of Fun Foam and use
craft knife to cut 1 cherub. Glue cherub to
remaining piece of foam-core board. (For
finished cherub to face right, glue cherub
onto foam-core board facing left.) Let dry.

44

2. For cards, paint block stamp with
Dusty Green. Position stamp on center of 1
note card and press firmly, being sure all
areas of stamp come in contact with card.
Let paint on both card and stamp dry. Paint
block stamp with Gold. Press onto remain-
ing note card as above. Let dry.

Paint cherub stamp with Gold. Position
stamp in center of Dusty Green block on
note card and press firmly, being sure all
areas of stamp come in contact with card.
Let paint on both card and stamp dry. Paint
cherub stamp with Silver. Position stamp in
center of Gold block on remaining note
card and press as above. Let dry. If desired,
paint 3 silver stars above and below Gold
block (see photo). Let dry.

Tie each length of gold metallic thread
in bow. Glue 1 bow to neck of each
cherub. Let dry.

3. For tote bag, for each color of acrylic
paint, mix equal parts textile medium and
paint. Place cardboard covered with waxed
paper inside tote bag. Paint block stamp
with Gold. Position stamp in center of 1
side of tote bag and press firmly, being sure
all areas of stamp come in contact with
bag. Let dry. Paint cherub stamp with
Silver. Position stamp in center of Gold
block on tote bag and press as above. Let
dry. If desired, paint 3 silver stars above
and below Gold block (see photo). Let dry.
Tie length of gold metallic thread in bow.
Glue bow to neck of cherub. Let dry.

Cherub

5. For child's dress, wash and dry dress; do not use fabric softener in washer or dryer. For each color of acrylic paint, mix equal parts textile medium and paint. Place cardboard covered with waxed paper inside dress. Mark center front of dress neck. Paint block stamp with True Turquoise. Position stamp ¼" below center mark on dress and press firmly, being sure all areas of stamp come in contact with dress. Let dry. Paint cherub stamp with Silver. Position stamp in center of True Turquoise block and press as above. Let dry. Referring to photo, paint Silver circles along edges of True Turquoise block. Let dry. Tie satin ribbon length in bow. Glue bow to dress below True Turquoise block (see photo). Let dry. Do not wash garment for at least 1 week. Turn garment wrong side out, wash by hand, and hang to dry.

4. For adult's T-shirt, wash and dry T-shirt; do not use fabric softener in washer or dryer. For each color of acrylic paint, mix equal parts textile medium and paint. Place cardboard covered with waxed paper inside shirt. Mark center front of shirt neck. Paint block stamp with Deep Beige. Position stamp ¼" below center mark on shirt and press firmly, being sure all areas of stamp come in contact with shirt. Let paint on stamp and shirt dry. Paint block stamp with Deep Khaki. Position stamp ½" to left of first stamped block and press as above (see photo). Reload stamp with Deep Khaki. Position stamp ½" to right of first stamped block and press as above. Let dry. Paint cherub stamp with Ivory. Position stamp in center of Deep Beige block and press firmly, being sure all areas of stamp come in contact with shirt. Reload stamp and repeat as above for Deep Khaki blocks. Let dry. Do not wash garment for at least 1 week. Turn garment wrong side out, wash by hand, and hang to dry.

Keepsake Container

Recycle your favorite angel cards by decoupaging them to a papier-mâché container of your choice.

Materials

1 papier-mâché cylinder-shaped container with lid, 5" in diameter and 14" high (or box of choice)
Gold spray paint
Craft knife
Assorted angel cards *
Aleene's Instant Decoupage™ Glue
½" flat shader or sponge paintbrush
Pop-up craft sponges
Waxed paper
Aleene's Premium-Coat™ Acrylic Paint: True Yellow
Paper towel
Aleene's 3-D Foiling™ Glue
Aleene's Gold Crafting Foil™
1 (36") length 1¼"-wide pink organdy ribbon
6" length 26-gauge florist's wire
Needlenose pliers (optional)
Star beads
2 (13") lengths gold cording
Aleene's Designer Tacky Glue™
* See Sources on page 144.

Directions

Note: See pages 141 and 142 of Crafting Tips and Techniques for more information on sponge painting and decoupaging.

1. Remove lid from container. Spray-paint box and lid with gold. Let dry. Cut along fold of each card and discard card backs. Working over 1 area at a time, apply coat of Decoupage Glue to surface of container where 1 card will be placed. Apply thin coat of Decoupage Glue to back of 1 card front. With glue side down, place card onto glue-covered area of container and press out any air bubbles. Brush coat of glue on top of card. Let dry. Repeat to decoupage remaining cards around container as desired.

2. Transfer pattern to sponge and cut 1 star. Dip sponge into True Yellow and blot excess paint on paper towel. Referring to photo for inspiration, sponge-paint stars on container and lid as desired. Let dry.

3. Using 3-D Foiling Glue, outline each card with wavy lines; then outline stars with straight lines. Let dry. (Glue will be opaque and sticky when dry. Glue must be thoroughly dry before foil is applied.) To apply gold foil, lay foil dull side down on top of glue lines. Using finger, gently but firmly press foil onto glue, completely covering glue with foil. Peel away foil paper. If any part of glue is not covered, reapply foil as needed.

4. Make multilooped bow with ribbon. Secure bow with florist's wire. Use pliers to twist wire if necessary. Cut and discard remaining wire. Thread star beads on each end of gold cording lengths. Tie knot above and below each star to secure. Glue center of each cording length to center of container lid. Glue bow in center of lid, using Tacky Glue. Let dry.

Star

The cards featured here were designed by Heidi. Each boxed set contains an assortment of 6 angels.

46

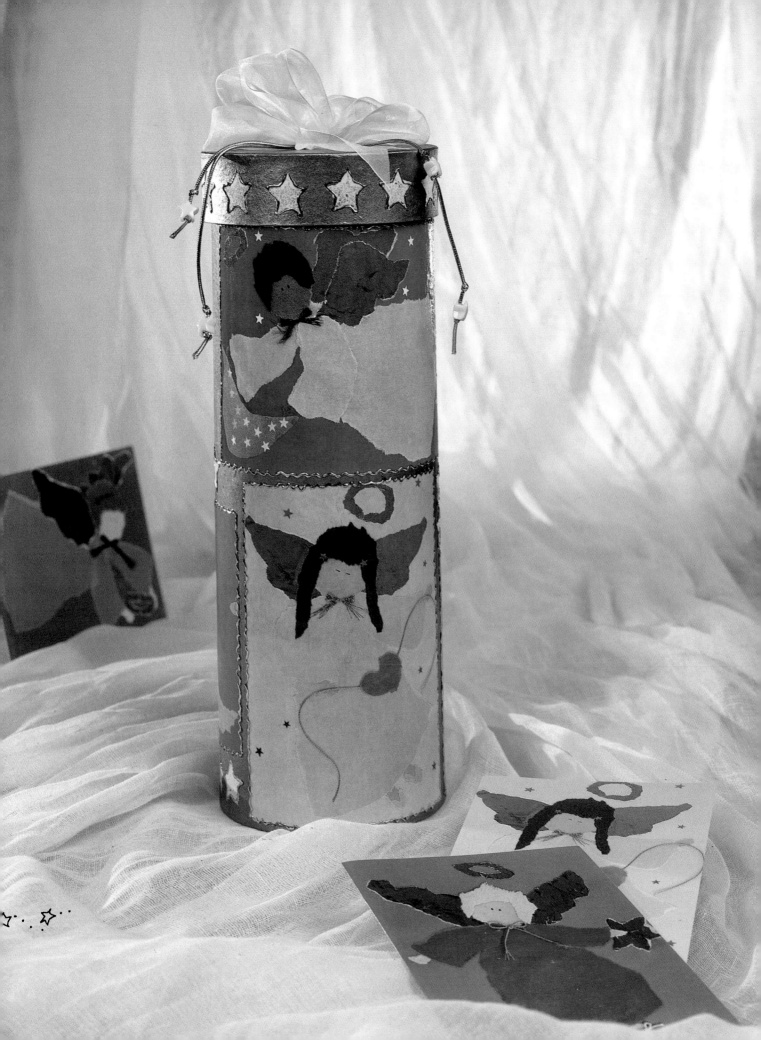

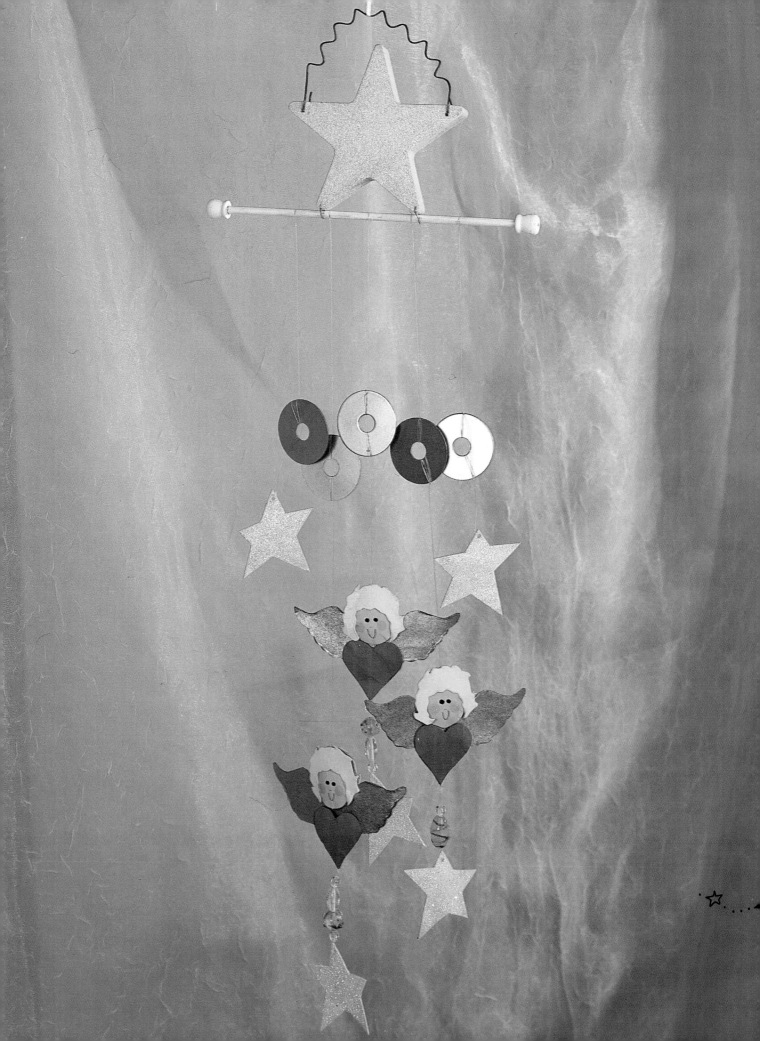

Wings and Washers Wind Chimes

Whenever you hear this chime tinkling softly in the breeze,
you'll be reminded of the line, "Every time a bell rings,
an angel gets its wings."

Materials

Thin cardboard
7" square ¾"-thick block wood
Scroll saw
Aleene's Premium-Coat™ Acrylic
 Paints: True Yellow, flesh color, hair
 color, Medium Fuchsia, Gold, Light
 Fuchsia, Black, White
Paintbrushes
Ultra fine-tip permanent black marker
10½" length ¼"-diameter dowel
2 dowel caps with ¼" opening
Gold spray paint
5 (2"-diameter) metal washers
Waxed paper
Aleene's Reverse Collage™ Glue
Fine iridescent glitter
⅛"-diameter hole punch
Fishing line
Variety of clear beads
Aleene's Tacky Glue™
Drill with 1/16" bit
18" length 18-gauge uncovered florist's
 wire
Pencil
2 (5") lengths fine-gauge copper wire

Directions

1. Transfer patterns on pages 50 and 51 to cardboard and cut 5 small stars, 6 heads, 6 hair, 6 hearts, and 3 wings. Transfer large star pattern to block of wood and cut out, using scroll saw.

2. Paint 1 side of each cardboard piece as follows: paint stars with True Yellow, heads with flesh color, hair with hair color, hearts with Medium Fuchsia, and wings with Gold. Let dry. Repeat to paint remaining side of each cardboard piece. On 1 side of each head, referring to photo, paint cheeks with Light Fuchsia. Dip end of 1 paintbrush handle into Black and dot on eyes. Let dry. Using black marker, draw nose and mouth. Repeat to paint faces on remaining side of each head. Paint both sides of wooden star with True Yellow, letting dry between applications. Paint dowel and dowel caps with White. Let dry. Attach 1 dowel cap to each end of dowel. Spray-paint both sides of each washer with gold, letting dry between applications.

3. Cover work surface with waxed paper. Brush thin coat of Reverse Collage Glue on 1 side of each cardboard star. While glue is still wet, sprinkle glitter onto stars. Shake excess glitter onto waxed paper. Let dry. Repeat on opposite side of each star. Punch holes in 1 point of each star.

4. Cut 2 (24") lengths of fishing line. Thread 1 end of 1 length of fishing line

through hole in 1 cardboard star. Knot fishing line just above point of star. Approximately 2" from star, tie another knot. Wrap fishing line around lower half of 1 washer twice. Pull fishing line up washer and wrap twice around upper half of washer. Knot fishing line at top of washer. Approximately 6" from washer, tie fishing line in knot around right end of dowel. Trim excess fishing line. Repeat with remaining 24" length of fishing line to make chime for left end of dowel.

5. From fishing line, cut 1 (26") length, 1 (30") length, and 1 (36") length. Thread 1 end of 26" length of fishing line through hole in 1 cardboard star. Knot fishing line just above point of star. Thread enough beads onto fishing line to fill up approximately 2". Tie knot in fishing line at top of beads. Referring to photo for placement, glue 1 hair to 1 head. Let dry. Then glue head to 1 wings. Glue heart in place just below head. Let dry. Place angel facedown. Center 26" fishing line length on top of wrong side of angel, positioning angel so that tip of heart just touches top of beads. Tape fishing line to wrong side of angel. With edges aligned, glue 1 heart faceup on top of heart attached to fishing line. Glue 1 hair to 1 head. With edges aligned, glue head faceup on top of head attached to

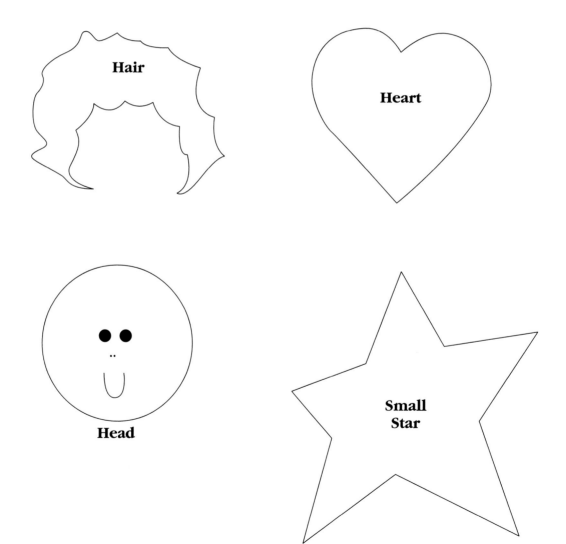

Hair

Heart

Head

Small Star

50

fishing line. Let dry. Approximately 4" from angel, tie knot in fishing line. Attach washer to fishing line as in Step 4. Approximately 5" from washer, tie fishing line in knot around center of dowel. Trim excess fishing line.

6. Using 30" length of fishing line, assemble chime as in Step 5, attaching washer approximately 5½" above top of angel. Knot fishing line around dowel approximately 6" above washer, positioning chime to right of center chime. Trim excess fishing line. Repeat with 36" length of fishing line, attaching washer approximately 7½" above top of angel. Knot fishing line

around dowel approximately 6½" above washer, positioning chime to left of center chime. Trim excess fishing line.

7. Drill holes in 2 opposite points at top of wooden star (see photo). Twist florist's wire around pencil to curl. Referring to photo, insert 1 end of florist's wire into each hole in wooden star, working from front to back. Bend each end of wire up to secure. Drill holes in 2 adjacent points at bottom of star. Thread 1 (5") length of copper wire through each hole. Twist each length of copper wire around dowel to attach wooden star to dowel.

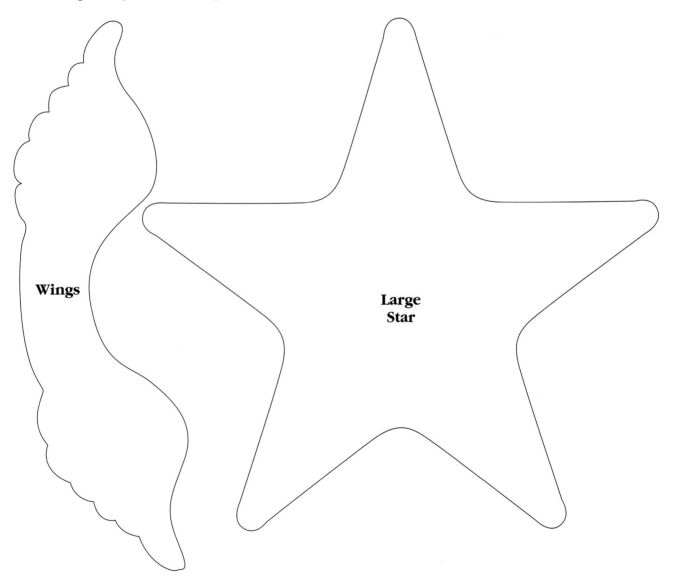

Wings

Large Star

Angels-All-Around Tree Skirt

Playful folk art angels dance around the base of your tree
when you wrap it in this no-sew skirt.

Materials

Felt: 1 (56½"-diameter) circle and 1
(6" x 12") piece ivory; 1 (6" x 12")
piece burgundy; 1 (6" x 12") piece
sage green; 1 (8" x 14") piece tan;
scraps of light brown, black, dark
brown, and yellow
Aleene's OK to Wash-It™ Glue
20 pairs black half-round bead eyes
Aleene's Fusible Web™
10" x 20" piece gold lamé
¼ yard each of 6 different cotton print
fabrics
Black embroidery floss
Embroidery needle
Dimensional fabric paints: burgundy,
sage green

Directions

Note: See page 140 of Crafting Tips and
Techniques for more information on work-
ing with fusible web.

1. Cut 1 (4"-diameter) circle from center of
ivory felt circle, making sure not to cut
from outside edge. For tree skirt opening,
cut straight across from inner circle to
outer edge. Cut 36 (1") squares each from
burgundy and sage green felt. Refer to page
54 to cut the following. Transfer border
star pattern to tan felt and cut 64. Transfer
border heart pattern to 6" x 12" piece of
ivory felt and cut 36; then transfer to
remaining burgundy felt and cut 20. Center
and glue 1 tan star on each burgundy
square. Set aside remaining tan stars.
Center and glue 1 ivory heart on each sage
green square. Let dry.

2. Alternating colors, glue burgundy and
sage green squares around outer edge of
tree skirt, leaving approximately 1¼" space
between squares (see photo). Let dry.

3. Cut 5 (1"-diameter) circles from remain-
ing tan felt. Cut 10 (1"-diameter) circles
from remaining ivory felt. Cut 5 (1"-
diameter) circles from light brown felt.
Transfer light brown hair pattern to light
brown felt and cut 5. Transfer black hair
pattern to black felt and cut 5. Transfer
dark brown hair pattern to dark brown felt
and cut 5. Transfer blonde hair pattern to
yellow felt and cut 5. Refer to photo to
glue 1 light brown hair on each tan circle,
1 black hair on each of 5 ivory circles, 1
dark brown hair on each light brown cir-
cle, and 1 blonde hair on each of remaining
ivory circles. Let dry. Glue pair of eyes in
place on each head. Let dry.

4. Fuse web to wrong side of lamé and
cotton print fabrics. Transfer wings pattern
to gold lamé and cut 20. Referring to
photo, transfer star dress pattern to variety
of cotton print fabrics and cut 10. Transfer
heart dress pattern to variety of cotton
print fabrics and cut 10. Transfer back-
ground heart pattern to variety of cotton
print fabrics and cut 10. Transfer back-
ground star pattern to variety of cotton
print fabrics and cut 10.

*Position a string on the tree skirt
in waves to mark the way you want
"Merry Christmas Angels" to flow.
Then use the string as a baseline for
painting the words.*

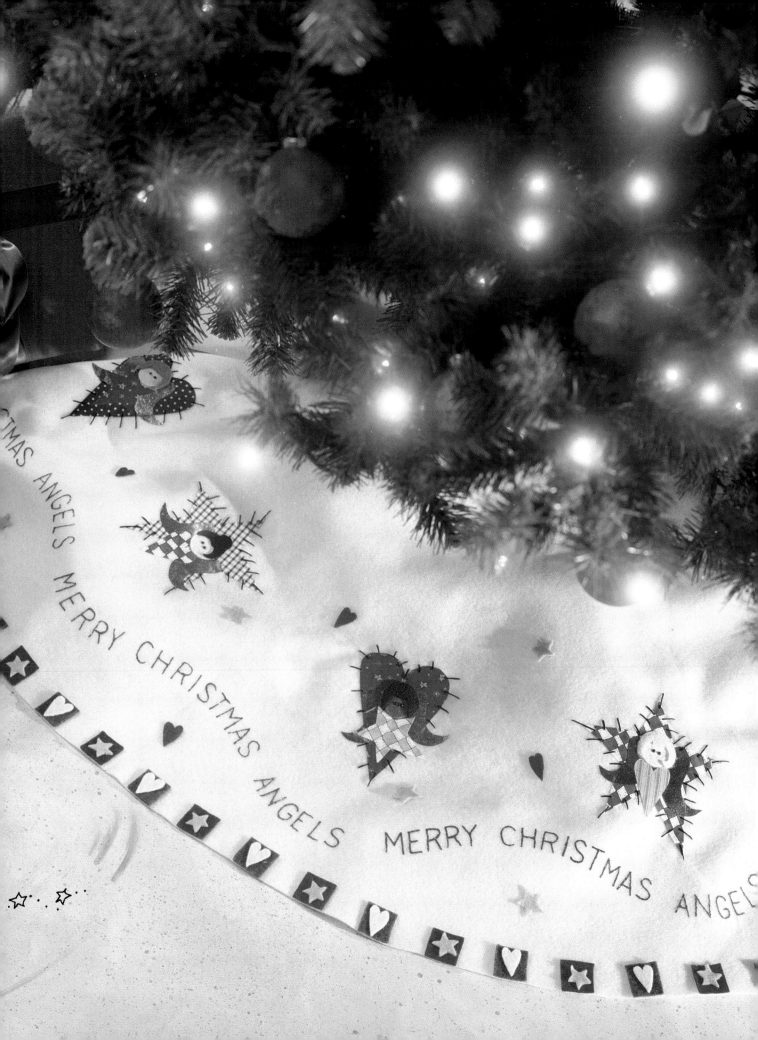

5. Referring to photo for placement and alternating motifs, fuse background hearts and stars to tree skirt, positioning motifs approximately 6" from outer edge of tree skirt and leaving approximately 4½" to 5" between motifs. Referring to photo, fuse 1 set of wings on top of each heart and star motif. If background motif is heart, fuse 1 star dress on top of wings. If background motif is star, fuse 1 heart dress on top of wings. Alternating styles of hair, glue 1 head in place at top of each dress (see photo). Let dry.

6. Using black embroidery floss, buttonhole-stitch around each heart and star background motif. Referring to photo and using dimensional paints, write "Merry Christmas Angels" in waves below angels. Let dry. Glue burgundy border hearts and remaining tan border stars to tree skirt as desired. Let dry.

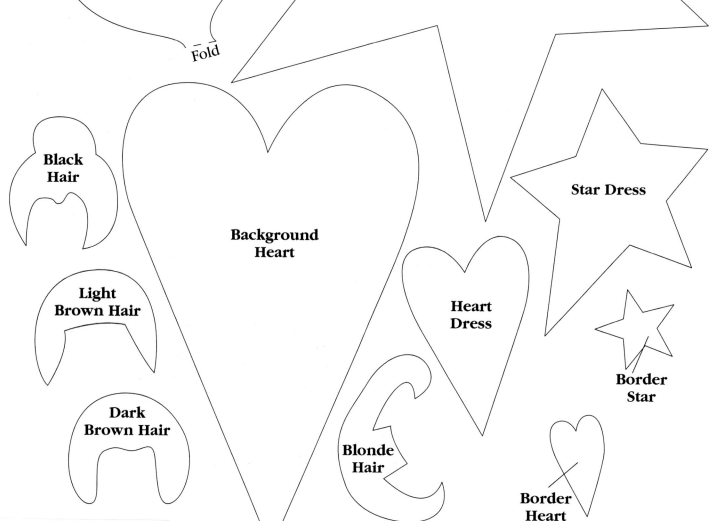

Wings

Fold

Background Star

Black Hair

Background Heart

Star Dress

Light Brown Hair

Heart Dress

Border Star

Dark Brown Hair

Blonde Hair

Border Heart

Tooth Angel

Tuck a little one's lost tooth in the pocket of this sweet pillow. Then give the pillow to the child to hang on a dresser knob or doorknob in anticipation of a tooth angel's visit.

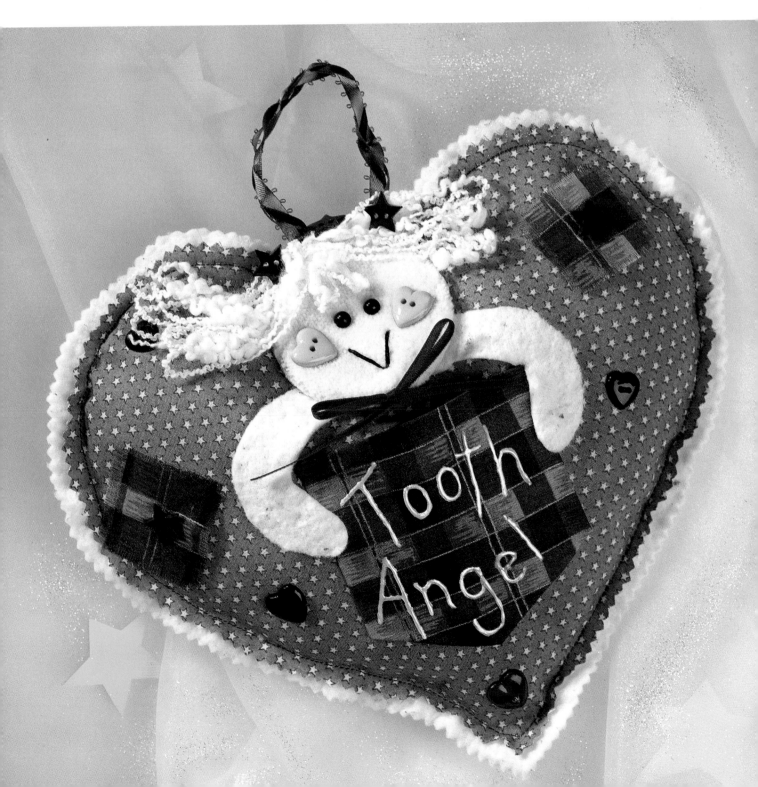

Materials

10" square lavender print fabric
12" square cotton batting
Pinking shears
Needle and thread
6½" square coordinating fabric for
 pocket and patches
Buttons: 5 (½") stars, 6 (½") hearts
Stuffing
Aleene's No-Sew Fabric Glue™
White pearlescent dimensional fabric
 paint
¼" black half-round bead eyes
2½"-diameter powder puff
Black embroidery floss
2 yards cotton string doll hair in
 desired color *
Satin ribbon: 30" length ⅛"-wide rose,
 20" length ⅛"-wide purple, 20"
 length ¼"-wide green
* See Sources on page 144.

Directions

1. Transfer heart pattern to 10" square of
lavender fabric and 12" square of cotton
batting. Using pinking shears, cut out laven-
der heart along outline; cut out batting
heart ¼" beyond outline. Transfer pocket
pattern to 6½" square of coordinating fab-
ric. Using regular scissors, cut out pocket,
adding ½" seam allowance to each side;
also cut 2 (1½") squares. Pull threads and
fray ¼" of each side of each 1½" square.

2. Referring to photo for placement, posi-
tion 1½" square patches on lavender heart.
Center 1 star button on top of each patch.
Stitch buttons and patches in place on
lavender heart. Center and stack lavender

heart faceup on top of batting heart.
Machine-stitch ¼" from edge of lavender
heart, leaving open where indicated on pat-
tern. Stuff. Using glue, seal open edge. Let
dry.

3. Fold each edge of pocket piece under
½". Glue in place. Let dry. Using dimen-
sional fabric paint, write "Tooth Angel" on
front of pocket. Let dry. Referring to photo
for placement, glue side and bottom edges
of pocket to front of heart. Let dry.

4. Transfer pattern to remaining batting
and cut 2 arms. Referring to photo for
placement, glue arms to heart front, slight-
ly overlapping sides of pocket. Let dry.

5. Referring to photo for placement, glue
eyes and heart button cheeks to 1 side of
powder puff. Let dry. Using embroidery
floss, stitch V-shaped mouth between
cheeks. Cut doll hair in half. Wrap 1 hair
length around 4 fingers. Repeat with
remaining length of doll hair. Glue looped
hair lengths to top of powder puff face. Let
dry. Glue 3 star buttons in hair. Let dry. Cut
10" length from rose satin ribbon. Tie rib-
bon length in bow and glue to bottom cen-
ter of powder puff face. Let dry. Referring
to photo for placement, glue face to front
of heart. Let dry.

6. Referring to photo for placement, glue
remaining heart buttons to front of heart.
Let dry. For hanger, braid remaining lengths
of ribbon. Fold braided ribbon lengths in
half. Glue cut ends to back of heart at
crevice. Let dry.

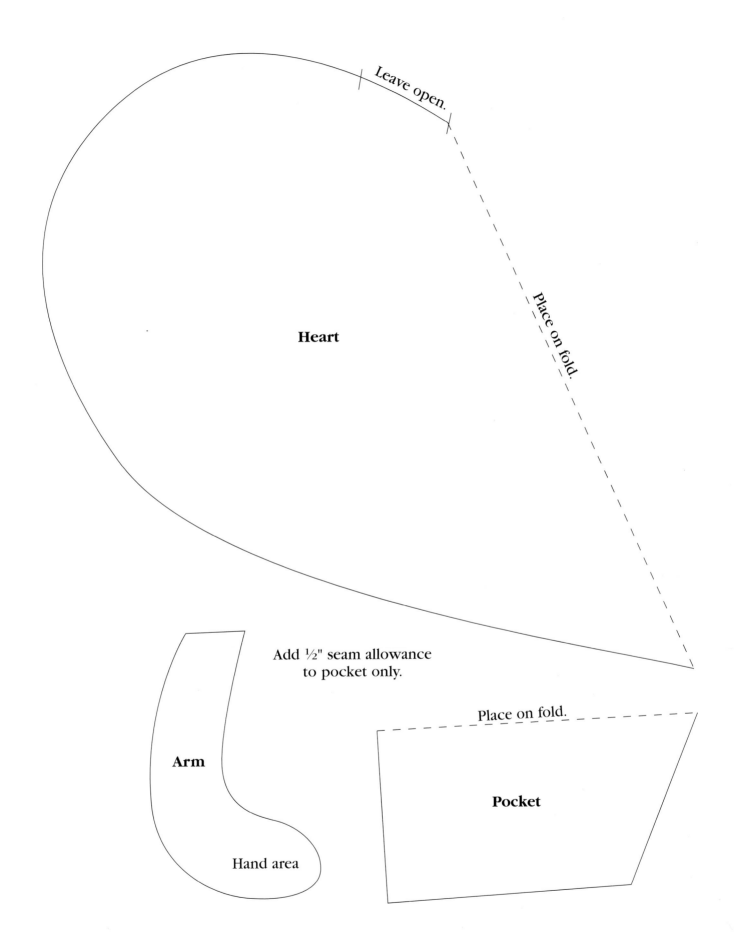

Leave open.

Place on fold.

Heart

Add ½" seam allowance
to pocket only.

Arm

Hand area

Place on fold.

Pocket

57

Merry Messengers Wall Border

After you have completed this border, you can use the angel stamps again to make place mats like the one that appears on page 61. ·

Materials

2 sheets of Fun Foam
Foam-core board: 2 (7" x 9") pieces, 2 (2") squares
Aleene's Designer Tacky Glue™
Aleene's Premium-Coat™ Acrylic Paints: Medium Violet, Gold, Light Turquoise, flesh color, hair color, Medium Yellow, Light Fuchsia
Paintbrushes
10"-wide blank wallpaper border *
* See Sources on page 144.

Directions

1. To make stamps, transfer heart, star, and individual pieces of angel pattern on page 60 to Fun Foam and cut out. Reverse angel pattern pieces, transfer to Fun Foam, and cut out. Referring to photo and pattern, center and glue 1 set of foam angel pieces to 1 (7" x 9") piece of foam core, leaving space between pieces as indicated on pattern. Repeat to glue remaining set of foam angel pieces to remaining 7" x 9" piece of foam core. Center and glue foam heart and star on separate 2" squares of foam core. Let dry.

2. Beginning with stamp of angel facing left, paint stamp as follows: dress and shoes with Medium Violet; wings with Gold; sash with Light Turquoise; face, hands, and feet with flesh color; hair with hair color; and halo and star with Medium Yellow. Referring to photo and beginning at cut end of wallpaper border, center stamp on border and press firmly, making sure all areas of stamp come in contact with border. Carefully remove stamp. Let dry. Repeat to apply paint to remaining stamp and to stamp next angel, positioning stamp approximately 2½" from angel just stamped.

3. Continue stamping sets of angels along length of border, leaving approximately 3½" between sets of angels. (If desired, let

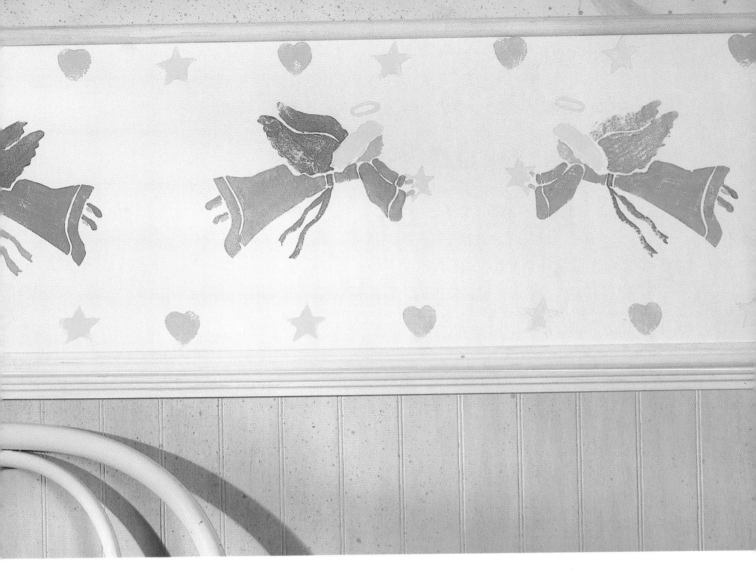

paint on stamp dry and change sash color to Medium Violet and dress and shoe color to Light Turquoise.)

4. Paint heart stamp with Light Fuchsia. Paint star stamp with Medium Yellow. Referring to photo, alternate stamping hearts and stars along top and bottom edges of border. Reload stamps with paint as needed. Let dry.

5. Referring to manufacturer's instructions, hang border.

Keep in mind that the angel facing to the left on the stamp will face to the right when stamped on the border and vice versa.

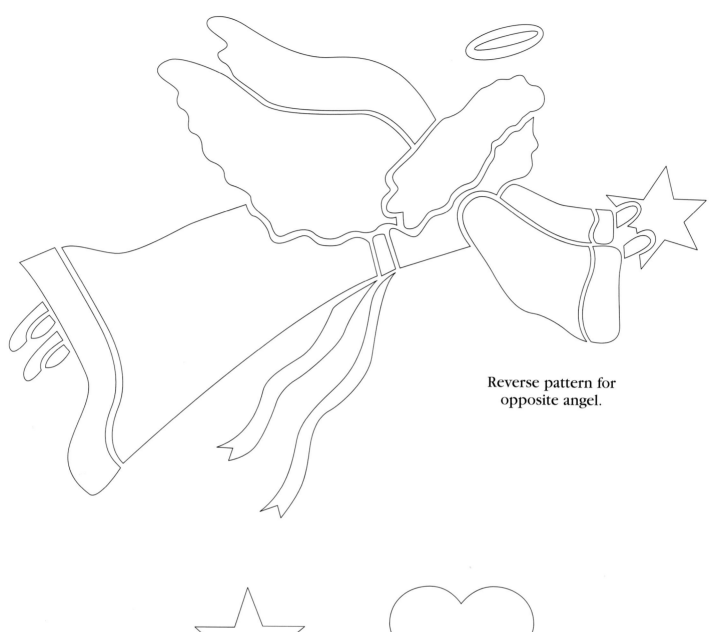

Reverse pattern for
opposite angel.

Heavenly Hostess Linen Set

For an inexpensive hostess gift, make several of these pretty place settings. The napkin ring is a cinch to create with purchased wooden shapes. The matching napkin and place mat are easy no-sew projects!

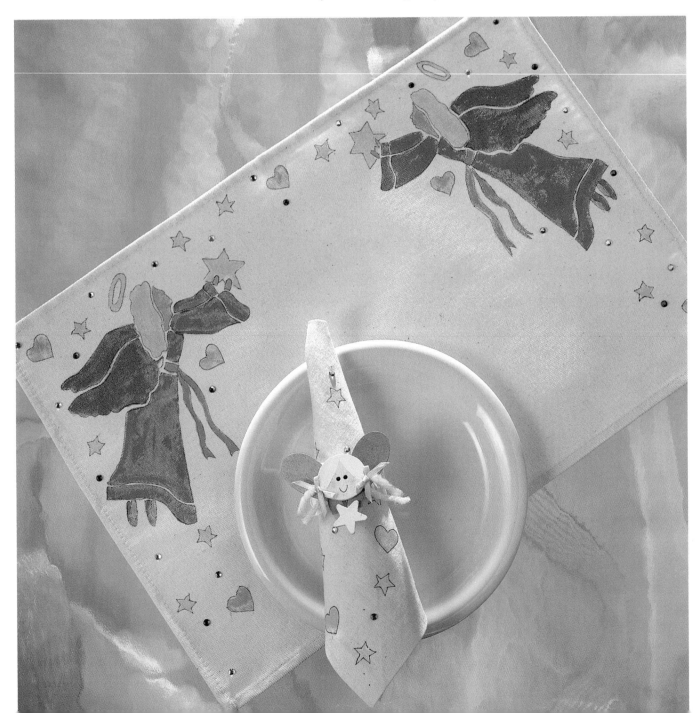

Materials (for 1 napkin and 1 napkin ring)

14" square muslin
4 (½" x 14") strips Aleene's Fusible Web™
Fine-tip permanent black fabric marker
Aleene's Premium-Coat Acrylic Paints: Medium Yellow, Light Fuchsia, Gold, Medium Violet, flesh color, hair color
Aleene's Enhancers™ Textile Medium
Paper cups
Wooden craft sticks
Paintbrushes
4 (5-mm) round topaz acrylic jewels
Aleene's Designer Tacky Glue™
1" x 6½" strip thin cardboard
Aleene's Satin Sheen Twisted Ribbon™: white
Woodsies™ wooden shapes: 2 (2") teardrops, 2 (1") ovals, 1 (1¼"-diameter) round, 1 (1") star *
Fine-tip black paint pen
2 (3") lengths yellow yarn
6" length ⅛"-wide lavender satin ribbon
* See Sources on page 144.

Directions

1. For napkin, with edges aligned, iron 1 fusible web strip to each edge of muslin square. Remove paper. Fold hem under and fuse, trimming corners as necessary.

2. Using black fabric marker, transfer heart and star patterns as desired to 1 corner of napkin. In separate cups, use craft sticks to mix equal parts of Medium Yellow and textile medium and of Light Fuchsia and textile medium. Inside outline, paint stars with Medium Yellow and paint hearts with Light Fuchsia. Let dry. Glue acrylic jewels among hearts and stars as desired. Let dry.

Heart

Star

3. For napkin ring, bend cardboard strip into circle, overlapping ends. Glue. Let dry. Tear twisted ribbon into 1"-wide strips. Wrap cardboard circle with ribbon strips, gluing ends to secure. Let dry.

4. Paint teardrop Woodsies with Gold. Let dry. Referring to **Painting Diagrams,** paint 1 side each of oval and round Woodsies as shown. Let dry. Paint Woodsie star Medium Yellow. Let dry.

Arm

Head

Painting Diagrams

5. Referring to photo, glue lavender end of 1 oval arm to pointed end of each teardrop wing. Let dry. Fold each length of yarn in half. For each, glue folded end of yarn to teardrop wing just above oval arm. Let dry. Glue round head in place at top of oval arms. Let dry. Cut ribbon in half. Tie each ribbon length into bow. Glue 1 bow on top of each yarn ponytail at edge of face. Let dry. Glue star in place on arms. Let dry. Glue entire angel to twisted ribbon-covered cardboard circle. Let dry.

Materials (for 1 place mat)

2 sheets Fun Foam
Foam-core board: 2 (7" x 9") pieces, 2 (1") squares
Aleene's Designer Tacky Glue™
Aleene's Premium-Coat™ Acrylic Paints: Medium Violet, Gold, Light Turquoise, flesh color, hair color, Medium Yellow, Light Fuchsia
Aleene's Enhancers™ Textile Medium
Paper cups
Wooden craft sticks
Paintbrushes
Plain canvas place mat
Fine-tip permanent black fabric marker
5-mm round acrylic jewels: 9 purple, 10 clear, 7 amber

Directions

1. To make angel stamp, transfer individual pieces of angel pattern on page 60 to Fun Foam and cut out. Reverse angel pattern pieces, transfer to Fun Foam, and cut out. Referring to photo and pattern, center and glue 1 set of foam angel pieces to 1 (7" x 9") piece of foam core, leaving space between pieces as indicated on pattern. Repeat to glue remaining set of foam angel

pieces to remaining 7" x 9" piece of foam core. Let dry. To make border heart and star stamps, transfer patterns to remaining Fun Foam and cut out. Center and glue foam heart on 1 (1") square of foam core. Center and glue star on remaining 1" square of foam core. Let dry.

2. For each color of paint, in separate cups, use craft stick to mix equal parts of paint and textile medium. Beginning with stamp of angel facing left, paint stamp as follows: dress and shoes with Medium Violet; wings with Gold; sash with Light Turquoise; face, hands, and feet with flesh color; hair with hair color; and halo and star with Medium Yellow. Referring to photo, stamp top left corner of place mat, pressing firmly and making sure all areas of stamp come in contact with mat. (Once stamped, angel will face to right.) Carefully remove stamp. Let dry. Repeat to apply paint to remaining stamp and to stamp top right corner of place mat.

3. Referring to photo, stamp hearts and stars as desired around border of place mat. Let dry. Using black fabric marker, outline individual areas of each angel and border hearts and stars. Glue acrylic jewels among hearts and stars as desired. Let dry.

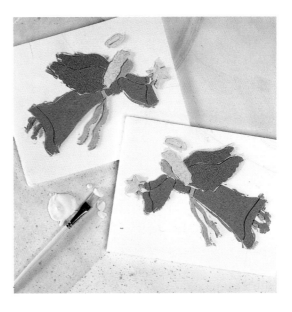

Gossamer Gift Boxes

Use inexpensive paper napkins to transform throwaway
boxes into handsome gift containers.

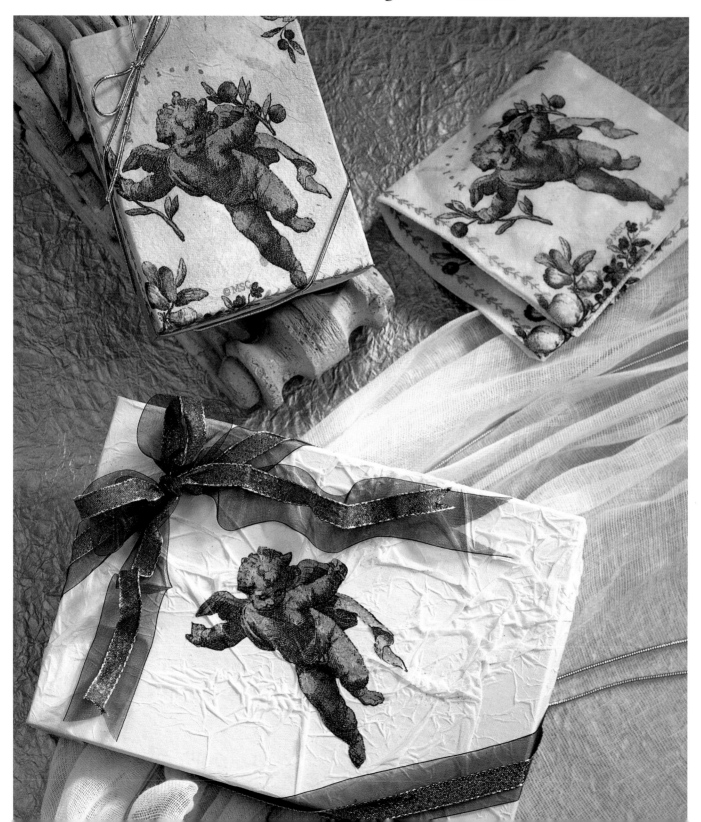

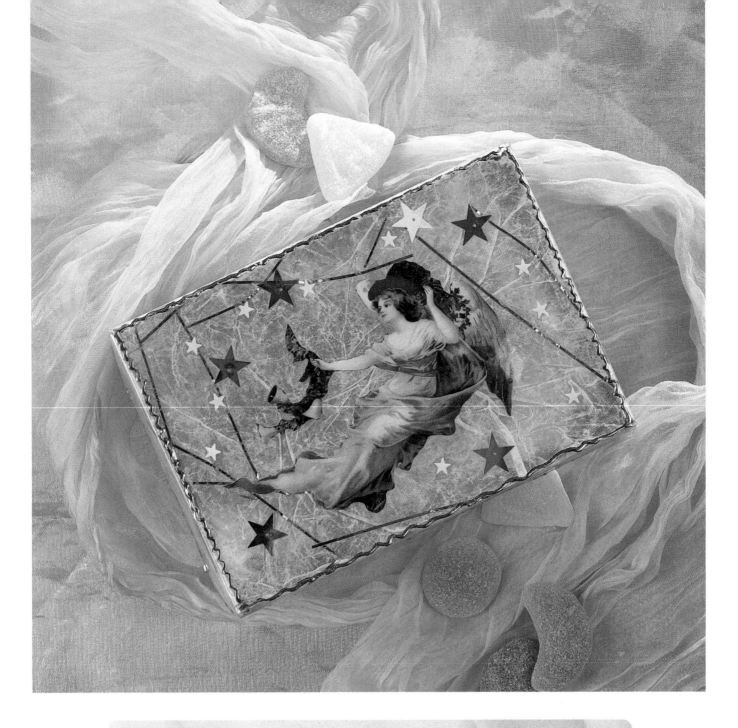

Materials

For each: Paintbrush
Gold spray paint
For napkin appliqué boxes: 2
 small boxes with lids
Ivory tissue paper
Aleene's Paper Napkin Appliqué™
 Glue
2 paper napkins with angel motif
1 (40") length each ribbon: 1"-
 wide burgundy organdy, ½"-
 wide gold metallic
Aleene's Designer Tacky Glue™

Straight pins
Gold cording
For reverse collage box: Small
 box with clear plastic lid
Gift wrap or decoupage print with
 angel motif
Aleene's Reverse Collage™ Glue
Waxed paper
Gold metallic and white star
 confetti
Gold metallic tinsel
Aleene's 3-D Foiling Glue™
Aleene's Gold Crafting Foil™

Directions

1. For napkin appliqué boxes, cut 1 piece of ivory tissue paper equal to 1 box lid (including sides of lid) plus 2" on each side. Brush coat of Napkin Appliqué Glue over top and sides of lid. Crumple tissue paper piece and then flatten it, leaving some wrinkles. Press tissue paper onto glue-covered area, covering top and sides of lid. Use fingers or brush to gently wrinkle paper, shaping it to fit lid. Brush coat of Napkin Appliqué Glue on top of tissue. Let dry.

2. Cut out desired angel motif from 1 napkin. Remove bottom plies so that angel is 1-ply thick. Using Napkin Appliqué Glue, glue angel in place on box lid. Brush coat of glue on top of angel. Let dry. Place lid on box.

3. Referring to photo, center gold ribbon on burgundy ribbon. Holding 2 ribbons as 1, wrap ribbon around 1 top corner and diagonally opposite bottom corner of box (see photo). Tie in bow. Trim ribbon tails as desired. Glue tails to lid in waves with Tacky Glue, using straight pins to hold tails in place until dry.

4. Remove lid from remaining box. Spray-paint bottom half of box with gold. Let dry. With angel motif centered, cut 1 piece from remaining napkin equal to box lid (including sides of lid) plus ½" on each side. Remove bottom plies so that napkin is 1-ply thick. Brush coat of Napkin Appliqué Glue over top and sides of lid. Crumple napkin and then flatten it, leaving some wrinkles. Press napkin onto glue-covered area, covering top and sides of lid. Brush coat of Napkin Appliqué Glue on top of napkin. Let dry. Place lid on box. Wrap cording around 1 top corner and diagonally opposite bottom corner of box (see photo). Tie in bow. Trim tails.

5. For reverse collage box, remove lid from box. Spray-paint bottom half of box with gold. Let dry. Cut out angel motif from gift wrap or decoupage print. Brush coat of Reverse Collage Glue on right side of angel motif. Place motif facedown in desired position inside box lid. Brush coat of glue over angel, pressing out any air bubbles.

6. Cut 1 piece of waxed paper equal to inside of box lid (including sides of lid) plus 1" on each side. Crumple waxed paper and then flatten it, leaving some wrinkles. Brush coat of Reverse Collage Glue on inside of lid. Press confetti and tinsel onto glue-covered area; then press waxed paper onto glue, clipping paper as need to fit corners. Use fingers or brush to gently wrinkle waxed paper, shaping it to fit lid. Brush coat of glue on top of waxed paper. Let dry.

7. To add gold foil, apply fine wavy lines of 3-D Foiling Glue around edges of lid (see photo). Let dry. (Glue will be opaque and sticky when dry. Glue must be thoroughly dry before foil is applied.) Lay foil dull side down on top of glue lines. Using finger, gently but firmly press foil onto glue, completely covering glue with foil. Peel away foil paper. If any part of glue is not covered, reapply foil as needed. Place lid on box.

Victorian Vanity Decorations

Brighten a powder room vanity with embellished bars of soap or sweet-smelling candles. These decorative accents are quick to complete.

Materials (for each)

1 bar soap or block candle
Assorted ribbons, lace, or doilies
Aleene's Designer Tacky Glue™
Small straight pins
Assorted trims: angel cutouts, buttons, pearls, ribbon rosettes, charms

Directions

Wrap ribbon, lace, or doily around soap or candle. Trim excess and glue ends together. Pin to soap or candle to secure. Let dry. Referring to photo for inspiration, embellish as desired. Let dry.

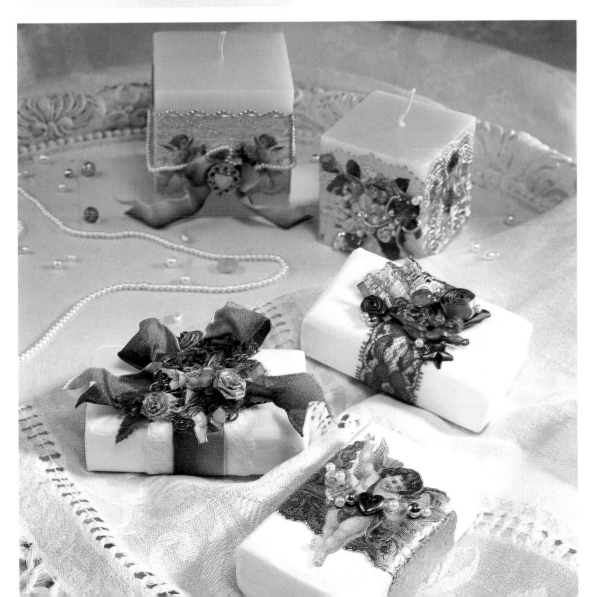

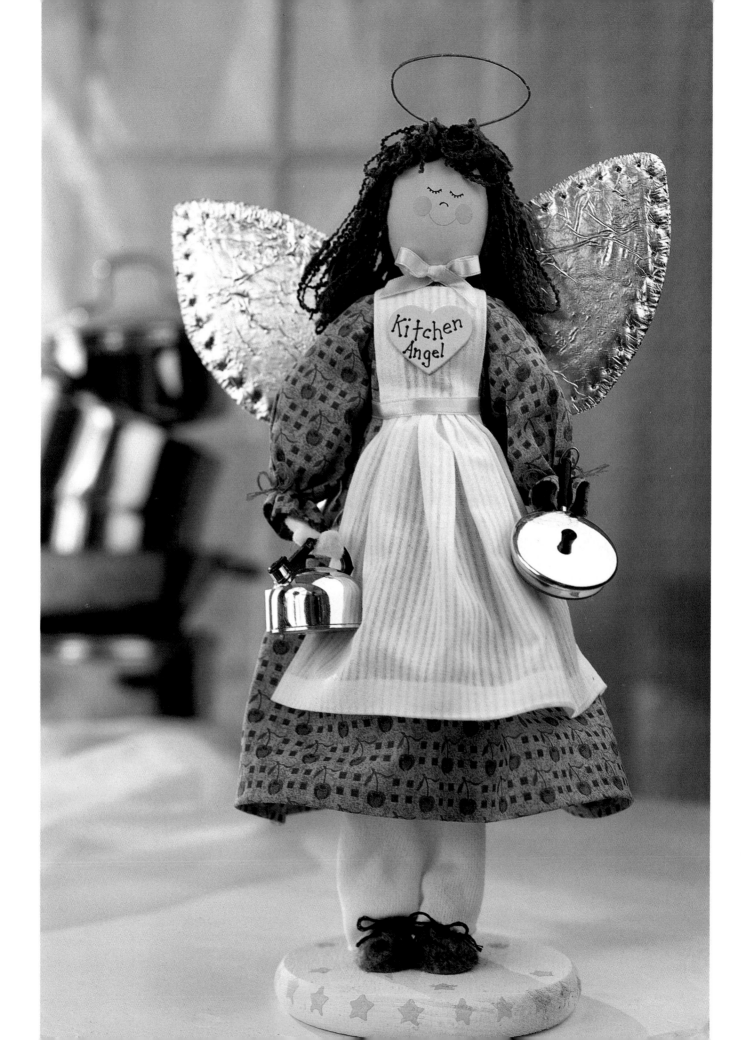

Guardian Gourmet

This kitchen angel is the main ingredient in the recipe for whimsy. She adds a spirited flavor of fun to time spent in front of the stove.

Materials

Wooden egg
¼"-diameter dowel
Aleene's Premium-Coat™ Acrylic Paints: flesh color, Ivory, Medium Apricot
Paintbrushes
5"-diameter ⅝"-thick wooden circle
1⅜"-wide flat wooden heart
Fine-tip permanent navy marker
Drill with ¼" bit
Knife
10" square cardboard
Aluminum foil
Aleene's Tacky Glue™
Pushpin
Felt: flesh color, gray
Embroidery floss: black, blue
2 (4½" x 7") pieces white cotton fleece
6" Styrofoam cone
Straight pins
Blue print fabric: 9½" x 22" piece, 2 (5½") squares
Needle and thread
23" (18-gauge) uncovered florist's wire
Stuffing
White cotton fabric: 3" x 3½" piece, 6" x 9½" piece
Rub-on doll face *
Cotton string doll hair
1 yard ⅜"-wide blue satin ribbon
Miniature cookware **
* See Sources on page 144.
** Teakettle and pan used on model are refrigerator magnets. You can also use doll cooking utensils or very small cookie cutters.

Directions

1. Paint wooden egg and dowel with flesh color. Let dry. Paint wooden circle with Ivory. Let dry. Using Medium Apricot, paint wooden heart; paint stars around rim of wooden circle and randomly on top of circle. Let dry. Using navy marker, write "Kitchen Angel" on wooden heart.

2. Drill 2 (½"-deep) holes 1¼" apart in center of wooden circle. Drill ¾"-deep hole in 1 end of wooden egg. Using knife, cut 2 (7") lengths and 1 (2½") length from dowel. Transfer pattern on page 70 to cardboard and cut 1 wings. Cover 1 side of cardboard wings with aluminum foil, folding excess foil to back of wings and gluing in place. Let dry. Using pushpin, poke holes approximately ⅜" apart along outline of wings.

3. Refer to patterns on page 71 to cut the following. Transfer pattern to flesh-colored felt and cut 4 hands. Transfer patterns to gray felt and cut 2 shoe bottoms and 2 shoe tops. Insert 1 (7") dowel length in each hole in wooden circle. Slip 1 shoe bottom onto base of each dowel. Apply thin line of glue along edges of shoe bottoms. With center flap of shoe tops aligned with curved toe of shoe bottoms, wrap 1 shoe top around each shoe bottom, pressing straight bottom edge of shoe top into glue. Overlap back edges of each shoe top and glue together. Let dry. Fold center flap of each shoe top down; then fold sides of each shoe top over and glue in place. Let dry. Tie 2 small bows from black embroidery floss. Glue 1 bow to top of each shoe. Let dry.

Wings

Hand

Shoe Bottom

Cut slit.

Shoe Top

Diagram A

4. With fleece side to inside, fold 1 piece of cotton fleece so that long edges overlap. Glue long edges in place. Let dry. Repeat with remaining piece of cotton fleece. Slip 1 fleece tube over each dowel. Push fleece tubes down and coat ends of dowels with glue. Push base of Styrofoam cone onto dowels so that approximately 2" of each dowel is inside cone. Let dry. Pull up top edge of each fleece tube and pin top edge to base of cone. (Fleece will softly bunch on top of shoes.)

5. For dress, fold 1 long edge of 9½" x 22" blue print piece under ½". Glue in place. Let dry. Fold short edges of blue print dress piece so that they overlap. Glue short edges in place. Let dry. Referring to **Diagram A,** run gathering stitches by hand along remaining raw edge of dress piece. Pull threads to gather. Slip dress piece over cone so that gathered end is flush with top of cone. Adjust gathers and tie off. Glue gathered edge to cone. Let dry.

6. Cut 2 (7½") lengths of wire. Sandwich 1 end of each wire length between 2 felt hand pieces. Glue in place. Let dry. For sleeves, fold each edge of each 5½" blue print square under ½". Glue in place. Let dry. Fold 2 opposite raw edges of each piece so that edges overlap. Glue in place. Let dry. Referring to **Diagram B,** run gathering stitches by hand along open ends of each sleeve piece. Pull threads to gather slightly. Slip 1 sleeve on each 7½" wire piece so that bottom hemmed edge of sleeve rests on felt hand. Pull threads of wrist gathers tightly and tie off. Tie length of blue embroidery floss in bow around each wrist. Lightly stuff each sleeve. Coat free end of each wire arm with glue. Referring to photo for placement, insert each wire arm into top of cone. Pull threads of shoulder gathers tightly and tie off. Glue gathers in place. Let dry.

Diagram B

71

7. For apron, fold each 3" edge of 3" x 3½" white cotton piece under ½". Glue in place. Let dry. Fold 1 remaining raw edge under ½". Glue in place. Let dry. For apron straps, referring to **Diagram C,** clip remaining raw edge ½" in from each side and ⅞" down from top edge. Fold clipped section under and glue in place. Let dry. Fold ½" of both 6" edges and 1 (9½") edge of 6" x 9½" white piece under. Glue in place. Let dry. Run gathering stitches by hand along remaining raw edge. Pull threads to gather slightly. Referring to **Diagram D,** glue apron top to gathered edge of apron bottom. Glue waist and shoulder straps of apron in place on dress. Let dry.

Shoulder straps

6" x 9½" gathered rectangle

Diagram D

½" ½"

⅞" ⅞"

Hemmed edge

Fold
Hemmed edge

Hemmed edge Hemmed edge

Hemmed edge

Diagram C

8. Insert 1 end of 2½" length of dowel into hole in wooden egg. Coat remaining end of dowel with glue and insert into top of cone so that egg rests on cone. Let dry. Rub doll face onto front of egg. Glue doll hair in place. Let dry. Cut 6" length of satin ribbon and tie in bow. Glue bow to neck of dress. Glue wooden heart to center of apron top. Let dry. Wrap remaining length of satin ribbon around waist of angel and tie in bow at back. For halo, holding ends together, shape center of remaining length of wire into 2¼"-diameter circle. Twist ends together to secure. Bend ends down at a 90° angle from circle. Glue ends of halo to back of head. Let dry. Pin wings in place on back of angel. Shape arms and hands as desired. Glue cookware in hands. Let dry.

Animal Angel Pins

These angelic animals can be made as pins or package toppers—or both!

Materials (for 1 of each animal)

For each: Woodsies™ wooden shapes: 6 (1½"-long) teardrops, 1¼"-diameter circle *

Aleene's Premium-Coat™ Acrylic Paint: Gold

Paintbrushes

Aleene's Designer Tacky Glue™

Pin back (optional)

Transparent tape (optional)

For pig: Woodsies™ wooden shapes: ¾"-diameter circle, ⅜"-diameter circle, 1¾"-wide heart, 2 triangles with ⅝"-wide base, ⅞"-wide star

Aleene's Premium-Coat™ Acrylic Paints: Light Orange, Medium Yellow, Medium Poppy

2 (⅛") black bead eyes

For cat: Woodsies™ wooden shapes: 1¾"-wide heart, 2 triangles with 1"-wide base, ⅞"-wide star

Aleene's Premium-Coat™ Acrylic Paints: Medium Grey, Medium Yellow, Black, Light Fuchsia

For cow: Woodsies™ wooden shapes: 2"-long oval, 2 triangles with ⅝"-wide base, 2 (⅜"-diameter) circles

Aleene's Premium-Coat™ Acrylic Paints: White, Light Fuchsia, Black

2 (¼") black half-round bead eyes

Small gold jingle bell

8" length ¼"-wide turquoise satin ribbon

For bear: Woodsies™ wooden shapes: 3 (¾"-diameter) circles, 1¾"-wide heart, ⅞"-wide star

Aleene's Premium-Coat™ Acrylic Paints: Dusty Beige, Burnt Umber, Medium Yellow, Black

2 (⅛"-diameter) black bead eyes

* See Sources on page 144.

Directions

1. Paint 1 side of each teardrop Woodsies with Gold. Let dry.

2. For pig, paint 1 side of circles, heart, and triangles with Light Orange. Let dry. Paint 1 side of star with Medium Yellow. Let dry. Referring to photo, for wings, glue 3 teardrops on each side of point on back of heart. Let dry. For head, stack circles and glue in place on painted side of heart tip. Let dry. For ears, glue triangles facedown at top back of head. Let dry. Using Medium Poppy, paint nostrils on nose, accents on ears, and accents on heart curves. Let dry. Glue bead eyes in place. Let dry. Glue star in place. Let dry.

3. For cat, paint 1 side of circle, heart, and triangles with Medium Grey. Let dry. Paint star with Medium Yellow. Let dry. Referring to photo, for wings, glue 3 teardrops facedown on each side of point on back of heart. Let dry. For head, glue circle in place on painted side of heart tip. Let dry. For ears, glue triangles facedown at top back of head. Let dry. Paint face and stripes on heart with Black. Let dry. Paint accents on ears with Light Fuchsia. Let dry. Glue star in place. Let dry.

5. For bear, paint 1 side of 1¼" circle, 2 (¾") circles, and heart with Dusty Beige. Let dry. Paint ½" Burnt Umber circle in center of each ¾" Dusty Beige circle. Paint 1 side of remaining ¾" circle with Burnt Umber. Let dry. Paint 1 side of star with Medium Yellow. Let dry. Referring to photo, for wings, glue 3 teardrops facedown on each side of back of heart. Let dry. For head, glue 1¼" circle in place on painted side of heart tip. Let dry. For muzzle, glue Burnt Umber circle in place at bottom of head. Let dry. For ears, glue bicolored circles facedown at top back of head. Let dry. Paint nose with Black. Let dry. Paint mouth with Dusty Beige. Let dry. Paint accents on heart with Burnt Umber. Let dry. Glue bead eyes in place. Let dry. Glue star in place. Let dry.

4. For cow, paint 1 side of 1¼" circle, oval, and triangles with White. Let dry. Paint 1 side of each ⅜" circle Light Fuchsia. Let dry. Referring to photo, for head, glue 1¼" circle facedown to back of oval. Let dry. For ears, glue triangles facedown at top back of head. Let dry. For wings, glue 3 teardrops facedown on each side of back of head. Let dry. For nostrils, glue ⅜" circles in place on oval muzzle. Let dry. Paint mouth, patches on head and muzzle, and accents on nostrils with Black. Let dry. Paint accents on ears with Light Fuchsia. Let dry. Glue half-round bead eyes in place. Let dry. Thread jingle bell onto ribbon length. Tie ribbon in bow. Glue bow and bell to bottom center of muzzle. Let dry.

6. If desired, glue 1 pin back to back of each animal. Alternatively, tape animals to top of wrapped packages.

Choir of Angels

Because these elegant paper ornaments are very inexpensive, you can make a multitude of heavenly hosts.

Materials (for 1 angel)

4" x 6" piece watercolor paper
¼"-diameter hole punch
Aleene's Premium Coat™ Acrylic
 Paints: Gold, flesh color, hair color
Paintbrush
Fine-tip permanent black marker
3" length ¼"-wide gold ribbon
Aleene's Designer Tacky Glue™
Transparent tape
6" length gold thread

Directions

1. Transfer pattern to paper and cut 1 angel. Punch hole where indicated. Referring to photo, paint wings and halo with Gold. Let dry. Paint face with flesh color and hair with hair color. Let dry. Outline inside edge of hair with Gold. Let dry. Using black marker, draw eyelashes and mouth.

2. Tie gold ribbon in bow. Referring to photo, glue ribbon to angel's neck. Let dry. Bend arms to front until cut edges of book touch (see photo). Tape edges of book together along inside.

3. For hanger, fold length of thread in half. Slip loop end of folded thread through hole in halo. Pull cut ends of thread through loop and pull to tighten. Knot cut ends of thread.

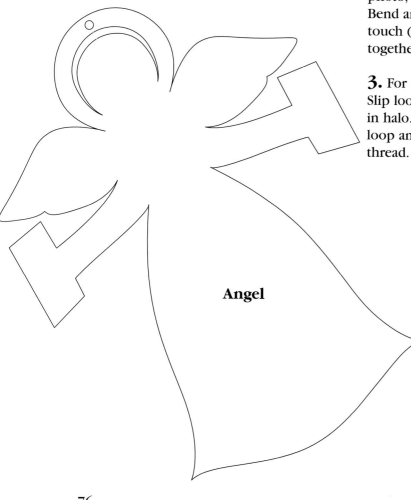

Angel

For greater accuracy, use a craft knife instead of scissors to cut out the area between the halo and the head.

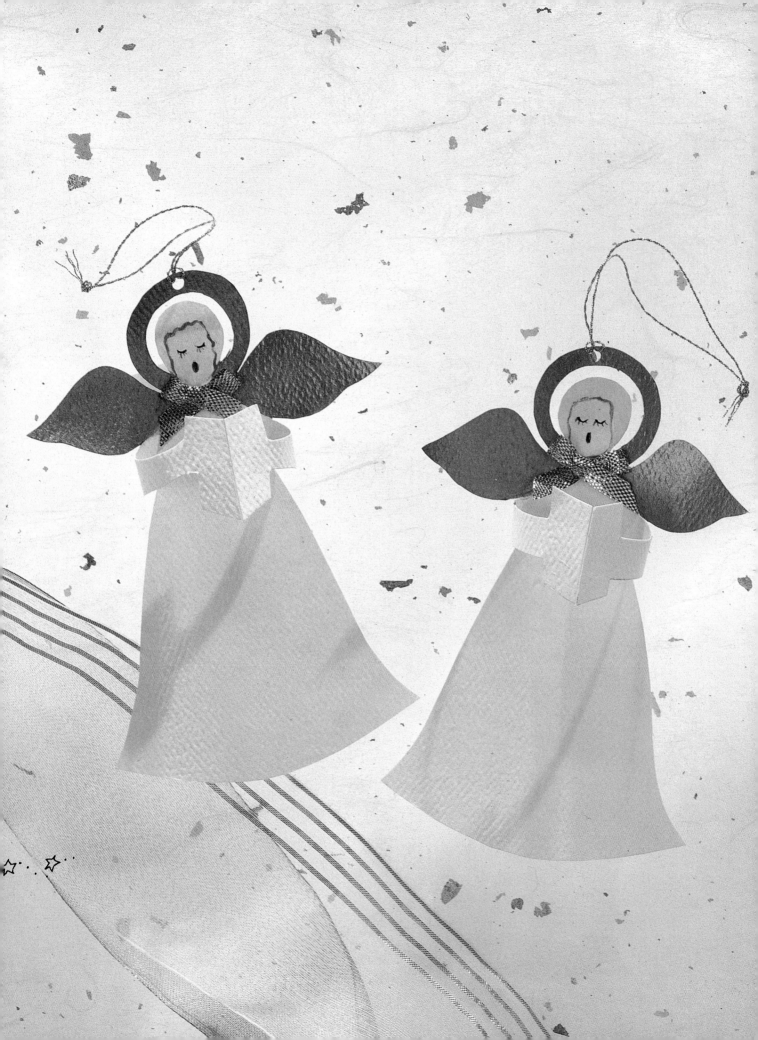

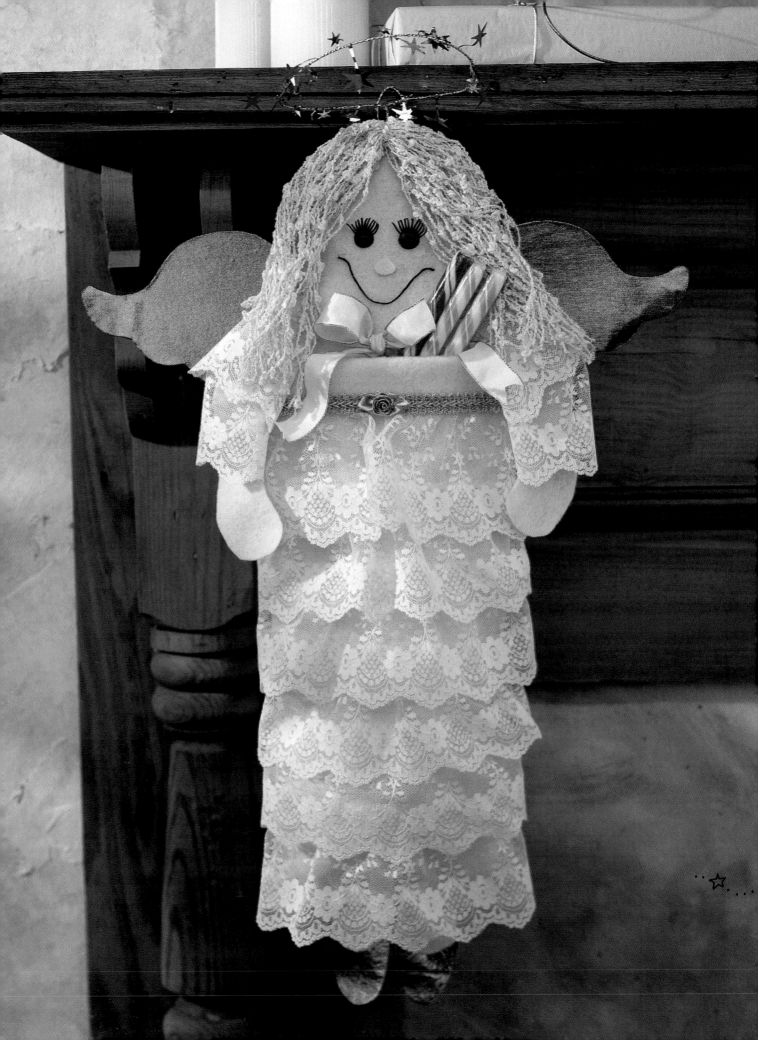

Layers of Lace Angel Stocking

This stocking is a unique holder for lightweight Christmas treasures.

Materials

Felt: 2 (7" x 16") pieces ivory; 5½"-diameter circle and 14" square flesh color

Aleene's Designer Tacky Glue™

Aleene's Fusible Web™: 5½"-diameter circle, 7" x 21" piece

7" x 21" piece gold lamé

Thin cardboard: 5½"-diameter circle, 5" x 17" piece

2⅛ yards 3½"-wide ivory lace

11" length ½"-wide gold braid

Gold ribbon rosette

2 plastic eyes with eyelashes

Powder blusher

4" length black embroidery floss

Cotton string doll hair *

18" length ½"-wide gold-edged ivory ribbon

1 yard gold wire star garland

* See Sources on page 144.

Directions

1. Fold 1 short end of 1 (7" x 16") ivory felt piece under 1". Glue in place. Let dry. Referring to **Diagram A,** stack 7" x 16" ivory felt pieces. Glue together along side and bottom edges, leaving top folded edge open. Let dry.

Diagram A

The strength and versatility of Designer Tacky Glue allows you to create this project without having to pull out your sewing machine.

2. Iron fusible web circle to flesh-colored felt circle and 7" x 21" web piece to wrong side of gold lamé. Transfer patterns to paper side of fused lamé and cut 1 wings and 2 shoes, cutting wings approximately ½" beyond outline and shoes along traced outline. Remove paper. Transfer pattern to 5" x 17" piece of cardboard and cut 1 wings. Transfer patterns to 14" square of flesh-colored felt and cut 2 arms and 2 feet. Fuse lamé wings to cardboard wings, folding excess lamé to back. Clip excess lamé

Place on fold.

Top

Lace placement

Lace placement

Wings

Arm

Foot

Shoe

as necessary and fuse to back of cardboard wings. Fuse 1 lamé shoe in place on each felt foot. Fuse felt circle to cardboard circle.

3. Cut 6 (11") lengths and 4 (2½") lengths from lace. Center and glue finished edge of 1 (11") length 3" from bottom edge of glued felt pieces **(Diagram B)**. Wrap excess lace to back and glue in place. Let dry. Repeat to glue remaining 11" lengths 5¼", 7½", 9½", 11½", and 13½" from bottom edge. Referring to photo, center and glue gold braid on top of finished edge of last row of lace. Let dry. Center and glue gold rosette to center of braid. Let dry. Glue finished edge of 1 (2½") length of lace around top of each arm. Glue remaining 2½" lengths around middle of arms. Let dry.

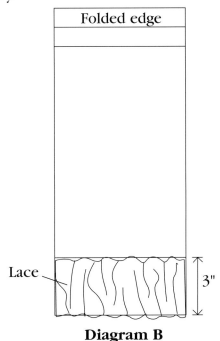

Diagram B

4. Transfer pattern to flesh-colored felt scrap and cut 1 nose. Referring to photo for placement, glue eyes and nose to felt side of 5½"-diameter circle. Using blusher, make cheeks. Shape embroidery floss into mouth and glue in place on felt circle. Glue doll hair in place around top of face.

Nose

5. Referring to **Diagram C,** with wings faceup, center and glue lace-embellished felt piece on top of wings, aligning cut edge of felt with top straight edge of wings. Let dry. Round off top edges of felt piece. Glue top of each arm in place along top edge of felt piece. Let dry. Glue lower edge of head in place between arms. Let dry. Referring to photo for placement, glue feet to bottom back of felt piece. Let dry. Tie ribbon in bow. Center and glue bow just below face. Let dry.

Diagram C

6. For halo, cut 22" length of star garland. Holding ends together, shape center of garland into 4½"-diameter circle. Twist ends together to secure. Bend ends down at a 90° angle from circle. Glue ends of halo to back of head. Let dry.

7. For hanger, shape remainder of star garland into loop. With loop extended slightly beyond top of head, glue cut ends of loop to back of head. Let dry. Cut 2½" x 3½" piece from flesh-colored felt scrap. Glue felt piece to back of head, covering ends of star garland pieces. Let dry.

Angel Album Cover

Relive happy moments spent with the beloved angels in your life through fond memories tucked away in this embossed muslin album.

Materials

Make-A-Memory 10" x 12" photo album kit by Gick * or white mat board
¼"-diameter hole punch (optional)
White-on-white muslin print: 2 (12" x 14") pieces, 2 (9¼" x 11½") pieces
9" square muslin solid
Aleene's Fusible Web™
9¼" x 11½" album filler paper *
36" length ⅞"-wide white satin ribbon
Gold metallic dimensional paint
*** See Sources on page 144.**

Directions

Note: If you prefer to make photo album, cut 2 (10") squares for cover and 2 (2" x 10") strips for spine from mat board. Using hole punch, center and punch 5 holes in each 2" x 10" piece. Punch first hole 2" from 1 short end. Punch subsequent holes 1½" apart, ending 2" from other short end. See page 140 of Crafting Tips and Techniques for more information on working with fusible web.

1. Fuse web to wrong side of white-on-white muslin pieces. Remove paper backing. Center 1 (10") cover and 1 (2" x 10") spine side by side on wrong side of 1 (12" x 14") muslin piece, leaving ⅟₁₆" between cover and spine.

2. Fold muslin corners over cover and spine at 45° angle. Using tip of iron, fuse to wrong side of cover and spine. Carefully turn cover over and fuse muslin to right side of cover and spine.

3. Using iron, press muslin over each edge of cover and spine and fuse excess muslin to wrong side of cover pieces. In same manner, use remaining cover, spine, and 12" x 14" white-on-white muslin piece to assemble back of album cover.

4. For lining, center and fuse 1 (9¼" x 11½") white-on-white muslin piece on wrong side of each cover. While muslin and web are still warm, bend spine backwards to ensure easy opening of finished album.

5. Using tip of scissors, punch holes through muslin to match holes in each spine. With holes aligned, stack album back (right side down), paper, and album front (right side up). Referring to **Lacing Diagrams,** thread satin ribbon through holes to assemble album. Tie ribbon ends in bow on front of cover.

6. Pull threads to slightly fray each edge of 9" muslin square. Fuse web to 1 side of muslin square. (Do not fuse webbing to frayed edges.) Remove paper backing. Transfer pattern on page 84 to right side of muslin square. Paint over traced lines with gold dimensional paint. Let dry. Place pressing cloth over painted area to protect design. Center and fuse muslin square to front of album cover.

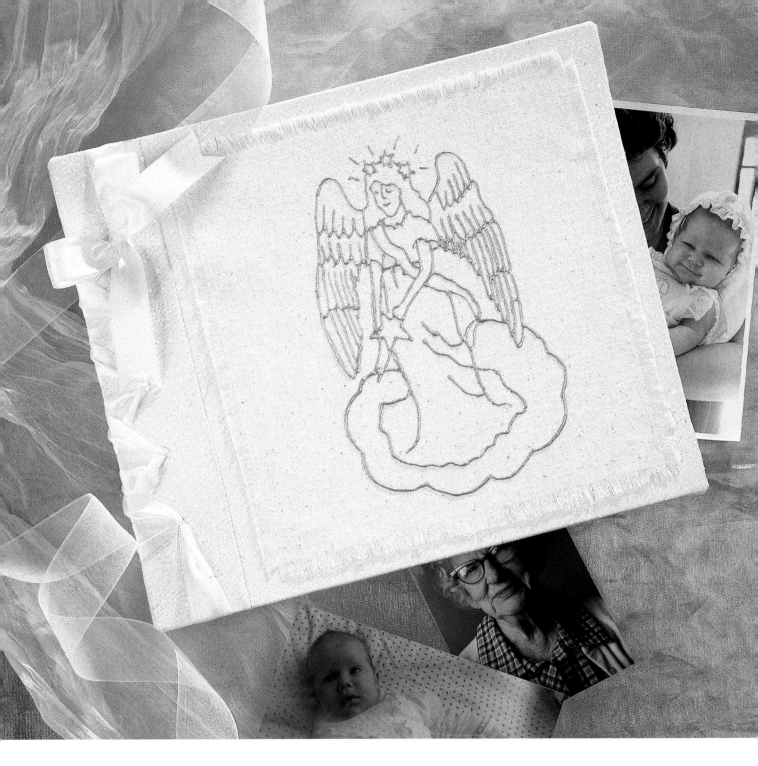

Step 1 Step 2 Step 3 Step 4

Lacing Diagrams

Angel

Plant Protector

This angel really has a stake in how well your house plants are doing! Made from grocery bags and wooden skewers, she's as economical as she is charming.

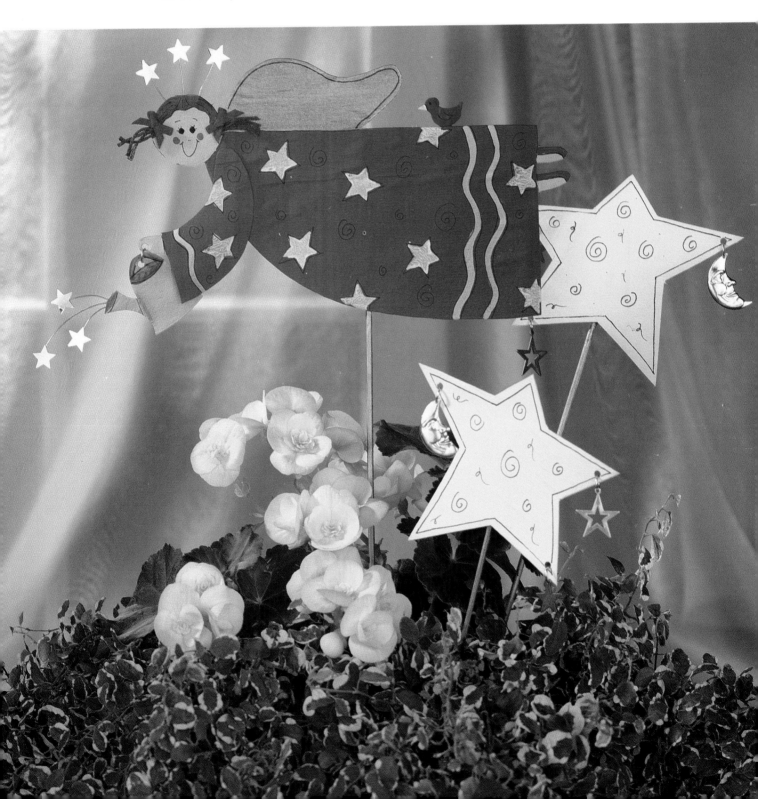

Materials (for 1 angel and 2 star plant stakes)

Brown grocery bag
3" square cardboard for squeegee
Aleene's Designer Tacky Glue™
Aleene's Premium-Coat™ Acrylic
 Paints: Gold, True Violet, flesh color,
 hair color, Medium Grey, True Grey,
 True Lavender, Light Lavender,
 Medium Yellow, Medium Fuchsia
Paintbrush
3 wooden skewers
Fine-tip permanent black marker
⅛"-diameter hole punch
7 jump rings
6 celestial charms
8" length 30-gauge wire
12 sequin stars
Embroidery floss in desired hair color
6" length ⅛"-wide rose satin ribbon

Directions

1. Cut 2 (8½" x 11") pieces of brown bag. Using cardboard squeegee, apply 1 coat of glue to 1 side of 1 brown bag piece. With edges aligned, press remaining brown bag piece into glue. Let dry. Transfer patterns to layered bag and cut 1 angel, 1 arm, 1 watering can, 1 bird, and 2 stars.

2. Paint wings and wooden skewers with Gold. Paint dress, shoes, and sleeve of arm with True Violet. Let dry. Paint hand, face, and feet with flesh color. Let dry. Paint hair with hair color. Let dry. Paint watering can with Medium Grey. Let dry. Paint handle, inside rim, and mouth of watering can spout with True Grey. Paint bird head and body with True Lavender. Let dry. Paint waves on sleeve and at bottom of dress with Light Lavender. Let dry. Paint star stakes, stars on dress, and bird beak with Medium Yellow. Let dry. Paint cheeks with Medium Fuchsia. Using black marker, draw facial features and details in hair; outline waves and stars on dress; draw swirl designs on dress and on star stakes; outline mouth, spout, and handle of watering can; outline angel wing; outline beak and wing of bird and draw bird eye; outline shoes; and outline star stakes.

3. Punch holes in hand and watering can where indicated on pattern. Punch holes in 3 points of each star. Referring to photo, attach 1 jump ring to watering can; attach watering can and jump ring to hand. Glue arm in place. Let dry. Attach 1 charm to each remaining jump ring; attach 1 jump ring and charm to hole in each star stake.

4. Cut 3 (1") lengths of wire. Sandwich and glue 1 end of each wire length between 2 star sequins. Let dry. Referring to photo, glue to back of head. Cut small piece from brown bag scrap and glue over ends of wire at back of head. From remaining wire, cut 2 (1") lengths and 1 (2") length. Bend wire lengths slightly. Sandwich and glue 1 end of each length of wire between 2 star sequins. Let dry. Referring to photo, glue to back of watering can spout. Cut small piece from brown bag scrap and glue over ends of wire at back of spout. Let dry. Referring to photo for placement, glue stem of bird to top back of dress. Let dry.

5. For ponytails, cut 10 (¾") lengths of embroidery floss. Referring to photo, glue 5 lengths to each side of head. Let dry. Cut ribbon in half. Tie each half in small bow, trimming as necessary. Glue 1 bow on top of each ponytail. Let dry.

6. Glue 1 skewer to center back of angel and to center back of each star. Cut 3 pieces from brown bag scraps. Glue 1 piece over skewer at back of angel. Let dry. Repeat to glue remaining brown bag pieces to stars.

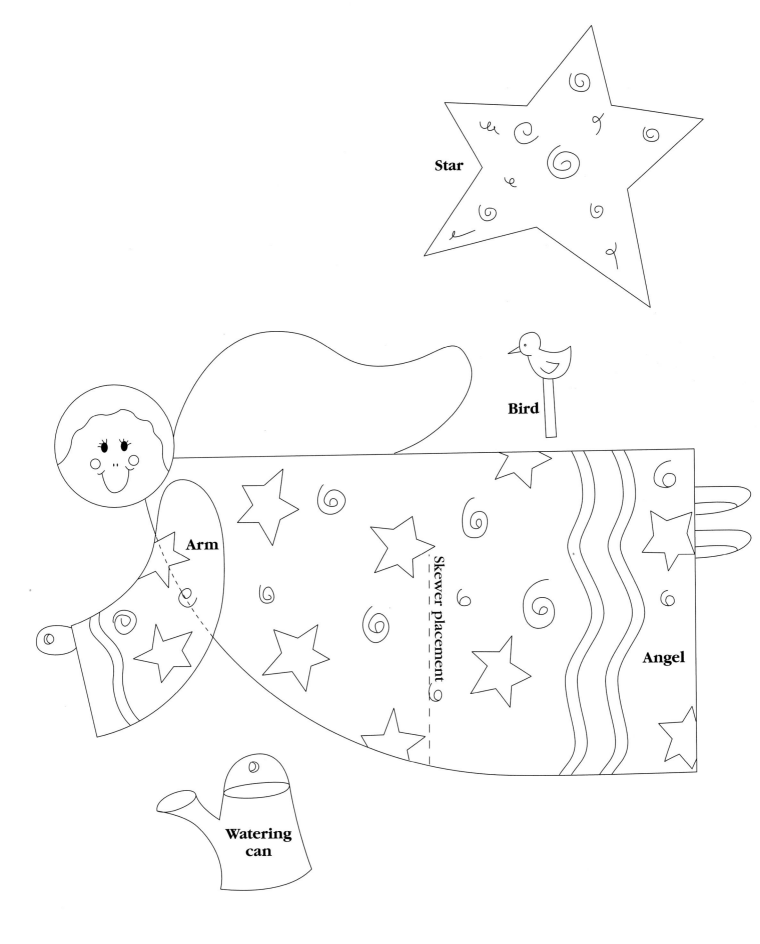

Star

Bird

Arm

Skewer placement

Angel

Watering
can

87

Glad Tidings Note Cards

Throughout history angels have been the messengers of good tidings. Continue that tradition by spreading words of joy with these watercolor angel note cards.

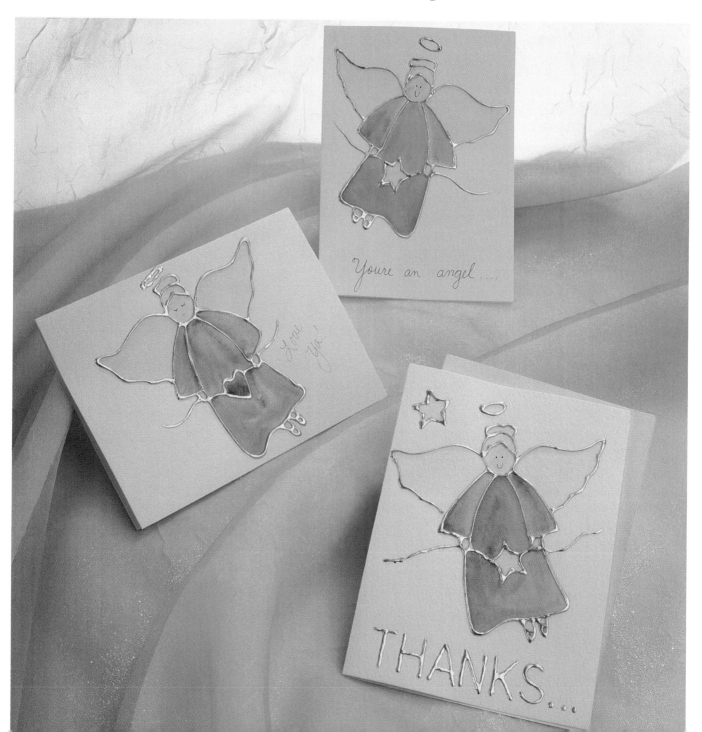

Materials (for 1 card)

7" x 10" piece watercolor paper or
 card stock
Aleene's 3-D Foiling™ Glue
Aleene's Gold Crafting Foil™
Aleene's Premium-Coat™ Acrylic
 Paints: Medium Yellow, flesh color,
 hair color, color desired for robe,
 True Red (optional, for heart)
Paper cups
Small paintbrush
Fine-tip permanent markers: black,
 desired color for message (optional)
Envelope to match

Directions

1. Fold watercolor paper in half width-wise. Referring to photo, determine desired position for angel. (Reverse pattern if desired.) Transfer pattern to front of note card, substituting star motif for heart if desired.

2. Trace pattern lines, using 3-D Foiling Glue. Let glue dry for about 24 hours.

(Glue will be opaque and sticky when dry. Glue must be thoroughly dry before foil is applied.)

3. To apply foil, lay foil dull side down on top of glue lines. Using fingers, gently but firmly press foil onto glue, completely covering glue with foil. Be sure to press foil into crevices. Peel away foil paper. If any part of glue is not covered, reapply foil as needed.

4. For each color of paint, in separate cups, use craft stick to mix equal parts of paint and water to make a wash. Paint wings with Medium Yellow wash. Let dry. Paint face, hands, and feet with flesh-colored wash. Let dry. Paint hair with hair-colored wash. Let dry. Paint robe in desired color wash. Let dry. For heart motif, paint heart with True Red wash. For star motif, paint star with Medium Yellow wash. Let dry. Using black marker and referring to photo, draw facial features.

5. If desired, write message on front of card, using marker in desired color.

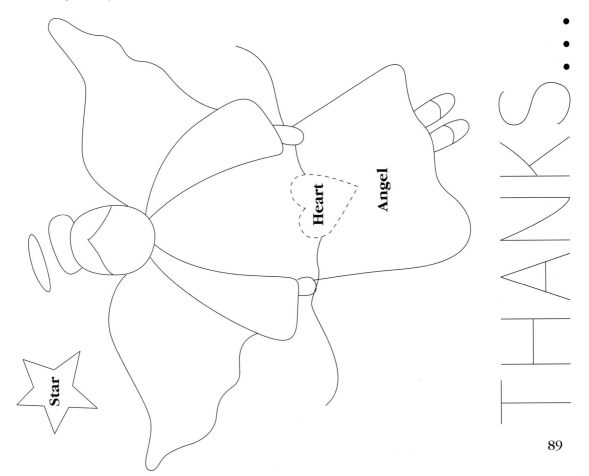

Appliquéd Accent Pillows

These whimsical pillows add a touch of love and joy to your home. Because the angel motifs are simply fused in place, they are very easy to assemble.

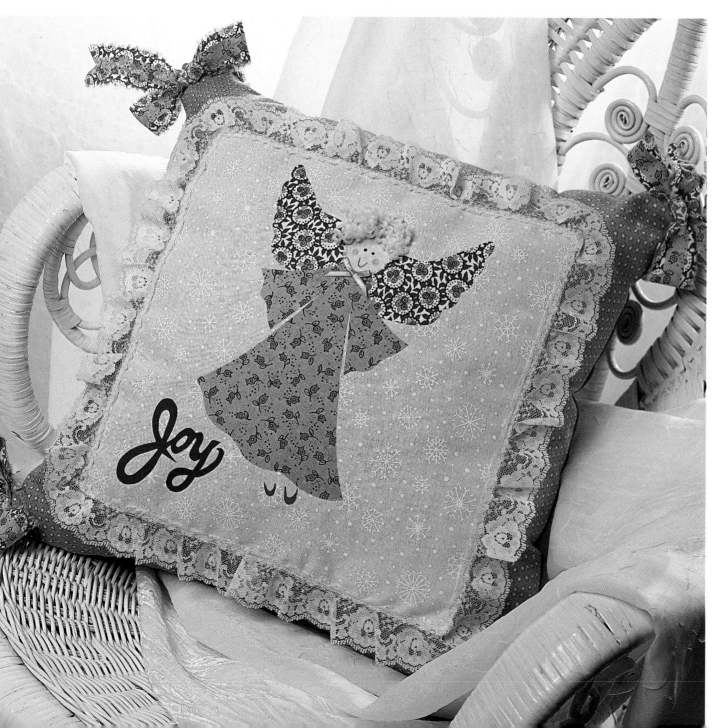

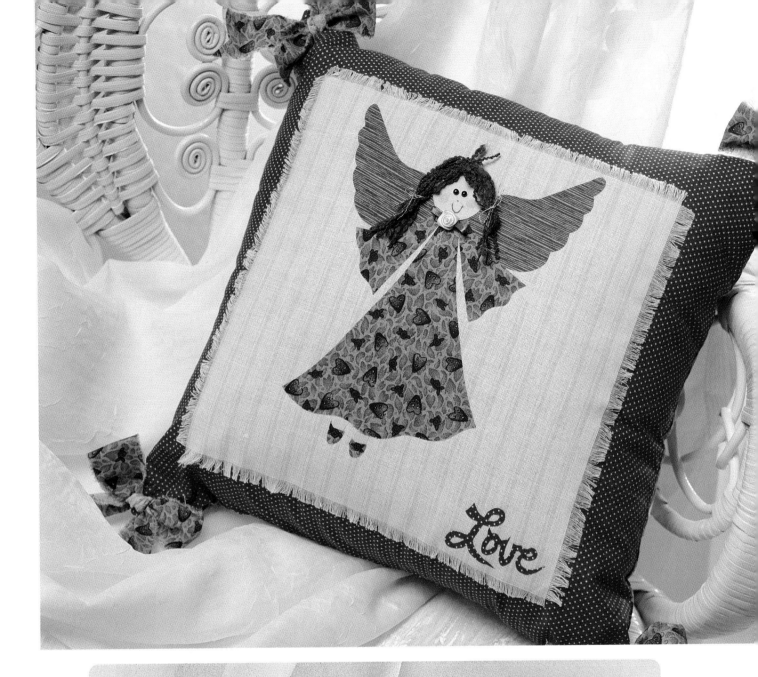

For each: Flesh-colored scraps
Aleene's Fusible Web™
Ultra fine-tip permanent black marker
Thread to match fabrics
Aleene's Premium-Coat™ Acrylic Paint:
 Light Poppy
Small paintbrush
Aleene's OK to Wash-It™ Glue
16" pillow form
For joy pillow: Fabric: 8" x 13" piece
 green print, 10½" square white-on-
 white print, 1 (17") square each pur-
 ple print and purple solid, scraps of
 beige print and purple solid
Aleene's Premium-Coat™ Acrylic Paint:
 Black

43" length 1½"-wide pregathered lace
 trim
Hair color yarn scrap
3½" length ⅛"-wide lavender satin
 ribbon
For love pillow: Fabric: 10" square
 white-and-pink pinstripe; 1 (17")
 square each heart print and rose-
 and-white minidot; scraps of heart
 print, rose stripe, and rose-and-white
 minidot
2 black half-round bead eyes
Cotton string doll hair
Gold metallic thread
1 ribbon rosette

Directions

Note: See page 140 of Crafting Tips and Techniques for more information on working with fusible web.

1. For each, wash and dry fabrics and fabric scraps; do not use fabric softener in washer or dryer.

2. For joy pillow, cut 4 (1¼" x 13") strips from green print. Fray edges slightly. Fuse web to wrong side of remaining green print, beige print scrap, flesh-colored scrap, purple solid scrap, and white-on-white print. Transfer patterns, reversing dress pattern, and cut wings from green print; sleeves, dress, and 4 (½" x 13") strips from beige print; head, hands, and feet from flesh color; and shoes and "Joy" from purple solid scrap. Remove paper backings except from white-on-white print.

Center and fuse 1 (½" x 13") beige print strip on each 1¼" x 13" green print strip. Tie each strip in bow and cut notch in streamers. Set aside.

3. Referring to photo, arrange pattern pieces on right side of white-on-white print. Fuse pieces in place. Remove paper backing from white-on-white print. On right side of white-on-white print, machine-stitch lace trim to edges, folding final end of lace under and stitching in place. Center

and fuse white-on-white piece on right side of purple print square for pillow front. Using black marker, draw mouth. Paint cheeks and nose with Light Poppy. Use Black to paint dots for eyes (see photo). Let dry. Glue yarn in place for hair. Tie satin ribbon in bow and glue to neck of dress (see photo). Let dry.

4. With right sides facing, raw edges aligned, and using ½" seam allowance, stitch pillow front and purple solid square together along 3 sides. Turn right side out and insert pillow form. Slipstitch open side closed. Referring to photo, glue 1 bow from Step 2 to each corner of pillow. Let dry.

5. For love pillow, cut 4 (1¼" x 12") strips from heart print. Slightly fray edges. Tie each strip in bow and cut notch in streamers. Set aside. Slightly fray edges of white-and-pink pinstriped square. Fuse web to wrong side of remaining heart print scrap, rose striped scrap, rose-and-white minidot scrap, flesh-colored scrap, and white-and-pink pinstriped square. Transfer patterns (do *not* reverse dress) and cut sleeves, dress, and shoes from heart print scrap; wings from rose striped scrap; head, hands, and feet from flesh-colored scrap, and "Love" from rose-and-white minidot scrap. Remove paper backings except from white-and-pink pinstripe.

"Joy" Pattern

"Love" Pattern

6. Referring to photo, arrange pattern pieces on right side of white-and-pink pin-striped square. Fuse pieces in place. Remove paper backing from white-and-pink pinstriped square. Center and fuse white-and-pink pinstriped on right side of rose-and-white minidot square for pillow front.

7. Referring to photo and using black marker, draw mouth and nose. Paint cheeks with Light Poppy. Glue bead eyes in place. Let dry. Glue doll hair in place. Let dry. Tie gold thread to each end of hair to form ponytails. Glue ribbon rosette to neck of dress. Let dry.

8. Refer to Step 4 to finish pillow.

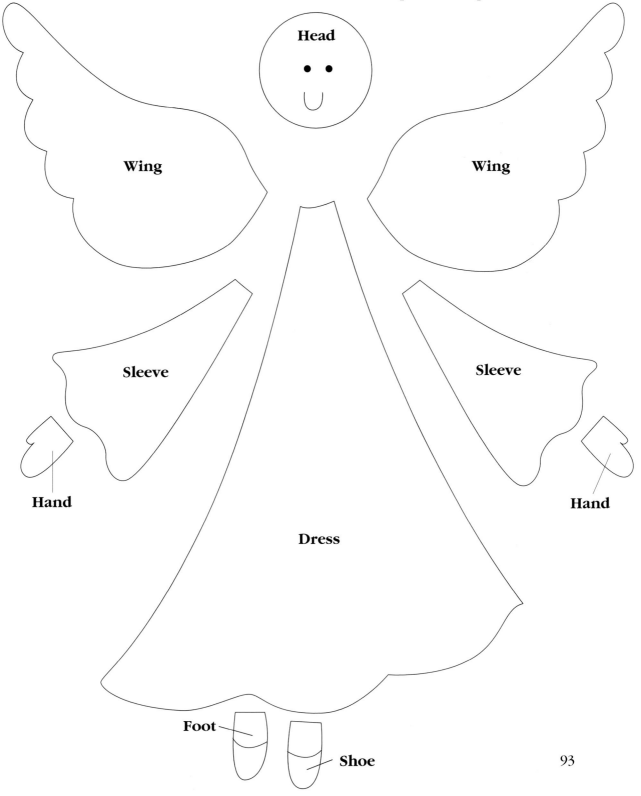

Head

Wing

Wing

Sleeve

Sleeve

Hand

Hand

Dress

Foot

Shoe

93

Goodwill Ornaments

These heavenly hosts proclaim the tidings of the season
on their gowns of white.

Materials (for 3 ornaments)

8" x 12" piece white-on-white muslin
 print
Felt: flesh scrap, 2" x 4" piece white
3 (1"-diameter) wooden beads
Aleene's Premium-Coat™ Acrylic
 Paints: flesh color, Light Fuchsia
Paintbrushes
Fine-tip permanent black marker
Doll hair in desired colors
Aleene's Designer Tacky Glue™
White thread
Stuffing
Aleene's Fabric Stiffener™
Extra fine-tip gold paint pen
Gold buttons: 2 (⅝") hearts, 1 (⅝")
 star
3 gold ribbon rosettes
Ribbon: 18" length 1½"-wide white
 organdy, 14" length 1"-wide gold
 braid, 14" length 1⅜"-wide white
 satin
3 (1¼"-diameter) earring hoops *
21" gold metallic thread for hanger
* Earring hoops can be found in the
 jewelry findings section of crafts
 stores.

Directions

1. Transfer pattern to muslin and cut 6
body pieces, adding ¼" seam allowance to
each. Transfer patterns to scraps of flesh-
colored felt and cut 3 pairs of feet and 6
hands. Transfer pattern to white felt and
cut 6 arms.

2. For each angel head, paint wooden bead
with flesh color. Let dry. Using black mark-
er and referring to photo, draw facial fea-
tures. Using Light Fuchsia, paint round
cheeks. Let dry. Glue doll hair to top of
head. Let dry.

3. With right sides facing and raw edges
aligned, stitch 2 body pieces together, leav-
ing top edge open. Turn and stuff. Wrap
doubled length of thread around top, ¼"
from cut edge. Tighten thread to gather top
edge. Tie off. Coat body piece with fabric
stiffener. Let dry. Using gold paint pen and
referring to photo, write seasonal tidings
on front of body piece. Repeat with
remaining body pieces.

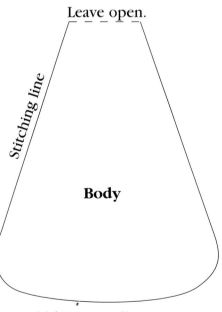

Leave open.

Stitching line

Body

Add ¼" seam allowance.

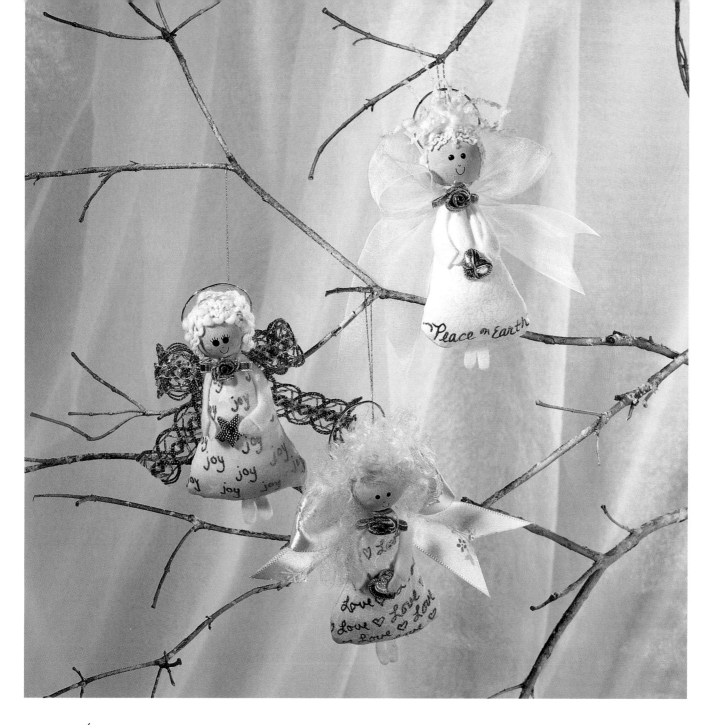

4. Glue 1 head on top of each body piece. Let dry. Referring to photo, glue 1 hand in place at bottom back of each arm. Let dry. Referring to photo, glue arms in place and glue 1 pair of feet at bottom of each body piece. Let dry. Glue 1 star or heart button between hands on front of each doll. Let dry. Glue ribbon rosette to front of each body at neckline. Let dry.

For wings, tie each ribbon length in bow. Glue 1 bow to back of each body, close to top. Let dry. For halos, referring to photo, glue 1 earring hoop to back of each head. Let dry.

5. For hangers, cut gold thread into 3 (7") lengths. Fold 1 thread length in half and knot ends. Repeat with remaining thread lengths. Glue knotted end of 1 thread length to back of each angel head. Let dry.

Arm

Feet

Hand

95

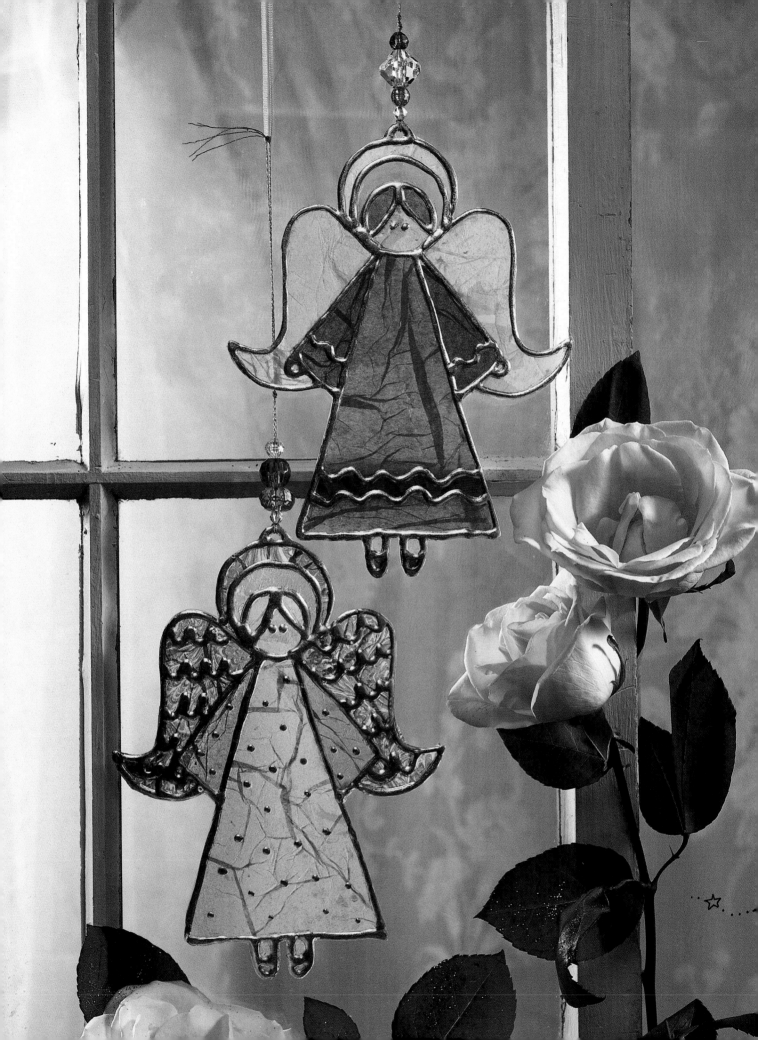

Cathedral Angels

This dazzling duo will brighten your window with
the look of faux stained glass.

Materials (for both angels)

Aleene's Crafting Plastic™
Aleene's 3-D Foiling™ Glue
Transparent tape (optional)
¼"-diameter hole punch
Aleene's Gold Crafting Foil™
Aleene's Tissue Paper: green, blue,
 gold print, hair color, flesh color,
 bright pink, purple, yellow
Fabric to cover work surface
½"-wide flat paintbrush
Aleene's Reverse Collage™ Glue
2 (16") lengths gold thread
Assorted beads

Directions

Note: See page 142 of Crafting Tips and
Techniques for more information on faux
stained glass.

1. For each angel, place crafting plastic
on top of pattern on page 98. Using 3-D
Foiling Glue, trace pattern onto crafting
plastic. Referring to photo, embellish angel
with additional 3-D Foiling Glue as desired.
For fine foiling lines, wrap piece of tape
around nozzle of 3-D Foiling Glue. (See
page 138 of Crafting Tips and Techniques
to make tape nozzle.) Punch hole where

indicated for hanger. Let dry for about 24
hours. (Glue will be opaque and sticky
when dry. Glue must be thoroughly dry
before foil is applied.)

2. To apply gold foil, lay foil dull side
down on top of glue lines. Using finger,
gently but firmly press foil onto glue, com-
pletely covering glue with foil. Be sure to
press foil into crevices. Peel away foil
paper. If any part of glue is not covered,
reapply foil as needed.

3. For angel wearing green dress, trans-
fer patterns to tissue paper and cut the fol-
lowing, adding ¼" to all edges of each
piece: 1 dress from green, 2 sleeves and 2
shoes from blue, 2 wings and 1 halo from
gold print, 1 hair from hair color, and 1
face and 2 feet from flesh color (see
photo).

For angel wearing pink dress, transfer
patterns to tissue paper and cut the follow-
ing, adding ¼" to all edges of each piece: 1
dress from bright pink; 2 sleeves, 2 shoes,
and 1 ruffle from purple; 2 wings and 1
halo from yellow; 1 hair from hair color;
and 1 face and 2 feet from flesh color (see
photo).

4. For each angel, crumple each paper
piece and then flatten it, leaving some
wrinkles. Cover work surface with fabric to
protect foiling. Lay angel, foil side down,
on fabric. Working over 1 design area at a
time, brush coat of Reverse Collage Glue
on wrong side of plastic. Press correspond-
ing paper piece onto glue-covered area.

*To protect your angels when stor-
ing them, place them between
two sheets of waxed paper.*

Working from outside edges to center, use fingers or brush to gently wrinkled paper, shaping it to fit design area. Brush coat of Reverse Collage Glue on top of paper. Let dry.

5. For each hanger, fold 1 gold thread in half. Thread free ends through punched hole in angel and then thread ends through loop. Pull to tighten. Referring to photo, thread beads on gold thread as desired. Knot thread at top of beads.

Place on fold.

Angel

Brown Bag Votive Angel

This celestial body's base is a one-liter drink bottle,
and the candle holder is a small clay pot.

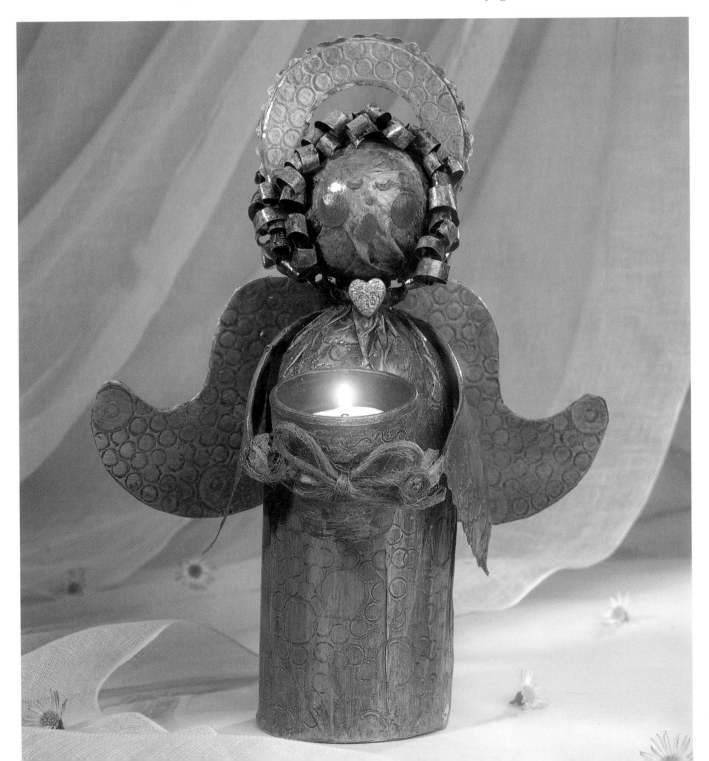

Materials

2 brown grocery bag
2¼"-diameter clay pot
Aleene's Premium-Coat™ Acrylic Paint:
 Ivory
Paintbrushes
Cardboard
3" square cardboard squeegee
Aleene's Tacky Glue™
Aleene's Fabric Stiffener™
Cap from felt tip pen
Umber antiquing spray
Soft cloth (such as cheesecloth)
Clean, empty 1-liter plastic soft-drink
 bottle with cap
Craft knife
2½"-diameter Styrofoam ball
Pencil
18" length 18-gauge uncovered florist's
 wire
20" length approximately ⅛"-diameter
 jute twine
Waxed paper
½" gold heart button
Aleene's Enhancers™ Gloss Varnish
Tea light candle

Directions

1. Cut brown bags so that they lay flat. Paint entire brown bags and clay pot with Ivory. Let dry. Transfer wings pattern on page 15 and halo pattern to cardboard and cut out. Transfer halo pattern to brown bag and cut 2. Transfer wings pattern to brown bag and cut out, adding ½" all around.

Halo

Dashed line is cutting line for cardboard.

100

2. Using squeegee, coat 1 side of cardboard halo with glue. With edges aligned, glue 1 brown bag halo piece to cardboard halo. Repeat on remaining side of halo. Let dry. Using squeegee, coat 1 side of cardboard wings piece with glue. Cover with brown bag wings piece. Wrap excess to back, clipping curves, and glue in place.

3. To create imprinted circle design, brush layer of fabric stiffener on front of halo and wings pieces. Let dry approximately 10 minutes until partially set. Press cap of pen and cap of soft-drink bottle into glue as desired to create circles (see photo). Let dry. Spray halo and wings with antiquing spray. While still wet, gently wipe off some of antiquing spray with soft cloth. Let dry.

4. If soft-drink bottle has a separate plastic base, remove base and discard. Cut off bottom 1½" of soft-drink bottle. For added support, turn cut-off portion of bottle upside down and insert in bottom of bottle. Cut 9" x 11½" piece from brown bag. Coat soft-drink bottle with glue. Wrap brown bag piece around bottle, overlapping ends and positioning bag so 1 (11") edge aligns with top of bottle and approximately 1" of opposite edge extends beyond bottom cut edge of bottle. Gather and crimp top of bag so that it conforms to top of bottle. Wrap bottom edge to inside of bottle and glue in place. Let dry. Imprint with circle design and antique as in Step 3. Let dry.

5. Coat Styrofoam ball with glue. Cover ball with piece of brown bag, using additional glue as necessary to hold. Let dry. Cut 8" x 10" piece of brown bag. Spray covered ball and 8" x 10" piece of brown bag with antiquing spray. While still wet, gently wipe off some of antiquing spray with soft cloth. Let dry.

Referring to photo, cut cheeks, eyes, nose, and mouth from 8" x 10" antiqued brown bag piece. Glue pieces to ball to make face. For hair, from remainder of 8" x 10" antiqued brown bag piece, cut 1½" x 2" pieces. For each piece, fringe 1 (2")

edge as if making eyelashes. Wrap fringe around pencil to curl. Referring to photo, glue straight edge of fringed strips to head, overlapping strips so that curls intertwine. Let dry. Glue halo to top of head. Let dry. Glue head to top of bottle. Let dry.

6. Cut 8½" x 11" piece of brown bag. Fold in half, with short edges together. Fold in half again, with short edges together. Transfer sleeve pattern to folded bag and cut out. (Do not cut along folded edges.) Unfold sleeve piece. Using squeegee, coat inside of sleeve piece with glue. Center florist's wire length along long center fold. Refold sleeves along long center fold, keeping wire sandwiched between layers. While glue is still somewhat wet, bend sleeves around top of bottle to shape (see photo). Remove from bottle and let dry. Referring to Step 3, imprint outside of sleeves with circle design. Let dry.

7. Transfer pattern to brown bag and cut 4 hands. With edges aligned, glue 2 hands together just below 1 sleeve, sandwiching wire between hand pieces. Repeat to glue remaining hand pieces below opposite sleeve. Let dry. Spray entire arms piece with antiquing spray. While still wet, gently wipe off some of antiquing spray with soft cloth. Let dry. Referring to photo, glue arms piece to top of bottle. Let dry. Bend wires extending beyond hands so that they curve and overlap. (Insert clay pot to make sure it does not slip through. Tighten wire if necessary.) Wrap and glue scrap of antiqued brown bag over exposed wire to cover. Let dry.

Dip jute twine in fabric stiffener. Tie in bow and lay flat on waxed paper. Make loop in each streamer. Let dry. Glue stiffened jute bow to center of wire extending from hands (see photo). Let dry.

8. Referring to photo, glue wings to back of angel. Let dry. Glue heart button to front of neck. Let dry. Using imprinting and antiquing techniques described in Step 3, imprint rim of clay pot with swirls, using pencil to make design. Then antique entire pot. Let dry. Brush coat of varnish over entire angel and pot to seal. Place tea light candle in pot. Place pot in angel's arms.

Place on fold.

Place on fold.

Sleeve

Hand

My Little Angel Frame

This sweet frame would please any new parents. The pastel colors accent the softness of a nursery.

Materials

Wooden shapes: ¾"-wide round beads; 1½"-wide, 1"-wide, and ⅝"-wide hearts; ¾"-wide stars
Small saw
Cardboard scrap
Aleene's Tacky Glue™
Aleene's Fine-Line Syringe™ Glue Applicator *
Flat wooden frame
Flat white spray paint
Paintbrushes with firm bristles
Pastel chalk in variety of colors
Ultra fine-tip permanent black marker
Clear matte spray sealer
* If desired, wrap transparent tape around tip of glue bottle to make fine line tip instead of using syringe. See page 138 of Crafting Tips and Techniques to make tape nozzle.

Directions

1. To make heads, saw wooden beads in half, positioning beads so that hole is at top and bottom of each head. Transfer wings pattern to cardboard and cut number equal to number of heads.

2. To emboss shapes, referring to photo for inspiration, use syringe to apply glue designs to 1 side of each wooden and cardboard shape. Let dry.

3. Referring to photo for inspiration, glue shapes randomly on front of frame. Let dry. Emboss small star and dot accents on blank areas of frame, using glue and syringe. Let dry. Spray-paint frame and shapes white. Let dry.

4. Referring to photo for inspiration, press bristles of paintbrushes into pastel chalk and then press chalk onto frame. Use black marker to draw faces on angels. Spray entire frame with spray sealer. Let dry.

Wings

While this frame may look challenging, it is actually quite easy to make. Simply glue on purchased wooden shapes, add texture by embossing with glue, and then color with pastel chalk.

103

Glorious Garden Angel

Angels must love gardens—they're little patches of heaven on earth. Celebrate both your appreciation of angels and your love of flowers with this clay-pot cutie.

Materials

Wooden beads: 1 (2"-diameter),
 3 (1"-diameter)
Aleene's Premium-Coat™ Acrylic
 Paints: flesh color, Medium Fuchsia,
 Black
Paintbrushes: small, fine-line
Aleene's Designer Tacky Glue™
Variety of Aleene's Botanical Preserved
 Flowers & Foliage™
Miniature dried rosebuds
Moss
Clay pots: 1¾"-diameter, 2½"-
 diameter, 3½"-diameter
20" length of cording
2 sticks, approximately 3" long and
 ¼"-diameter
Aleene's Satin Sheen Twisted Ribbon™:
 ivory
Approximately 20 (12") twigs

Directions

1. For head, paint 2" wooden bead with flesh color. Let dry. Referring to photo, paint cheeks with Medium Fuchsia. Dip end of 1 paintbrush in Black and dot on eyes. Using fine-line paintbrush and Black, paint eyelashes, eyebrows, nose, and mouth and outline cheeks. Let dry. Glue dried flowers to head for hair. Glue rosebuds in ring around head for halo. Let dry.

2. Glue moss around rim of each pot. Glue dried flowers on top of moss. Let dry.

3. Tie knot in 1 end of cording. Referring to **Diagram A,** thread 1 (1") wooden bead onto cording, sliding it down until it rests against knot. (Make sure knot is larger than hole in bead.) Thread 1¾" pot upside down onto cording. Tie knot in cording approximately 1½" above pot. Thread another 1" wooden bead onto cording, sliding it down until it rests against knot. Continue as above until all pots have been threaded onto cording. Thread 2" bead head onto cording. Tie knot at top of head. For hanger, loop remaining cording and securely tie free end around knot above bead.

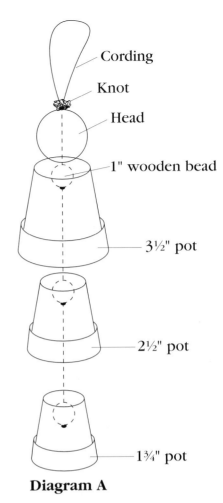

Diagram A

4. For arms, referring to photo, glue sticks in place on 3½" pot. Glue dried flowers in hands. Let dry. Tear length of Satin Sheen Ribbon into narrow lengthwise strips. Handling several strips as 1, tie bow and glue in place at neck. Let dry. For wings, bend twig lengths in half to form loops. Referring to **Diagram B,** divide twigs in half and lash halves together with piece of Satin Sheen Ribbon. Glue wings to back top of 3½" pot. Let dry.

Diagram B

105

Antiqued Angel Pin

For just pennies you can create this stylish
pin painted to resemble the muted
shade of aged copper.

Materials

Aleene's Opake Shrink-It™ Plastic
Fine-grade sandpaper
¼"-diameter hole punch
Aleene's Baking Board or nonstick
 cookie sheet, sprinkled with baby
 powder
Aleene's Tacky Glue™
Antique gold spray paint
Ultra fine-tip permanent black marker
⅜" gold star charm
Gold metallic thread: 3" length, 6"
 length
Transparent tape
Pin back

Directions

Note: See page 143 of Crafting Tips and
Techniques for more information on work-
ing with Shrink-It.

1. Sand 1 side of Shrink-It so that paint will
adhere. Be sure to thoroughly sand both
vertically and horizontally. Transfer hair,
body, arm, and wing patterns to Shrink-It
and cut out. Punch out 23 holes from
Shrink-It. Preheat toaster oven or conven-
tional oven to 275° to 300°. Place angel
pieces and punched-out holes on room-
temperature baking board and bake in
oven. Edges should begin to curl within 25

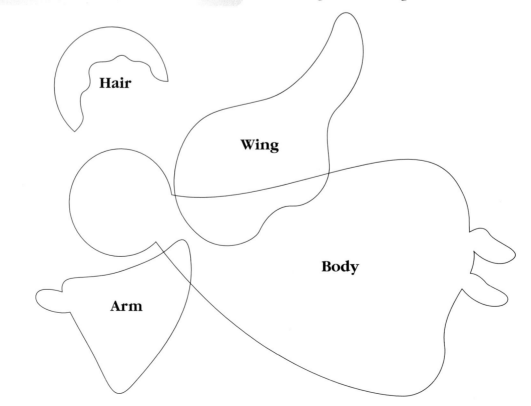

Hair

Wing

Body

Arm

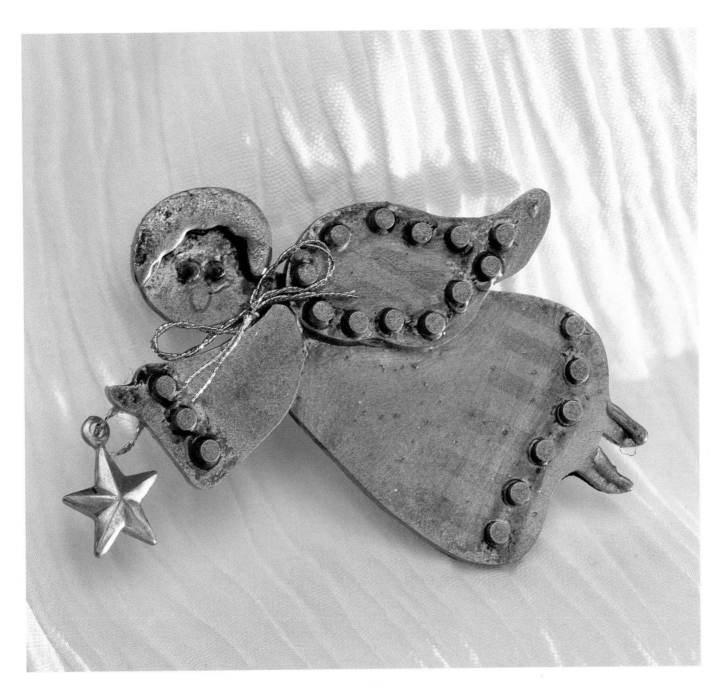

seconds; if not, increase temperature slightly. If edges begin to curl as soon as designs are put in oven, reduce temperature. After about 1 minute, designs will lie flat. Remove from oven. Let cool.

2. Referring to photo, glue wing, arm, and hair in place on body. Glue shrunken holes around wing, along hem of dress, along edge of sleeve, and to face for eyes (see photo). Let dry. Referring to photo, use glue to make embossed shoes. Let dry. Spray-paint angel with gold. Let dry. Using black marker, draw mouth.

3. Thread charm onto 3" length of gold thread. Tape thread to back of angel's hand (see photo). Trim ends of thread. Tie remaining thread in bow. Glue bow to neck of angel. Glue pin back to back of angel. Let dry.

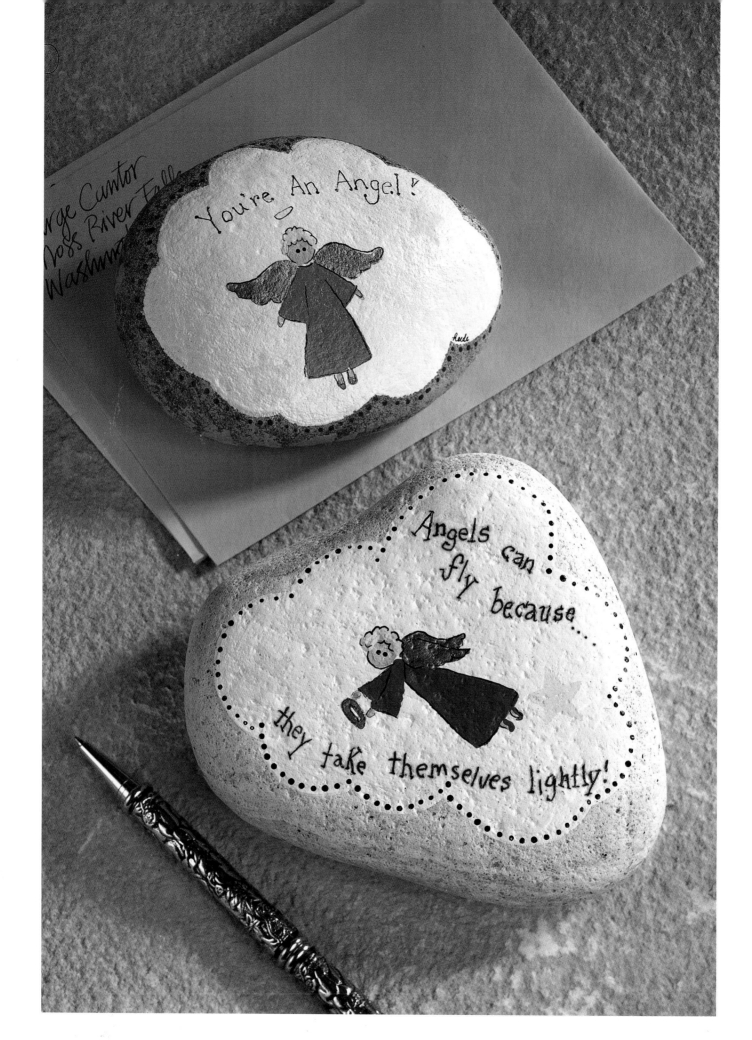

Painted Paperweights

Add a heavy hint of humor to a cluttered desktop with one of these playful paperweights.

Materials

For each: 1 smooth, flat garden rock, approximately 5"-wide
Ultra fine-tip permanent black marker
Aleene's Premium-Coat™ Acrylic Paints: White, True Yellow, flesh color, hair color, Gold, Black
Fine-tip paintbrush
For Angels Can Fly paperweight: Aleene's Premium-Coat™ Acrylic Paint: True Violet
For You're an Angel paperweight: Pop-up craft sponge
Aleene's Premium-Coat™ Acrylic Paints: Light Blue, Medium Fuchsia

Directions

Note: See pages 139 and 141 of Crafting Tips and Techniques for more information on transferring patterns and sponge painting.

1. For Angels Can Fly paperweight, using black marker, transfer pattern to top of rock. (Let shape of rock be your guide for drawing cloud.) Referring to photo and letting dry between colors, paint cloud with White; stars with True Yellow; face, hands, and feet with flesh color; hair with hair color; dress and shoes with True Violet; and wings and halo with Gold. Dip end of paintbrush in Black and dot along inside edge of cloud. In same manner, dot on eyes. Let dry. Using black marker, write phrase around angel.

2. For You're an Angel paperweight, using black marker, draw cloud and stars on rock. (Let shape of rock be your guide for drawing cloud.) Transfer angel pattern on page 115 to rock. Lightly sponge-paint around cloud with Light Blue. Paint design as for Angels Can Fly paperweight, using Medium Fuchsia for dress and shoes and drawing halo with black marker. Let dry. Using black marker, write phrase around angel.

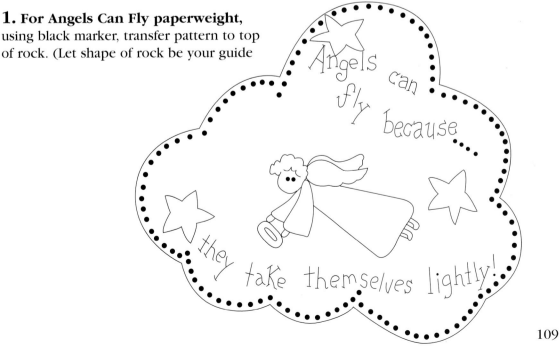

Angels can fly because they take themselves lightly!

Divine Doorstop

Transform an ordinary soda bottle into a chubby cherub doorstop.

Materials

Clean, empty 1-liter plastic soft-drink bottle with cap
Sand or small rocks
3"-diameter Styrofoam ball
Craft knife
Fabrics: 1 (14" x 15") piece and 2 (6½" x 9½") pieces burgundy plaid, yellow plaid scraps, 1 (4½" x 12") piece green gingham
Aleene's Designer Tacky Glue™
Needle
Threads: black, gold metallic, ivory
2 (6") chenille stems
12" x 14" piece natural cotton batting for hands and wings
Burgundy embroidery floss
Aleene's Fusible Web™
12" length 2"-wide crocheted lace
Ribbons: 1 (7") length ¼"-wide ecru satin, 1 (12") length ¼"-wide gold metallic
Buttons: 1 (⅞") gold metallic star, 2 (⅜") black shank
Panty hose
Black felt scrap
Powder blusher
Doll hair
4" x 12" piece thin cardboard
Embroidery needle
2 extralong straight pins

Directions

Note: See page 140 of Crafting Tips and Techniques for more information on working with fusible web.

1. Remove bottle cap and fill bottle with sand or rocks. Place cap on 3" Styrofoam ball and cut around cap, using craft knife. Make hole deep enough for bottle cap to fit inside ball. Set ball aside for later use. Replace bottle cap and tighten.

2. Fold under ½" of 1 (14") edge of 14" x 15" burgundy plaid piece and glue in place. Let dry. With wrong sides facing and hemmed edge on top, overlap short ends of fabric piece and glue together. Let dry. Run gathering stitches by hand along top and bottom raw edges of fabric cylinder. Slip fabric cylinder over bottle, aligning top edge of fabric with neck of bottle, just below cap. Pull top threads to gather fabric tightly around neck of bottle. Tie off. To secure, glue top gathered edge to neck of bottle. Let dry. Pull bottom threads to tightly gather bottom edge of fabric. Tie off. Glue gathers to bottom of bottle. Let dry.

3. For 1 sleeve, fold 1 long edge of 1 (6½" x 9½") burgundy plaid piece under ½". Glue in place. Let dry. With wrong sides facing, overlap short ends of fabric piece and glue together. Let dry. Run

Felt is a good alternative to use for the wings and the hands if you do not have a scrap supply of natural cotton batting.

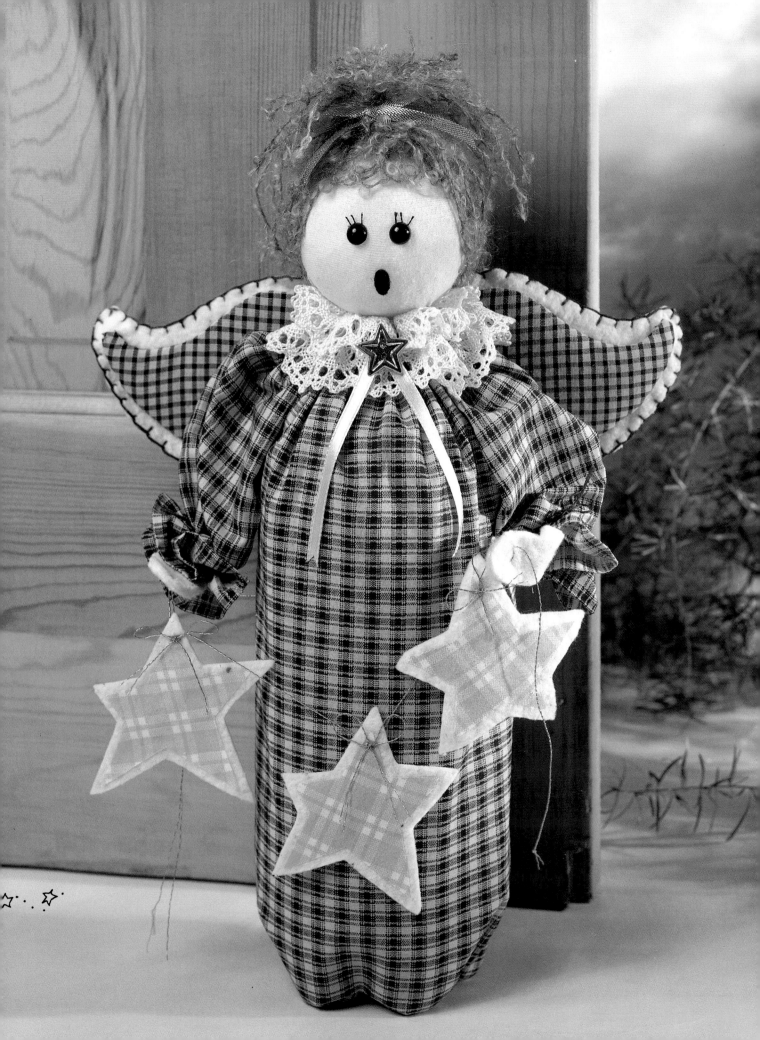

gathering stitches by hand along top raw edge of fabric cylinder. Insert chenille stem in fabric cylinder, positioning so that 1 end of chenille stem aligns with top raw edge of fabric. Pull threads to gather top edge of sleeve tightly around chenille stem. Tie off. Set aside. Repeat for remaining sleeve.

4. For 1 hand, transfer pattern to batting and cut 2 hands. Apply glue to 1 side of 1 hand. Referring to **Diagram,** sandwich 1" of free end of 1 chenille stem between hands and, aligning edges, glue hand pieces together. Let dry. Repeat for remaining hand. Glue gathered end of 1 sleeve to each side of body at top of bottle (see photo). Let dry. Referring to photo, tie length of burgundy embroidery floss around each sleeve, just above hand piece.

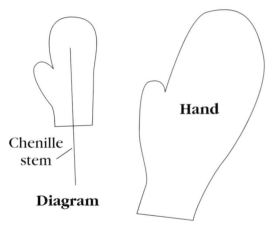

Chenille stem

Hand

Diagram

5. For garland, fuse web to back of yellow plaid scraps. Transfer patterns and cut 3 small stars from yellow plaid and 3 large stars from batting. Center and fuse 1 small star on each large star. Thread regular needle with 20" length of gold metallic thread. Run needle through 1 hand, leaving 5"

thread tail. Run needle through point of 1 star. Leaving 3" of thread between stars, run needle through point of second star. Repeat to thread last star. Run needle through remaining hand, leaving remainder of thread as tail. Cut 3 (6") lengths of gold metallic thread. Tie each length in bow. Referring to photo, glue 1 bow to top point of each star. Let dry.

6. Run gathering stitches by hand along lace, 1" from 1 long edge. Fold lace along gathering stitches. Place lace around neck of bottle; pull threads to gather snugly around bottle. Tie off. Referring to photo, fold ecru ribbon in half and glue gold star button to fold. Let dry. Glue ribbon and button to center front of lace. Let dry.

7. For head, cut 1 (4") length from toe of panty hose. Pull 4" length of panty hose tightly over Styrofoam ball. Glue raw edges of panty hose to inside of hole in ball. Let dry. From black felt, cut 1 small oval for mouth. To make eyelashes, cut 6 (¼") lengths of black thread. Glue 3 lengths to back of each black shank button. Let dry. Referring to photo, glue mouth and eyes in place on Styrofoam head. Let dry. Apply blusher to cheeks. Referring to photo, glue hair in place. Let dry. Gather hair in ponytail on top of head. Tie gold ribbon in bow around ponytail.

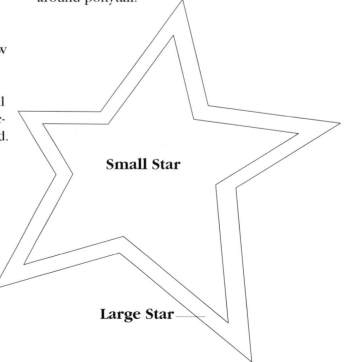

Small Star

Large Star

8. For wings, transfer pattern and cut 1 inner wings each from cardboard and batting. Transfer outer wings pattern to green gingham and cut 1. Coat 1 side of cardboard wings with glue. With edges aligned, press batting wings onto glue-covered side of cardboard wings. Let dry. Center batting-covered wings facedown on wrong side of fabric wings. Fold excess fabric to back of cardboard and glue. Let dry. Transfer outer wings pattern to batting and cut 1. Using burgundy embroidery floss and embroidery needle, blanket-stitch along edge of outer wings. Center fabric-covered wings on batting wings and glue. Let dry. Referring to photo, center wings on top back of angel and glue. Use straight pins to hold wings in place until dry.

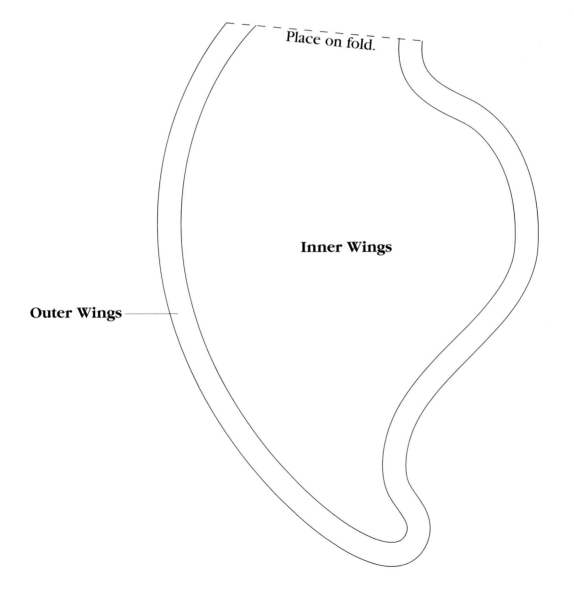

Place on fold.

Inner Wings

Outer Wings

Angelic Accessories

Entertain young ladies at a birthday celebration by helping them to create angelic jewelry. They will love making their very own party favors to remember the event.

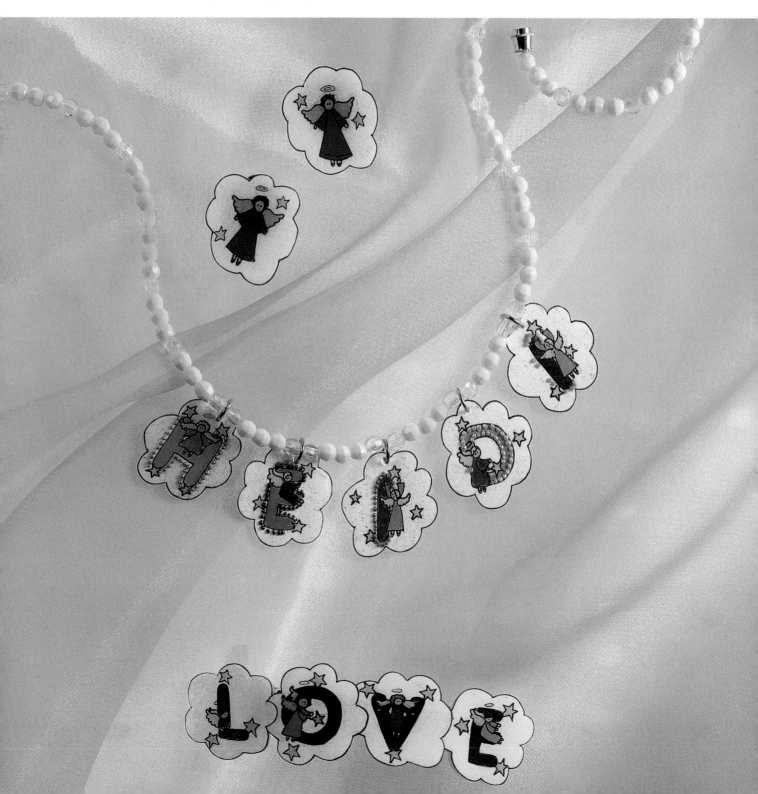

Materials

For each: Aleene's Opake Shrink-It™ Plastic
Fine-grade sandpaper
Ultra fine-tip permanent black marker
Colored pencils
Aleene's Baking Board or nonstick cookie sheet, sprinkled with baby powder
For barrette: Aleene's Designer Tacky Glue™
French-clasp barrette
For necklace: Pearlized dimensional craft paint in desired colors
⅛"-diameter hole punch
Aleene's OK to Wash-It™ Glue
Paintbrush
Iridescent glitter
Needlenose pliers
Jump rings
4-mm faceted beads: white, clear
Fishing line
Barrel clasp
For earrings: Aleene's Designer Tacky Glue™
2 clip earring backs

Directions

Note: See page 143 of Crafting Tips and Techniques for more information on working with Shrink-It.

1. For each angel design, sand 1 side of Shrink-It so that markings will adhere. Be sure to thoroughly sand horizontally and vertically. Using black marker, trace pattern on sanded side of Shrink-It. (Marker ink may run on sanded surface; runs will shrink and disappear during baking.)

For barrette, be sure to trace patterns so that cloud areas overlap and there is no space between designs.

Use colored pencils to color each design. (Remember that colors will be more intense after shrinking.) Cut out designs.

For necklace, outline letters with dots of dimensional craft paint in desired colors. Let dry. Punch 1 hole in top of each design used for necklace.

2. Preheat toaster oven or conventional oven to 275° to 300°. Place designs on room-temperature baking board and bake in oven. Edges should begin to curl within 25 seconds; if not, increase temperature slightly. If edges begin to curl as soon as designs are put in oven, reduce temperature. After about 1 minute, designs will lie flat. Remove designs from oven. Let cool.

3. For barrette, glue barrette to back of joined designs. Let dry.

4. For necklace, paint thin coat of OK to Wash-It Glue on cloud area of each design. Lightly sprinkle iridescent glitter onto glue while still wet. Shake off excess glitter. Let dry. Using needlenose pliers, attach 1 jump ring to each design. Referring to photo for beading sequence, thread beads and designs onto length of fishing line. Attach barrel clasp to ends of fishing line.

5. For earrings, glue 1 earring back to back of each design. Let dry.

Earring Pattern

Roses-and-Lace Angel Ornament

This dainty angel with her bread dough rose garland, is as delicate as a wisp of gossamer. She will add a touch of sweetness and light to the branches of your Christmas tree.

Materials

33" length 6"-wide ivory tulle
4½" length 26-gauge florist's wire
Aleene's Tacky Glue™
Porcelain doll bust
Ivory lace: 1 (6½" x 26") piece, 2 (2" x 3½") pieces, 2 (3½" x 5") pieces
Needle and thread
2 (3") lengths chenille stem
2 porcelain doll hands
10" length gold cording
Stretchable ribbons: 24" length 2½"-wide gold, 12" length ½"-wide white
⅛"-wide satin ribbons: sage, pink
1 slice white bread
Plastic cup
Wooden craft stick
Aleene's Premium-Coat™ Acrylic Paints: Medium Fuchsia, Dusty Sage
Zip-top plastic bag
Straight pin

Directions

1. To make tulle petticoat, fold 1 long edge of tulle under 2". Thread and gather folded edge of tulle onto length of florist's wire, holding 1 end of wire so that tulle does not slide off. Bend wire around and twist ends together so that tulle is tightly bunched. Bend wire ends down to form loop. Coat wire loop with glue. Slip wire loop and folded edge of tulle into opening in bottom of doll bust. Let dry.

2. For dress, fold 6½" x 26" lace piece so that short ends overlap. Glue short ends together. Let dry. Run gathering stitches by hand along 1 open end of lace. Slip lace cylinder over doll head and pull threads to gather lace around neck of doll head. Glue gathers to neck of doll head. Let dry.

3. For 1 arm, roll 1 (2" x 3½") lace piece into tube ¾" in diameter and 2" long. Insert 1 chenille stem into lace tube. Coat end of chenille stem extending from bottom of lace tube with glue. Insert glue-covered end of chenille stem into hole in base of 1 doll hand. Position lace tube so that bottom edge touches wrist of doll hand. Glue top edge of lace tube to chenille stem. (Approximately 1" of chenille stem should extend beyond top edge of lace tube.) Let dry. Repeat for remaining arm. Set arms aside.

4. For sleeves (arms will be covered with 2 layers of lace), fold each 3½" x 5" lace piece so that short ends overlap. Glue short ends together. Let dry. Run gathering stitches by hand along 1 open end of each lace cylinder. Insert 1 chenille stem arm into each lace cylinder. Align free end of each

For a quick-finish garland, substitute ribbon rosettes for the bread dough roses.

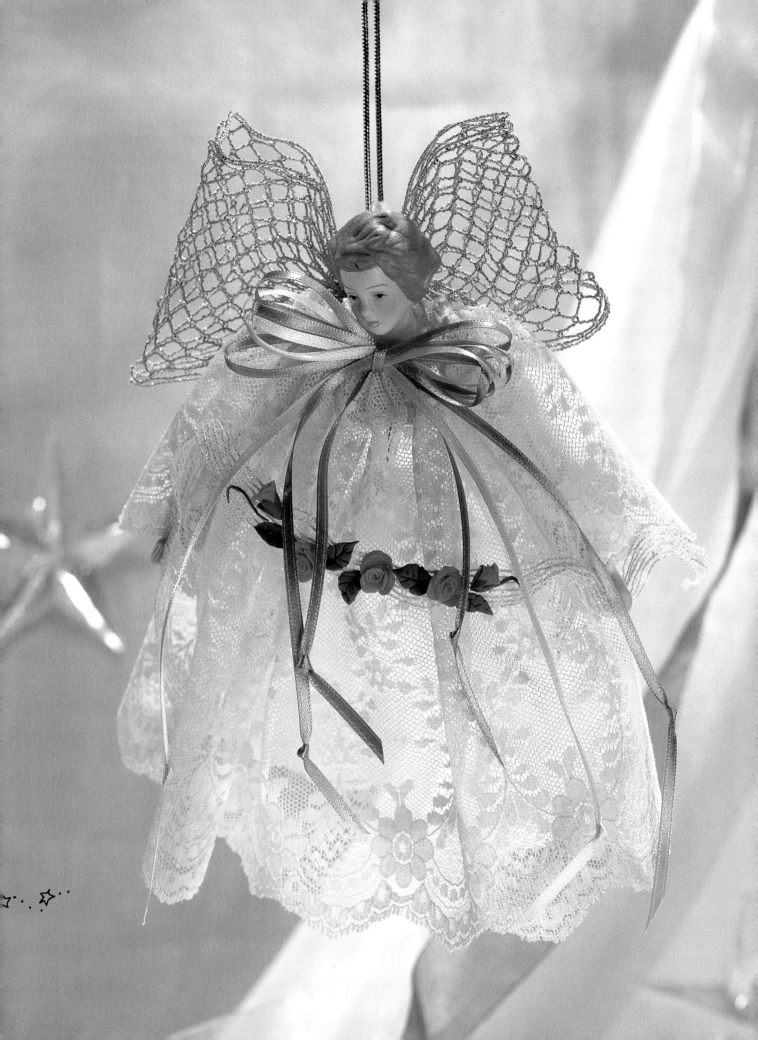

chenille stem with top edge of lace. Pull threads to gather lace tightly around chenille stems. Referring to photo, glue gathered edge of each sleeve to neck of dress. Let dry.

5. For hanger, fold gold cording in half to form loop. Glue ends of cording loop to back neck of dress. For wings, tie 2½"-wide gold stretchable ribbon in bow. Glue bow on top of gold cording ends. Let dry. Handling all lengths as 1, tie satin ribbon lengths in bow. Glue bow to front neck of dress. Let dry.

6. For bread dough roses, tear bread into small pieces and put in plastic cup. Add 1 tablespoon of Tacky Glue and mix with craft stick until coarse ball forms. Remove ball of dough from cup. With clean hands, knead dough until smooth, pliable, and claylike in consistency. Divide dough in half. Flatten 1 dough ball in hand and make small well in center. Pour small amount of Medium Fuchsia into well. Knead dough in your hands until paint is thoroughly incorporated. In same manner, color remaining dough ball, using Dusty Sage. (Store bread dough in zip-top plastic bag when not in use.)

7. To make each rose, pinch off pea-sized bit of Medium Fuchsia dough. Squeeze between fingers to flatten into small round piece the thickness of paper. For center of rose, roll flattened piece, turning top edge back slightly to look as if rose were just beginning to unfurl. Pinch off another pea-sized piece of dough and flatten as before. Press top edge back slightly to make petal. Wrap petal around center, gently pressing together at bottom. Make next petal and place opposite first petal; press together at bottom.

Continue in same manner to add total of 10 petals, overlapping edges slightly and placing subsequent petals higher on rose so that turned-back edges are even with rose center. Cut off bottom of rose before it dries completely. Let dry. Repeat to make 3 roses. Then make 2 rosebuds, using only 3 petals per bud.

8. To make each leaf, pinch off pea-sized piece of Dusty Sage dough and mold into teardrop shape. Flatten teardrop so that it is a bit thicker than paper. Using straight pin, make indentions in top of leaf for veins. Curl leaf as desired. Let dry. Repeat to make as many leaves as desired. (For leaves around rosebuds, make smaller versions of leaves above and do not add veins. Press small leaves around base of each rosebud.) For tendrils, roll very small pieces of Dusty Sage bread dough into 2 thin, snakelike shape. Curl shapes as shown in photo. Let dry.

9. Referring to photo, glue roses, leaves, and tendrils to center of ½"-wide stretchable white ribbon. Glue ends of ribbon in angel's hands. Let dry.

Angel Baby Birth Announcement

Celebrate the arrival of one of God's little miracles with this colorful birth announcement. The framed image is painted in reverse on glass.

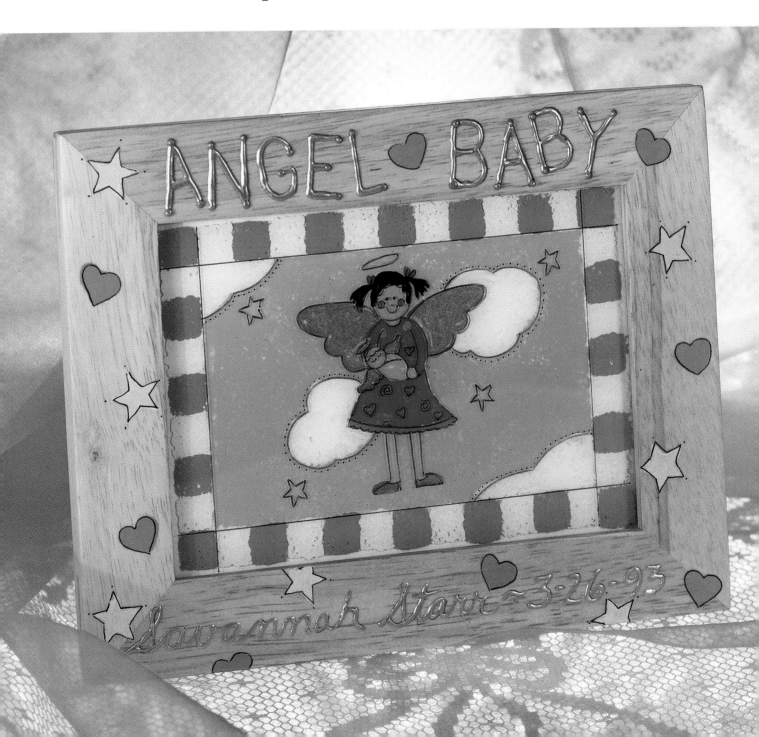

Materials

5" x 7" frame with glass
Ultra fine-tip permanent black marker
Aleene's Premium-Coat™ Acrylic
 Paints: Medium Fuchsia, True
 Turquoise, Gold, True Yellow, Light
 Fuchsia, hair color, flesh color,
 White, Light Blue
Fine-line round paintbrush
Pop-up craft sponge
Pearlized dimensional paints: laven-
 der, bright pink
Fun Foam scraps
2 (1") squares foam-core board or 2
 pencils with erasers
Aleene's Tacky Glue
Waxed paper
5" x 7" piece white paper

Directions

Note: See page 141 of Crafting Tips and
Techniques for more information on
sponge painting.

1. Place glass from frame on top of pat-
tern, aligning edges of glass with outside
line of pattern. Using black marker, transfer
pattern to glass. Add dots around outline of
clouds. Referring to photo for colors, paint
angel and baby angel, letting dry between
colors. Paint clouds with White. Let dry.
Paint stars with True Yellow. Let dry.
Sponge-paint background around angel
with Light Blue. Let dry.

2. Cut ½" square from sponge. Beginning
in upper right corner of center design,
sponge-paint Medium Fuchsia square (see
photo). Skip ½" space and sponge-paint
another Medium Fuchsia square. Continue
in same manner, sponge-painting Medium
Fuchsia squares around center design. Let
dry. Wash sponge square thoroughly and
wring out excess water. Sponge-paint
White squares in between Medium Fuchsia
squares. Let dry.

3. Transfer "Angel Baby" to top of frame.
Using lavender dimensional paint, paint
over marked words; then write child's
name and date of birth on bottom of frame.
Let dry. Add dots to ends of each letter at
top of frame, using bright pink dimensional
paint. Let dry.

4. To make heart and star stamps, transfer
heart and star patterns to Fun Foam and
cut out. Glue 1 shape to center of each
foam-core square or glue 1 shape to each
pencil eraser. Let dry. Dip star stamp into
puddle of True Yellow. Stamp stars ran-
domly on front of frame, reloading stamp
with paint as necessary. Let dry. Dip heart
stamp into puddle of Medium Fuchsia.
Stamp hearts randomly on front of frame,
reloading stamp with paint as necessary.
Let dry. Outline hearts and stars with black
marker. Add dots around points of stars.

5. Turn frame over. Place glass, paint side
up, in frame. Layer piece of white paper on
top of back of glass. Assemble frame.

Heart

Star

ANGEL BABY

Pattern

Scrap Happy Angel Shirt

Fuse scraps of fabric in place to make the angels adorning the front of this shirt. Add dimension by gluing buttons between their hands and a mop of hair on each head.

Materials

Aleene's Fusible Web™
Scraps of 3 coordinating prints and
 flesh-colored cotton fabric for each
 angel
Purchased cotton T-shirt
Dimensional fabric paints: gold
 metallic, black
Ultra fine-tip permanent black marker
Aleene's OK to Wash-It™ Glue
Cotton string doll hair *
3 metallic star buttons
* See Sources on page 144.

Directions

Note: See page 140 of Crafting Tips and
Techniques for more information on work-
ing with fusible web.

1. Fuse web to wrong side of all fabrics.
For center angel, transfer patterns to paper side of fusible web and cut the fol-
lowing: From 1 cotton print, cut 2 (½" x
3⅞") strips, 2 (½" x 5⅞") strips, and 1 arms
piece. From second cotton print, cut 1
dress piece. From third cotton print, cut
wings. From flesh color, cut 1 head and 2
legs. Remove paper backings.

2. Locate center front of neck of shirt.
Measure down ¼" from center point and
mark. Center 1 (½" x 3⅞") strip at mark.
Fuse in place. Referring to photo and pat-
tern, fuse remaining ½"-wide strips in
place. Then fuse angel pieces in place.
Paint halo with gold dimensional paint. Let
dry. Paint eyes with black dimensional
paint. Let dry. Draw mouth with black
marker. Glue hair in place on head. Glue
star button in place on center front of arms.
Let dry.

3. Repeat steps 1 and 2 to make angels on
each side of center angel.

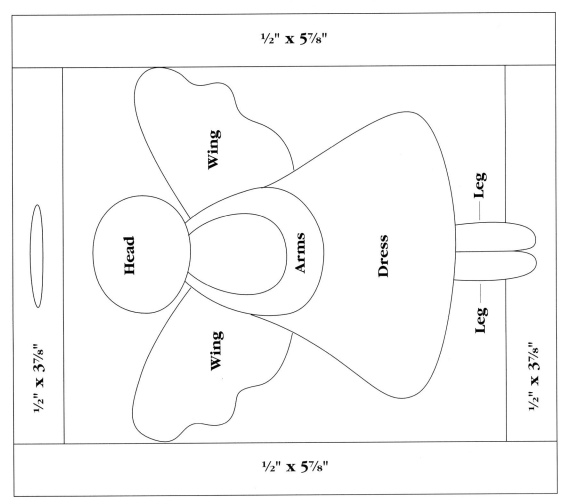

*M*easure of Kindness Ornaments

Show the measure of your affection for your favorite cook with these spoon angel ornaments.

Materials (for 3 ornaments)

Aleene's Fusible Web™
4½" square each of 3 different fabrics
Teaspoon, ½ teaspoon, and ¼ teaspoon from measuring spoon set
Aleene's Premium-Coat™ Acrylic Paints: flesh color, Light Fuchsia
Paintbrushes
Fine-tip permanent black marker
Aleene's Tacky Glue™
Doll hair in desired colors and textures
6" length ⅛"-wide satin ribbon
15" length gold cording
½" gold heart button
Ribbon rosette
Doilies: 1 (4"-wide) white heart, 1 (3"-wide) white heart, 1 (4"-diameter) gold round

Directions

Note: See page 140 of Crafting Tips and Techniques for more information on working with fusible web.

1. Fuse web to wrong side of each fabric square. Transfer pattern to paper side of each square and cut 1 dress from each. Remove paper.

2. For each angel, paint back of rounded area of spoon with flesh-colored paint. Let dry. Using black marker and referring to photo, draw facial details. Using Light Fuchsia, paint cheeks. Let dry. Glue doll hair in place at top of head. Let dry.

3. With back of spoon faceup, center and glue corresponding dress faceup on handle of each spoon. Let dry.

4. Tie length of satin ribbon in bow, trimming as necessary. Glue bow to teaspoon at top of dress, just below face. Cut 6" length of gold cording. Tie cording in bow, trimming as necessary. Glue cording to ¼ teaspoon at top of dress, just below face. Glue heart button to knot in cording bow. Glue ribbon rosette to ¼ teaspoon at top of dress, just below face. Let dry.

5. Turn spoons over. For wings, center and glue 4"-wide heart doily facedown on teaspoon handle, just below rounded area of spoon. Repeat to glue 3"-wide heart doily to ¼ teaspoon. Cut round doily in half. Referring to photo for placement, center and glue 1 doily half facedown on ½ teaspoon handle. Let dry. To shape wings, cut notch along top edge of doily.

6. For hangers, cut 3 (3") lengths from remaining gold cording. Fold 1 cording length in half. Glue cut ends to back of teaspoon angel in bowl of spoon. Cut small square from scrap of fabric used for dress. Glue fabric square over cut ends of cording. Let dry. Repeat to add hangers to ½ teaspoon and ¼ teaspoon.

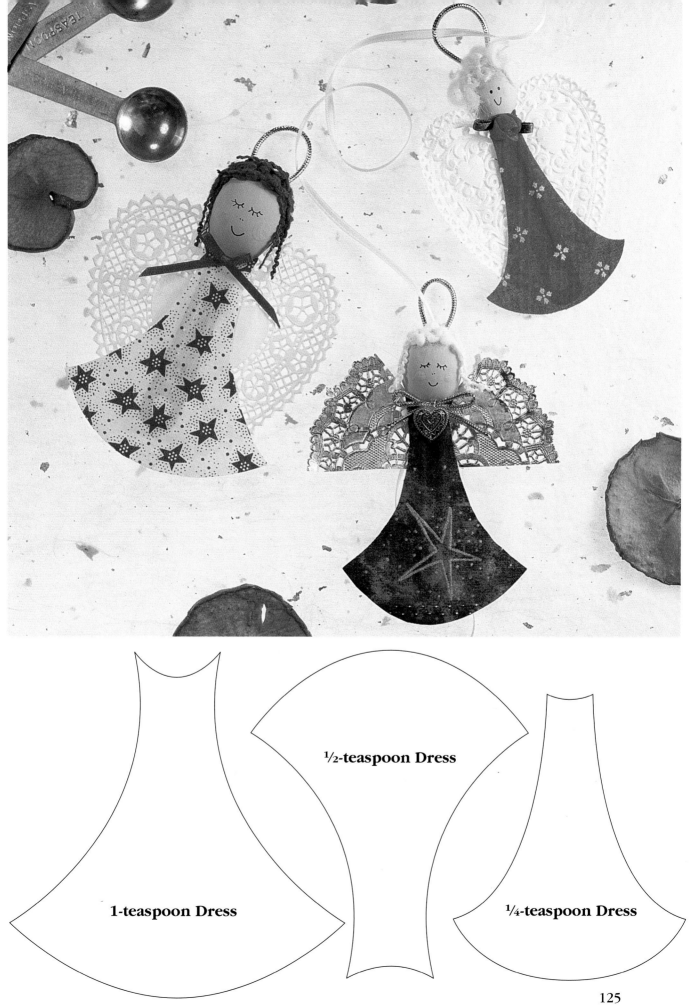

1-teaspoon Dress

½-teaspoon Dress

¼-teaspoon Dress

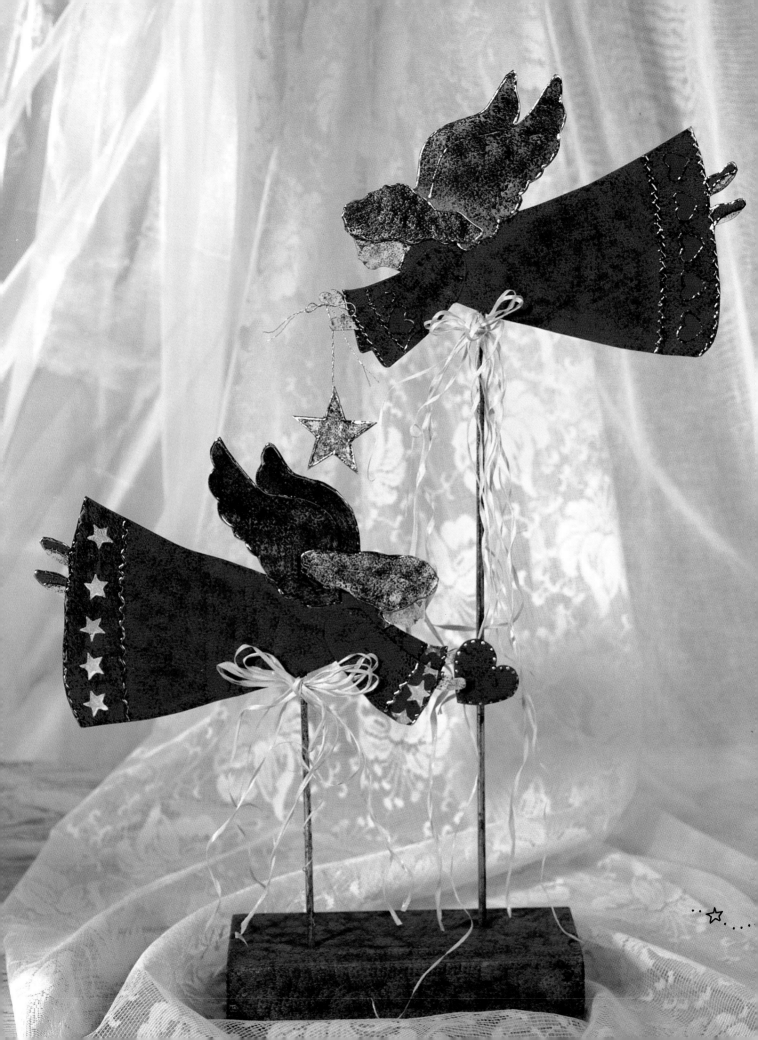

Sponge-Painted Seraphim

This tabletop decoration would make an elegant accent for a sideboard or an end table. Just drape soft fabric or stack a few jewel-toned Christmas balls around the base.

Materials

Brown grocery bags
3" square cardboard for squeegee
Aleene's Tacky Glue™
Small saw
³⁄₈"-diameter wooden dowel
Drill with ³⁄₈" bit
3¼" x 8½" x 1½" block wood
Aleene's Premium-Coat™ Acrylic
 Paints: Black, Medium Blue, Gold,
 True Fuchsia, True Violet, flesh color,
 hair color, Medium Yellow
Pop-up craft sponges
Ultra fine-tip permanent black marker
Aleene's 3-D Foiling™ Glue
Aleene's Gold Crafting Foil™
Pushpin
Gold metallic thread
Aleene's Satin Sheen Twisted Ribbon™:
 ivory

Directions

Note: See page 141 of Crafting Tips and Techniques for more information on sponge painting.

1. Cut 2 (11" x 17") pieces of brown bag. Using cardboard squeegee, apply 1 coat of Tacky Glue to 1 side of 1 brown bag piece.

If you desire, embellish the wooden block base by sponge-painting additional stars and hearts.

With edges aligned, press remaining brown bag piece into glue. Let dry. Transfer patterns to layered bag and cut 2 angels (see page 129), 2 hair, 4 arms, 1 large star, and 1 large heart. Use saw to cut 1 (11") length and 1 (18") length from dowel. Drill 1 hole in block of wood 2" from left side and 2¼" from top. Drill a second hole 2¼" from right side and 1¼" from top.

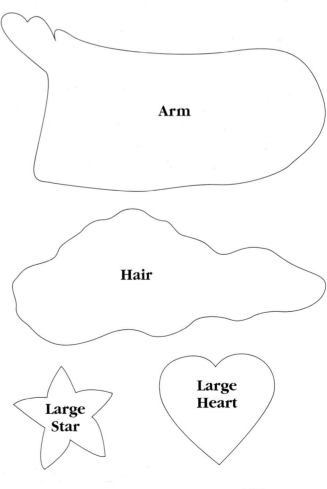

Arm

Hair

Large Star

Large Heart

2. Group brown bag pieces so that each group will make complete angel, 1 facing right and 1 facing left.

Sponge-paint front of each brown bag piece with Black. Let dry. Sponge-paint wooden block and dowel lengths with Black. Let dry. Then sponge-paint wooden block and dowel lengths with Medium Blue, making sure to leave some areas unpainted so that Black will show through. Sponge-paint dowel lengths with Gold, leaving some areas unpainted so that Black and Medium Blue will show through. Let dry. Referring to photo, sponge-paint front of each brown bag piece as follows, making sure to leave some areas of each unpainted so that Black will show through: angel dresses and sleeves with True Fuchsia and True Violet; faces, hands, and feet with flesh color; hair with hair color; wings with Gold; shoes with True Fuchsia or True Violet; star with Medium Yellow; and heart with True Fuchsia. Let dry.

3. Cut small heart and small star shapes from pop-up craft sponge. Referring to photo and using True Fuchsia, sponge-paint hearts along sleeves and bottom of dress of 1 angel; using Medium Yellow, sponge-paint stars along sleeves and bottom of dress of remaining angel. Let dry. Using black marker, draw eyes. Using True Fuchsia, paint cheeks and mouth. Let dry.

Small Star **Small Heart**

4. For each angel, use 3-D Foiling Glue to outline shoes, wings, hair, and neck of dress and to embellish dress (see photo). Outline star and add dots around edges of heart. Let glue dry for about 24 hours. (Glue will be opaque and sticky when dry. Glue must be thoroughly dry before foil is applied.) For each piece, lay foil dull side down on top of glue lines. Using finger, gently but firmly press foil onto glue, completely covering glue with foil. Be sure to press foil into crevices. Peel away foil paper. If any part of glue is not covered, reapply foil as needed.

5. Referring to photo and using Tacky Glue, glue hair and arms in place on each angel, sandwiching heart between hands of 1 angel and gluing in place. (One arm is glued to back of each angel, and 1 arm is glued to front of each angel.) Let dry. Using pushpin, poke hole in 1 point of star and in each hand of angel not holding heart. Thread length of gold thread through star. Thread ends of thread through holes in hands. Tie thread in bow.

6. Glue 1 angel to 1 end of each dowel length, using Tacky Glue. For added support, glue scrap of brown bag to back of each angel, covering dowel. Let dry. Cut 1 (20") length of Satin Sheen Ribbon. Untwist length, Tear ribbon into narrow lengthwise strips. Handling several narrow strips as 1, tie strips in bow at base of 1 angel. Repeat with remaining angel. Insert 1 dowel into each hole in wooden block.

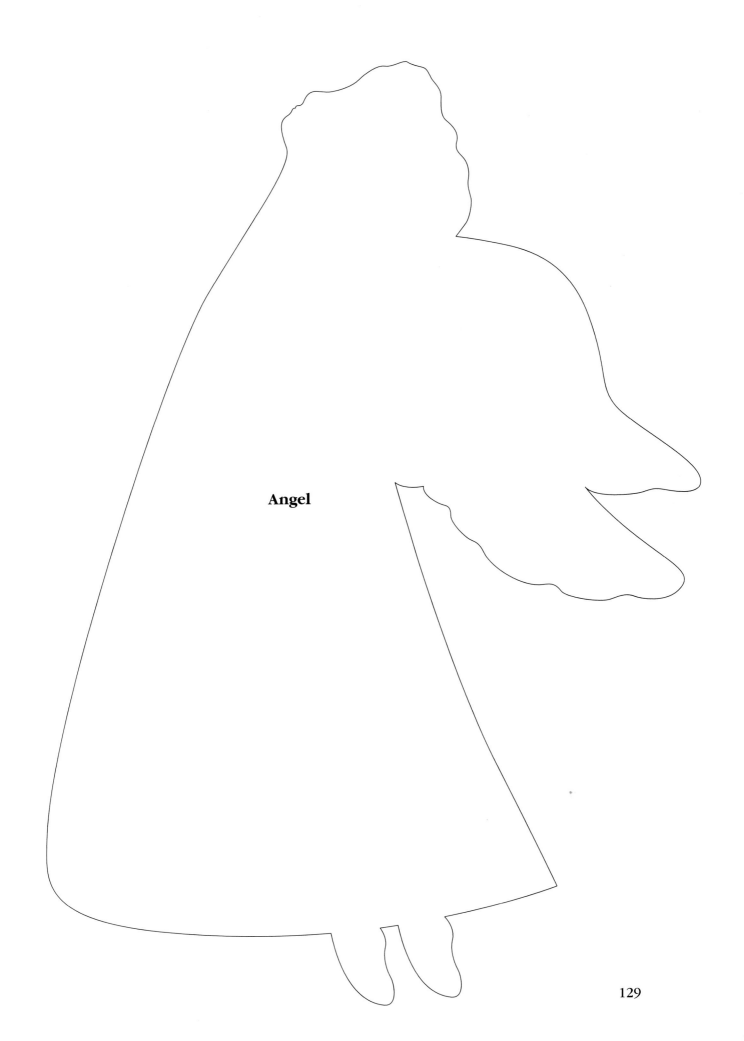

Angel

129

Garlands of Angels

Cut out one of these adorable angel garlands in a snip!
They're made from scraps of gift wrap.

Materials (for 1 garland)

Gift wrap
Craft knife

Directions

1. Cut 1 strip 5" wide by the desired length from gift wrap. Referring to **Diagram,** accordion-fold paper so that area between folds is 1⅞".

2. Transfer desired angel pattern to folded paper. Use scissors to cut along outline, making sure *not* to cut along fold lines. Use craft knife to cut paper from inside of halo. Unfold garland.

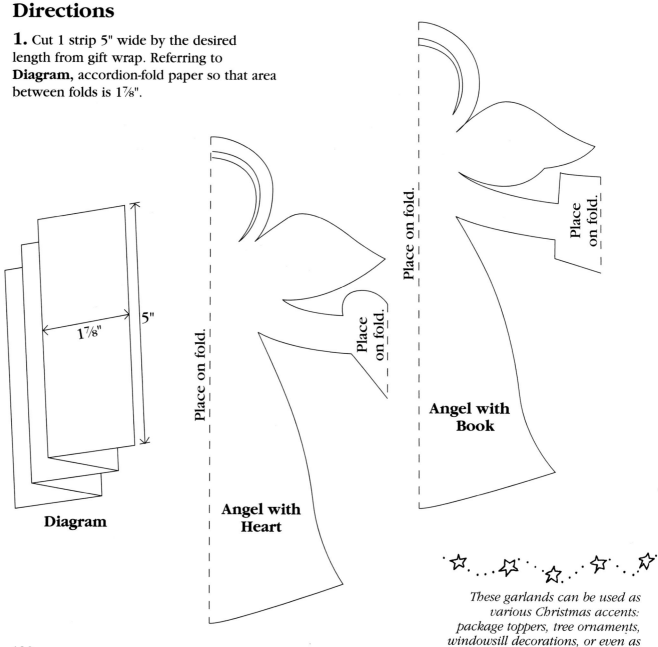

Diagram

Place on fold.

Angel with Heart

Place on fold.

Place on fold.

Place on fold.

Angel with Book

These garlands can be used as various Christmas accents: package toppers, tree ornaments, windowsill decorations, or even as table runners, just to name a few.

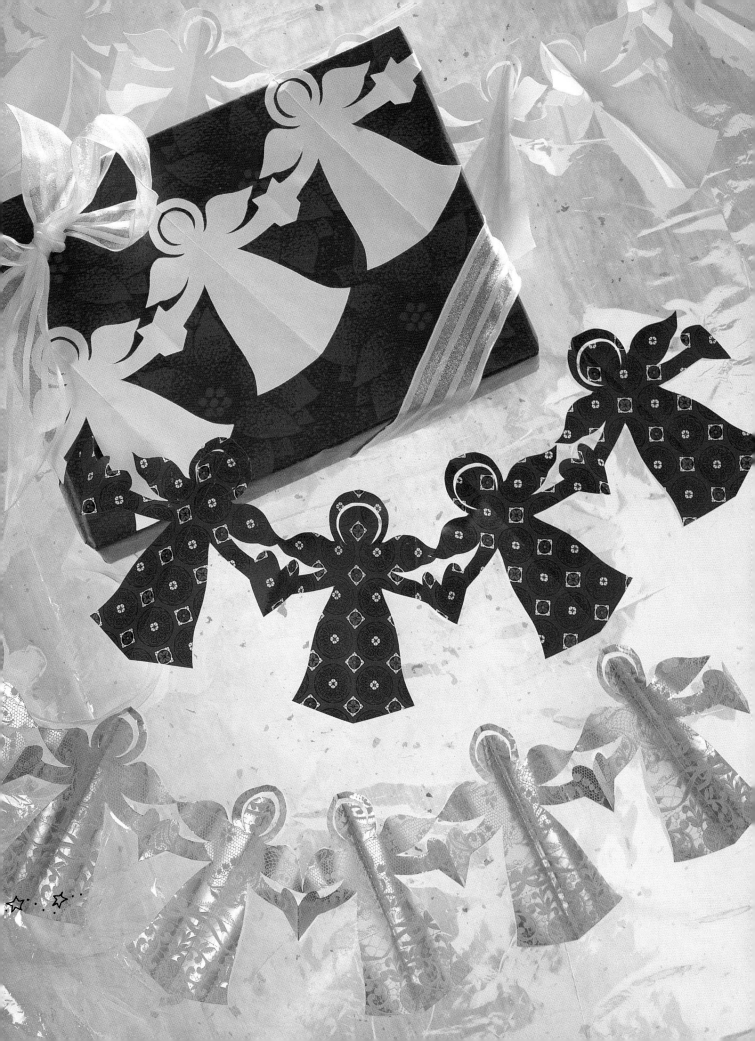

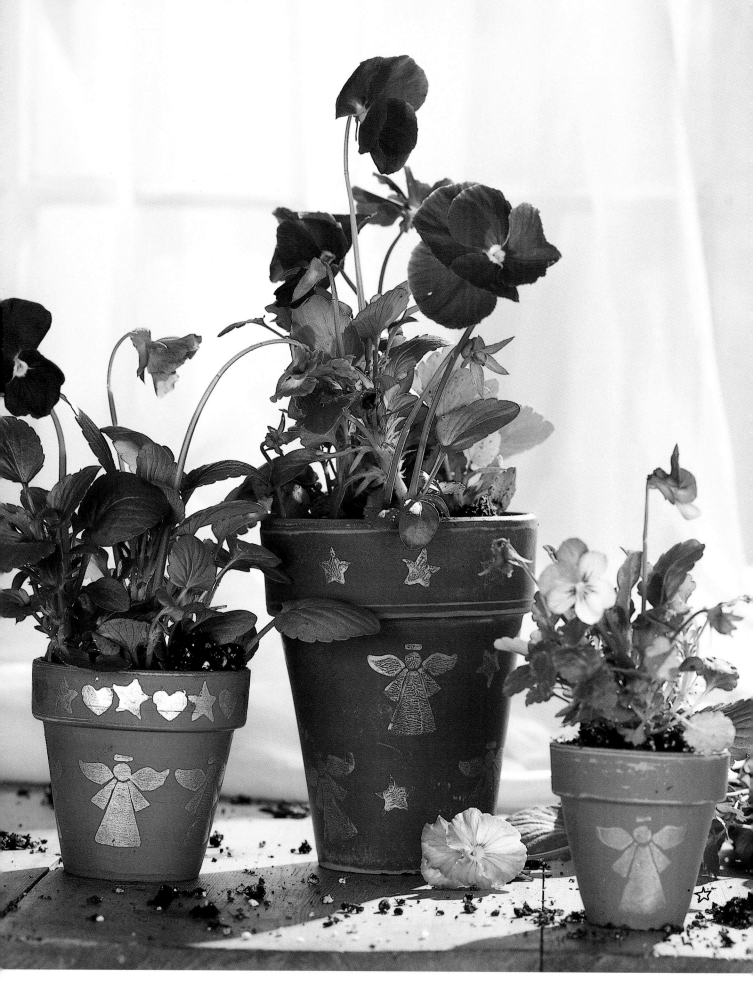

\mathcal{E}arth Angel Pots

A simple painting technique adds an earthy yet elegant touch to these plain clay pots.

Materials (for 3 pots)

Clay pots: 2½"-diameter, 3½"-diameter, 4½"-diameter
Aleene's Premium-Coat™ Acrylic Paints: Deep Beige, Deep Khaki, Deep Sage, Gold, Silver
Sponge brush
Fine-grade sandpaper
Paper towels
Fun Foam scraps
Foam-core board: 1 (2¼" x 3¼") piece, 2 (1") squares
Aleene's Designer Tacky Glue™
Clear matte spray sealer

Directions

1. Paint 2½" pot with Deep Beige and 3½" pot with Deep Khaki. Let dry. Lightly sand some paint off top and bottom of rim and off bottom edge of each pot. Paint 4½" pot Deep Sage. While paint is still wet, use paper towels to wipe some paint off various areas of pot so that clay shows through. Let dry. Lightly sand some paint off top and bottom of rim and off bottom edge.

2. To make angel stamp, transfer pattern to Fun Foam scraps and cut out. Center and glue foam pieces on 2¼" x 3¼" piece of foam-core board, leaving space between

pieces as indicated on pattern. Let dry. Cut 1 heart and 1 star from Fun Foam scraps. Center and glue 1 foam shape on each 1" square of foam-core board. Let dry.

3. Paint angel stamp with Gold. Referring to photo, position stamp on 2½" pot and press firmly, making sure all areas of stamp come in contact with pot. Let dry. Reapply Gold to angel stamp and randomly stamp angels on 4½" clay pot. Let dry. Paint star stamp with Gold. Randomly stamp stars around rim and on sides of 4½" clay pot. Let dry. Let paint on stamps dry. Paint angel stamp with Silver. Stamp angels around sides of 3½" pot. Let dry. Paint heart and star stamps with Silver. Alternately stamp hearts and stars around rim of 3½" pot (see photo). Let dry. Spray each pot with spray sealer. Let dry.

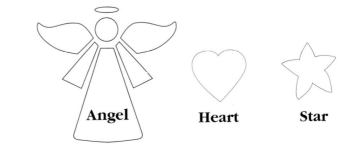

Angel **Heart** **Star**

Keep in mind that because clay pots are porous, your plants will dry out quicker than they would in plastic or ceramic pots.

Heavenly Heart Box

Make your Valentine's Day gift box as memorable as your valentine. Embellish an ordinary heart-shaped box with a decoupage print and a mixture of paints.

Materials

Heart-shaped papier-mâché box
Aleene's Premium-Coat™ Acrylic
 Paints: True Violet, Medium
 Lavender, True Fuchsia, Medium
 Fuchsia, White
Pop-up craft sponges
Waxed paper
Paper towel
Aleene's Decoupage Prints & Papers™:
 1 (9" x 12") *First Angel*
Aleene's Instant Decoupage Glue™
Aleene's 3-D Foiling Glue™
Aleene's Gold Crafting Foil™

Directions

Note: See page 142 of Crafting Tips and Techniques for more information on decoupaging.

1. Remove lid from box. Sponge-paint box and lid with True Violet. Let dry. Then sponge-paint box and lid with Medium Lavender, leaving some areas unpainted so that True Violet will show through. Let dry.

2. Transfer patterns to sponge and cut 1 large heart and 1 small heart. Place shapes in water to expand sponge and wring out excess water. Pour small amount of True Fuchsia, Medium Fuchsia, and White onto piece of waxed paper. To give heart mottled appearance, dip large heart into True Fuchsia. Blot excess paint on paper towel. Dip top half of heart into Medium Fuchsia and blot excess paint. Dip upper left side of heart into White and blot excess paint. Gently press sponge onto sides of box, reloading sponge as above as needed. Let dry. Repeat to load and sponge-paint small hearts onto sides of box lid.

3. Using lid as guide, cut angel from decoupage print. Brush even coat of Decoupage Glue on top of lid. Place angel cutout faceup onto glue-covered area of lid and press out air bubbles. Lightly brush top of cutout with coat of glue. Let dry completely.

4. Referring to photo, squeeze thin wavy lines of 3-D Foiling Glue around decoupage print, base of lid, base of box, and around large hearts. Then outline angel with 3-D Foiling Glue. Let glue dry overnight. (Glue will be opaque and sticky when dry. Glue must be thoroughly dry before foil is applied.) To apply gold foil, lay foil dull side down on top of glue lines. Using finger, gently but firmly press foil onto glue, completely covering glue with foil. Peel away foil paper. If any part of glue is not covered, reapply foil as needed.

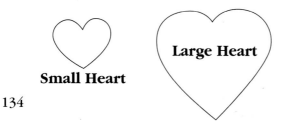

Small Heart

Large Heart

To determine the best method for achieving the mottled effect, practice sponge-painting hearts on a scrap piece of paper.

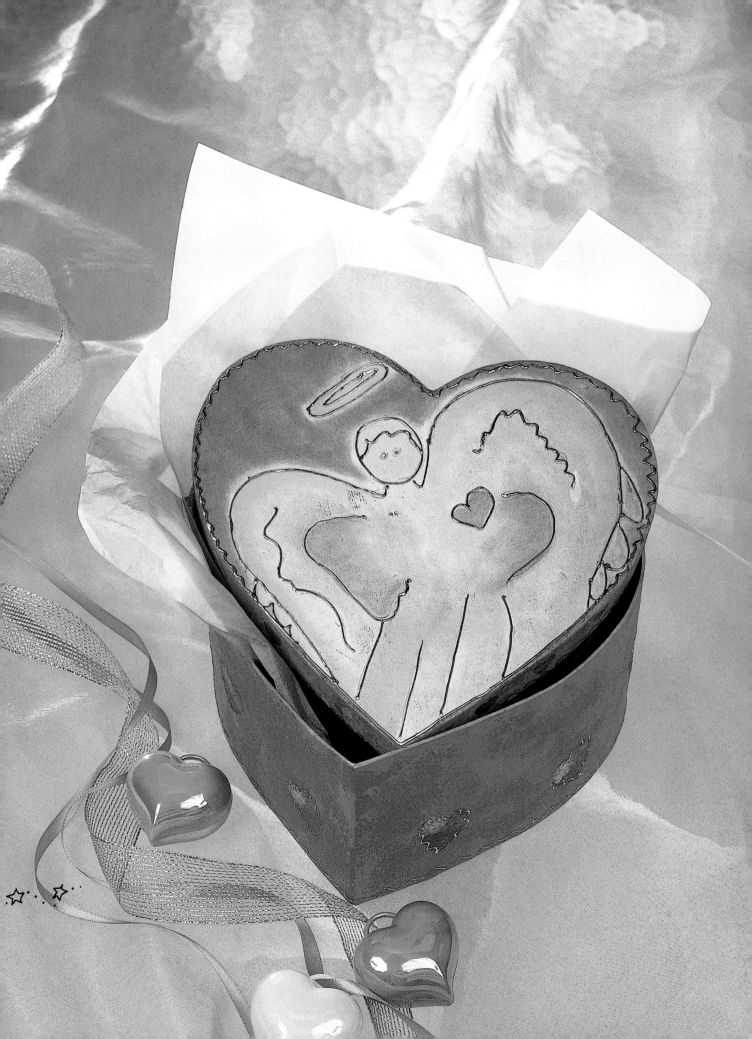

All-Season Angel Garland

This garland truly celebrates the knowledge that to everything there is a season and a time to every purpose under heaven.

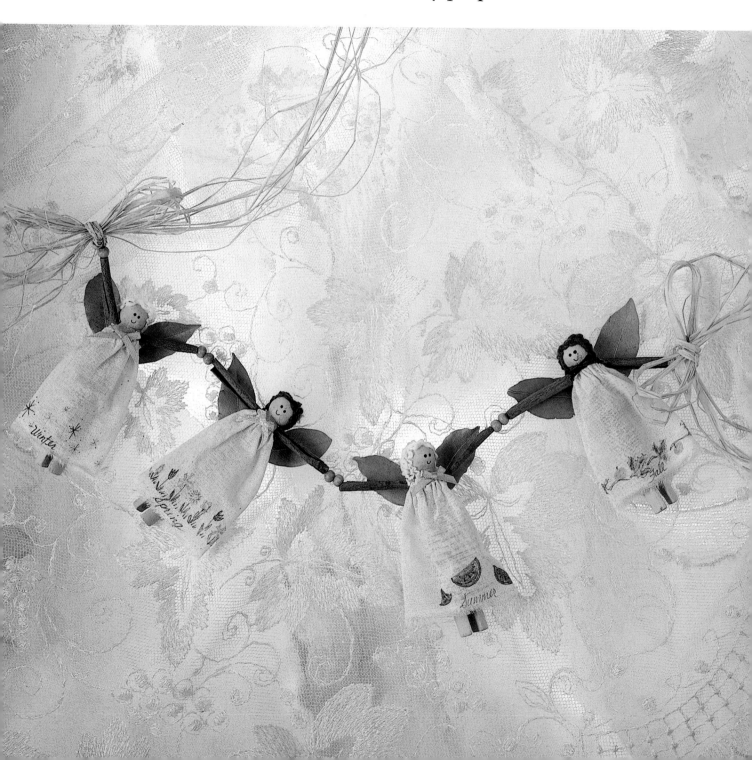

Materials

4 round clothespins
Drill with very small bit
Aleene's Premium-Coat™ Acrylic Paint:
 flesh color
Paintbrush
Black paint pen
Powder blusher
Aleene's Tacky Glue™
Cotton string doll hair in desired colors *
4 (3" x 5") pieces muslin
Fine-tip permanent fabric markers in
 variety of colors
Needle and thread
4" length each ⅛"-wide satin ribbon:
 blue, pink, green, brown
Fishing line
Raffia
8 cinnamon sticks
8 (¼"-diameter) wooden beads
8 bay leaves
* See Sources on page 144.

Directions

1. Drill hole through body of each clothespin, just below round head. Paint clothespins with flesh color. Let dry. Referring to photo, use black paint pen to add facial features. Let dry. Use blusher to make cheeks. Glue doll hair to each head. Let dry.

2. Apply glue to 1 short end of each muslin piece. Bring opposite short end around and press into glue to form tube. Let dry. Using fabric markers, transfer 1 set of seasonal patterns to bottom front of each muslin tube. Write season name beneath corresponding seasonal pattern. Pull threads to slightly fray bottom edge of muslin tubes.

3. Run gathering stitches by hand along top cut edge of each muslin tube. Slip gathered end of 1 muslin piece over 1 clothespin, positioning just below drilled holes. Pull threads to gather tightly and tie off. Glue to keep gathered end of muslin piece in place on clothespin. Let dry. Repeat with remaining muslin pieces and clothespins. Tie satin ribbon lengths in bows, trimming as necessary. Glue blue bow to front

gathered edge of winter angel, pink bow to spring angel, green bow to summer angel, and brown bow to autumn angel. Let dry.

4. Cut 1 (45") length of fishing line. Tie several knots on top of each other 14" from 1 end. Tie raffia bow with long streamers on top of knots in fishing line. If necessary, trim cinnamon sticks to 1¼" long. Thread 1 bead on fishing line, butting bead up against raffia bow. Thread 1 cinnamon stick on fishing line, butting cinnamon stick up against bead. Thread winter angel onto fishing line, butting angel up against cinnamon stick. Thread another cinnamon stick on fishing line, butting it up against angel. Thread another bead on fishing line, butting it up against cinnamon stick. Repeat process for each remaining angel, threading angels in following order: spring, summer, and autumn. After stringing last bead for autumn angel, tie several knots on top of each other in fishing line. Tie raffia bow with long streamers on top of knots.

5. For wings, referring to photo for placement, glue 2 bay leaves to back of each angel. Let dry.

Winter

Spring

Summer

Autumn

137

Crafting Tips and Techniques

Choosing Your Glue

Heidi relied on the extensive line of Aleene's products to make the projects in this book. To help you determine which glue is best suited for your general crafting, refer to the handy list below.

• **Aleene's Tacky Glue**™ is an excellent all-purpose glue for crafting. It is suitable for working with fabric but is not for use with wearables since it is not washable.

• **Aleene's Designer Tacky Glue**™ is a thicker, tackier version of Tacky Glue and is intended for use with heavy items or hard-to-hold items such as Fun Foam. It is a good alternative to a hot-glue gun because materials remain unaffected by heat or cold.

• **Aleene's Jewel-It**™ **Glue** and **OK to Wash-It**™ **Glue** are designed for use with wearables and other fabric items that will need to be washed. Both glues are good for applying appliqués, trims, and other crafting materials to fabric. In particular, use Jewel-It to adhere acrylic jewels or decorative buttons to wearables or to home decor items. Jewels can be embedded into the glue, which dries clear.

• **Aleene's Instant Decoupage**™ **Glue** is a quick and simple one-coat decoupage finish. It serves as both the glue and the finish for quick decoupage projects.

• **Aleene's Reverse Collage**™ **Glue** allows you to create mosaic collage looks on glass or on plastic. Use the glue to adhere decorative papers to the back of an item to create a beautiful, smooth-finish effect from the front.

Aleene's glues are nontoxic and ACMI (Art and Craft Materials Institute) approved. The glues dry clear and flexible, making them excellent for crafting.

Hints for Successful Gluing

To make Tacky Glue or Designer Tacky Glue even tackier, leave the lid off for about an hour before using the glue. This allows some of the moisture to evaporate. Do not dip a paintbrush or other item into the glue bottle as this will contaminate the glue and may cause mold to grow in the bottle. Instead pour a puddle of glue on a piece of waxed paper.

Do not use too much glue. Excess glue only makes the items slip around; it does not provide a better bond. To keep from applying too much glue when gluing together pieces of fabric or brown bag, use a cardboard squeegee to apply a film of glue to the surface. Simply cut a 3" square of cardboard (cereal box cardboard works well) and use the cardboard square to squeegee the glue onto the craft material. Wait a few minutes to let the glue begin to form a skin before putting the items together.

To apply consistent, fine lines of glue to a project, use either the Aleene's Fine-Line Syringe Applicator, following the package directions, or see the diagrams below to make a tape tip for your glue bottle.

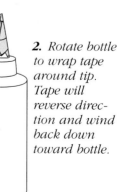

1. Using 4"-long piece of transparent tape, align one long edge of tape with edge of nozzle as shown. Press tape firmly to nozzle to prevent leaks.

2. Rotate bottle to wrap tape around tip. Tape will reverse direction and wind back down toward bottle.

3. Press tail of tape to bottle for easy removal.

Transferring Patterns

To transfer a pattern, lay a piece of tracing paper or lightweight white paper (for a longer-lasting pattern, use Aleene's Opake Shrink-It™ Plastic) on top of the printed pattern. Trace the pattern, using a pencil or a marker. Be sure to transfer any details, such as placement markings and facial features, to the tracing paper. Cut out the pattern.

When only half a pattern is given, fold the tracing paper in half and place the fold on the broken line of the pattern. Trace the pattern as printed and cut out through both layers. Unfold the paper for the complete pattern.

To transfer the pattern onto the craft material, lay the pattern on the material as specified in the directions. Trace, using a pencil or a pen on paper, on wood, or on cardboard and a disappearing-ink fabric marker on fabric. To transfer pattern details to light-colored lightweight fabric or paper, retrace the pattern details onto the paper with a black marker. Tape the traced pattern to a windowpane or a light box; then tape the material over the pattern. Using a disappearing-ink marker, trace the pattern and the markings onto the material. For solid or opaque materials (such as dark fabric, cardboard, wood, or plastic), you will need carbon paper or dressmaker's carbon. Stack the craft material (right side up), the carbon paper (carbon side down), and the traced pattern (right side up). With a dull pencil or a dried-up ballpoint pen, trace over the pattern to transfer the carbon onto the material.

To reverse a pattern to make a matched set of pieces when your craft material has a right side and a wrong side, trace the pattern onto paper as described above and cut it out. To transfer the reversed pattern to fusible web or to a print fabric, lay the pattern right side down on the paper side of the web or the wrong side of the fabric; trace the pattern and cut it out. Then flip the pattern over and trace it again. When your craft material has no right or wrong side, it is not necessary to reverse the pattern for matched pieces.

Metric Conversion Chart

U.S.	Metric
1/8"	3 mm
1/4"	6 mm
3/8"	9 mm
1/2"	1.3 cm
5/8"	1.6 cm
3/4"	1.9 cm
7/8"	2.2 cm
1"	2.5 cm
2"	5.1 cm
3"	7.6 cm
4"	10.2 cm
5"	12.7 cm
6"	15.2 cm
7"	17.8 cm
8"	20.3 cm
9"	22.9 cm
10"	25.4 cm
11"	27.9 cm
12"	30.5 cm
36"	91.5 cm
45"	114.3 cm
60"	152.4 cm
1/8 yard	0.11 m
1/4 yard	0.23 m
1/3 yard	0.3 m
3/8 yard	0.34 m
1/2 yard	0.46 m
5/8 yard	0.57 m
2/3 yard	0.61 m
3/4 yard	0.69 m
7/8 yard	0.8 m
1 yard	0.91 m

To Convert to Metric Measurements:

When you know:	Multiply by:	To find:
inches (")	25	millimeters (mm)
inches (")	2.5	centimeters (cm)
inches (")	0.025	meters (m)
feet (')	30	centimeters (cm)
feet (')	0.3	meters (m)
yards	90	centimeters (cm)
yards	0.9	meters (m)

Working with Aleene's Fusible Web

Use Aleene's Fusible Web™ to create fast and easy no-sew projects. For the best results, always wash and dry fabrics and garments to remove any sizing before applying fusible web. Do not use fabric softener in the washer or the dryer.

Lay the fabric wrong side up on the ironing surface. A hard surface, such as a wooden cutting board, will ensure a firmer bond. Lay the fusible web, paper side up, on the fabric. With a hot, dry iron, fuse the web to the fabric by placing and lifting the iron. Do not allow the iron to rest on the web for more than one or two seconds. Do not slide the iron back and forth across the web. Remember, you are only transferring the glue web to the fabric, not completely melting the glue.

Transfer the pattern to the paper side of the web and cut out the pattern as specified in the project directions. Or referring to the right side of the fabric, cut out the desired portion from a print fabric.

To fuse the appliqué to the project, carefully peel the paper backing from the appliqué, making sure the web is attached to the fabric. If the web is still attached to the paper, re-fuse it to the appliqué before fusing the appliqué to the project. Arrange the appliqué on the prewashed fabric or other surface, as listed in the project directions. If you are fusing more than one appliqué, place all the appliqués in the desired position before fusing. With a hot, dry iron, fuse the appliqués to the project by placing and lifting the iron. Hold the iron on each area of the appliqués for approximately five seconds.

Applying lines of dimensional paint to the edges of your fused appliqués provides a finished look, but it is not necessary.

Handcrafted Means Hand-Wash

After you have created a beautiful wearable, you want to care for it properly. Be sure to let the glue or the paint on your new garment dry for at least one week before washing. This allows the embellishment to form a strong bond with the fabric. (For glitter designs, wait two weeks before washing.)

Turn the garment wrong side out, wash by hand, and hang to dry. Hand-washing protects your work from the rough-and-tumble treatment of a washing machine.

Brush Up on Your Painting Techniques

For each of her painting projects, Heidi uses Aleene's Premium-Coat™ Acrylic Paints because she is able to get the coverage she wants in as few coats as possible.

The perfect companions to Aleene's paints are Aleene's Enhancers™. The Enhancers, when used with Aleene's acrylic paints, give the paint a variety of capabilities. **All-Purpose Primer** prepares your surface (except fabric) for even coverage of your base coat. It also protects the surface of the item being painted. Because it dries clear, it works well when you want to maintain a natural finish.

Mediums are always mixed with an acrylic color and are never used alone. Mix *Textile Medium* with the acrylic paint to make the paint pliable so that it can be absorbed into fabric fibers. No heat setting

is required and your fabric will retain its softness. Mix *Clear Gel Medium* with the acrylic paint so that the paint can be used as a stain or as an antiquing paint. Mix *Glazing Medium* with the acrylic paint to thin down the colors for transparent looks. Mix *Mosaic Crackle Medium* with the acrylic paint to create an easy faux finish. Use the Mosaic Crackle Medium in conjunction with Mosaic Crackle Activator.

Varnishes ensure your piece will be protected. *Satin Varnish* dries to a soft finish. *Gloss Varnish* dries to a shiny finish. Both varnishes dry clear.

Although Aleene's paints clean up easily with soap and water, be sure to thoroughly rinse out your paintbrushes or sponges immediately after you are through with them to prevent the paint from hardening in the bristles or in the sponge.

When stamping or sponge-painting a design, it's a good idea to practice on a piece of paper to determine the correct placement and proper amount of pressure and paint needed for the desired effect.

Sponge-Painting How-to

To sponge-paint a design, dip a small pop-up craft sponge piece into water to expand it. Wring out the excess water. Pour a puddle of one color of paint on a piece of waxed paper. Dip the sponge into the paint and blot the excess paint on a paper towel. Lightly press the sponge on the project surface. Repeat until the desired effect is achieved. Remember to apply the paint sparingly at first; you can always add more paint to the design. Sponge-paint small areas at a time and apply the paint in a random pattern.

Your project will have more depth if you apply several layers of colors. Sponge-paint your first layer, leaving some areas unpainted to allow the next color to show through. Repeat to apply a second and third layer. Always let each color of paint dry before applying the next layer of color or your work will become muddy and the colors will not be distinct.

If the sponge becomes saturated with paint, rinse it in clean water and wring out the excess water.

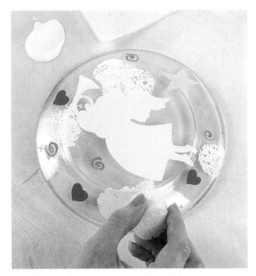

Applying first sponge-painted layer

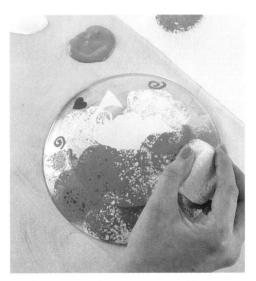

Applying second sponge-painted layer

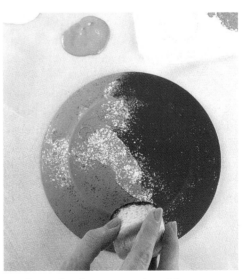

Applying third sponge-painted layer

Faux Stained-glass How-to

Transfer the pattern to white paper. If using a glass or clear plastic item that is flat, center the item on top of the pattern and tape or attach a paper clip to secure the pattern. Otherwise, cut out the pattern and then tape the pattern to the inside of the glass or clear plastic item. Trace the pattern lines on the right side (or outside) of the glass or clear plastic surface using 3-D Foiling Glue™. The glue line should be about ¼" thick for the best effect. Let the glue dry for about 24 hours. The glue will be opaque but sticky when completely dry. The glue must be thoroughly dry before the foil is applied. Remove the pattern from the item.

To apply the Aleene's Gold Crafting Foil™, lay the foil dull side down on top of the glue lines. Gently but firmly press the foil onto the glue, completely covering the glue lines with the foil. Be sure to press the foil into crevices. Peel away the foil paper. If any glue is not covered, reapply the foil as necessary.

Trace the pattern onto the tissue paper or the paper napkins, adding ¼" all around, and cut out as specified in the project directions. (Be sure to test paper for color-fastness as some colors bleed when wet.) If you are working with a flat glass or clear plastic item, cover the work surface with fabric to protect the foiled surface. Working over one design area at a time, apply a generous coat of Reverse Collage Glue™ to the wrong side (or inside) of the glass or clear plastic surface. Place one tissue paper cutout over the glue-covered area and gently press it into the glue. Working from the outside edges to the center, use your fingers or brush to gently wrinkle the tissue paper cutout, shaping the cutout to fit the design area. Brush a coat of Reverse Collage Glue on top of the cutout. In the same manner, cover all the remaining design areas with the cutouts. Let the glue dry.

Applying 3-D Foiling Glue

Applying Gold Crafting Foil

Applying tissue paper cutout

Creating Instant Decoupage Finishes

If the piece you are decorating is wooden, thoroughly sand all surfaces to remove any rough edges or imperfections. Some pieces that are labeled as presanded still need more sanding before decorating. Base pieces need to have a smooth and even surface. If your base piece is glass, be sure the glass is clean and dry before decorating.

If your base piece is to be painted, unless otherwise instructed, use a ½" shader paintbrush and paint one or more coats of acrylic paint on the surface, letting the paint dry between each application. If wooden surfaces feel rough or uneven after

painting, lightly sand and apply another coat of paint. Let the paint dry.

Cut out the desired motifs from gift wrap, greeting cards, or other decorative paper items. Arrange the cutouts on the base piece to determine placement. Remove the paper pieces from the base piece. Use a 1" sponge brush to apply a coat of Aleene's Instant Decoupage™ Glue in either matte or gloss to the base piece in the desired position. Place the paper piece on the glue-covered area and use your fingers to press out any air bubbles. Brush a coat of Decoupage Glue on top of the paper piece, covering the edges of the paper. In the same manner, apply additional paper pieces to the base piece until you achieve the desired effect. Let dry. Aleene's Instant Decoupage™ Glue cleans up with soap and water. However, once dry, the finish is water resistant.

Shrink-It How-to

Make jewelry, refrigerator magnets, and many other kinds of projects with Aleene's Shrink-It™ Plastic. Children especially enjoy watching the designs shrink during baking. Keep the following tips in mind when working with Shrink-It.

Before using colored pencils on Shrink-It, thoroughly sand the Shrink-It with fine-grade sandpaper. Hold the Shrink-It up to a light source to check for unsanded areas.

Cut out your design and punch holes as specified in the project directions before shrinking; the plastic is too hard to cut after shrinking. Wear a pair of cotton gloves to protect your hands while handling hot Shrink-It.

Preheat a toaster oven or a conventional oven to 275° to 300°. Sprinkle a room-temperature baking board or nonstick cookie sheet with baby powder to prevent sticking and to ensure even shrinking. Place the Shrink-It design on the prepared surface and put it in the oven.

The edges of the design should begin to curl within 25 seconds; if not, increase the temperature slightly. If the edges begin to curl as soon as the design is put in the oven, reduce the temperature. The design will curl and roll while it is shrinking. A large design may curl over onto itself. If this happens, open the oven and unfold the design; then continue baking.

After about one minute, the design will lie flat. Use a hot pad to remove the baking board from the oven. Use a spatula to move the design from the baking board to a flat surface. To keep the design flat during cooling, place a book on top of it. You may shape the design before it cools. If you are not happy with the shape of your design after it has cooled, return it to the oven for a few seconds. Remove the design from the oven and reshape it while it is still hot. Then set it aside to cool completely.

Shrink-It design ready to be baked

Design baking

Design before baking, design after baking, and design completed

143

Sources

Aleene's Products
1-800-825-3363

Angel Cards
Torn Paper Art Angel Cards
Simply Angels
P.O. Box 644
Cambria, CA 93428
1-800-914-7577

Blank Wallpaper Border
Stencil Decor™ Blank Wall Border
 Stencil Paper
Plaid Enterprises
P.O. Box 7600
Norcross, GA 30091-7600
(770) 923-8200

Cotton String Doll Hair
Bumples, Bumpy Doll Hair
One & Only Creations
P.O. Box 2730
Napa, CA 94558
(916) 663-9020

**Make-A-Memory Photo Album Cover
 Kit and filler paper**
Gick Companies
9 Studebaker Drive
Irvine, CA 92718

Rub-On Doll Faces
Lara's Crafts
590 North Beach Street
Fort Worth, TX 76117
1-800-232-5272

Self-Adhesive Decorator Lamp Kit
Kiti's Self-Adhesive Lamps and Shades
Mainely Shades
100 Gray Road
Falmouth, ME 04105
1-800-624-6359

Woodsies™
Creative Wholesale
P.O. Box 2070
Stockbridge, GA 30281
(770) 474-2110

SPECIAL THANKS to Woody Hall, Heidi Borchers's son, who worked from Heidi's sketches to electronically create the angel alphabet that appears on pages 23–25.